ART revolution

Alternative Approaches for Fine Artists and Illustrators

Lisa L. Cyr

NORTH LIGHT BOOKS
CINCINNATI, OHIO
www.artistsnetwork.com

Art Revolution. Copyright © 2009 by Lisa L. Cyr, Cyr Studio LLC. Manufactured in China. All rights reserved. No part of this book may be reproduced in any form or by any electronic or mechanical means including information storage and retrieval systems without permission in writing from the publisher, except by a reviewer who may quote brief passages in a review. Published by North Light Books, an imprint of F+W Media, Inc., 4700 East Galbraith Road, Cincinnati, Ohio, 45236. (800) 289-0963. First Edition.

Other fine North Light Books are available from your local bookstore, art supply store or online supplier, or visit our website at www.fwmedia.com.

13 12 11 10 09 5 4 3 2 1

DISTRIBUTED IN CANADA BY FRASER DIRECT
100 Armstrong Avenue
Georgetown, ON, Canada L7G 5S4
Tel: (905) 877-4411

DISTRIBUTED IN THE U.K. AND EUROPE BY DAVID & CHARLES
Brunel House, Newton Abbot, Devon, TQ12 4PU, England
Tel: (+44) 1626 323200, Fax: (+44) 1626 323319
E-mail: postmaster@davidandcharles.co.uk

DISTRIBUTED IN AUSTRALIA BY CAPRICORN LINK
P.O. Box 704, S. Windsor NSW, 2756 Australia
Tel: (02) 4577-3555

Library of Congress Cataloging in Publication Data

Cyr, Lisa.
 Art revolution : alternative approaches for fine artists and illustrators / Lisa L. Cyr. -- 1st ed.
 p. cm.
 Includes index.
 ISBN-13: 978-1-60061-149-0 (pbk. : alk. paper)
 1. Art--Technique. 2. Originality in art. I. Title.
 N7430.C97 2009
 702.8--dc22
 2008052327

Edited by Sarah Laichas
Designed by Guy Kelly
Production coordinated by Matt Wagner

DISCLAIMER: Before embarking on any new procedure or technique, it is very important to be knowledgeable about the products, equipment and processes you will be using. The demonstrations throughout the book are for general instruction only and do not cover the risks associated with using artist materials. For health and safety procedures and product information, go to the manufacturers' websites or contact them directly to obtain and follow the material safety data sheets for all products you use. Inhalation, ingestion or skin contact should always be avoided. As a general rule, never eat, drink or smoke when using artist materials and keep all products and processes away from children. Insure adequate ventilation in your studio and wear protective clothing and gear when needed. Also note that in the demonstrations some processes use ink-jet printers, scanners, cameras, copiers or other such equipment in alternative ways and may void manufacturers' warranties. The experimental processes covered in the book are by the individual artists and no guarantee or warranty of fitness is offered.

Cover art credits:

Matt Manley, Susan Leopold, Kazuhiko Sano, Stephanie Dalton Cowan, David Mack, Robert Maloney, Dorothy Simpson Krause and Lisa L. Cyr (background texture).

Front matter and back matter credits:

Portrait of Marshall Arisman by Max Gerber. Portrait of Kathleen Conover by Kathleen Mooney. Portrait of Stephanie Dalton Cowan by Ken Hawkins Photography with digital embellishments by the artist. Portrait of Lisa L. Cyr by Christopher B. Short. Portrait of Lynne Foster by the artist. Portrait of Rudy Gutierrez by the artist. Portrait of Brad Holland by Jon Twingley. Portrait of Dorothy Simpson Krause by the artist. Portrait of Susan Leopold by David Saltmarche. Portrait of David Mack by Linda Costa. Portrait of Dave McKean by Clare Haythornthwaite. Portrait of Robert Maloney by Geoff Kula. Portrait of Matt Manley by the artist. Portrait of Michael Mew by the artist. Portrait of A.E. Ryan by Jeff Dunn. Portrait of Kazuhiko Sano by the artist. Portrait of Barron Storey by Petra Davis. Portrait of Richard Tuschman by the artist. Portrait of Cynthia von Buhler by the artist. Portrait of Camille Utterback by Lyle Troxell. Textured backgrounds are created by Lisa L. Cyr.

Adobe and Photoshop are either registered trademarks or trademarks of Adobe Systems Incorporated in the United States and/or other countries.

*Art legends throughout *Art Revolution* are displayed height by width by depth.

Metric Conversion Chart

To convert	to	multiply by
Inches	Centimeters	2.54
Centimeters	Inches	0.4
Feet	Centimeters	30.5
Centimeters	Feet	0.03
Yards	Meters	0.9
Meters	Yards	1.1

acknowledgments and dedication

I would like to give special thanks to all of the artists who have participated in this book. Their ability to transcend boundaries serves as an inspiration to the next generation of artists who will expand upon their groundbreaking work, further elevating the platform of visual expression. I would also like to thank my publisher, Jamie Markle, and my editor, Sarah Laichas, for fully embracing my vision and making this project a reality. Lastly, I'd like to thank my family for their ongoing patience, understanding and support. I dedicate this book to the greatest creator of all, for all His infinite blessings.

contents

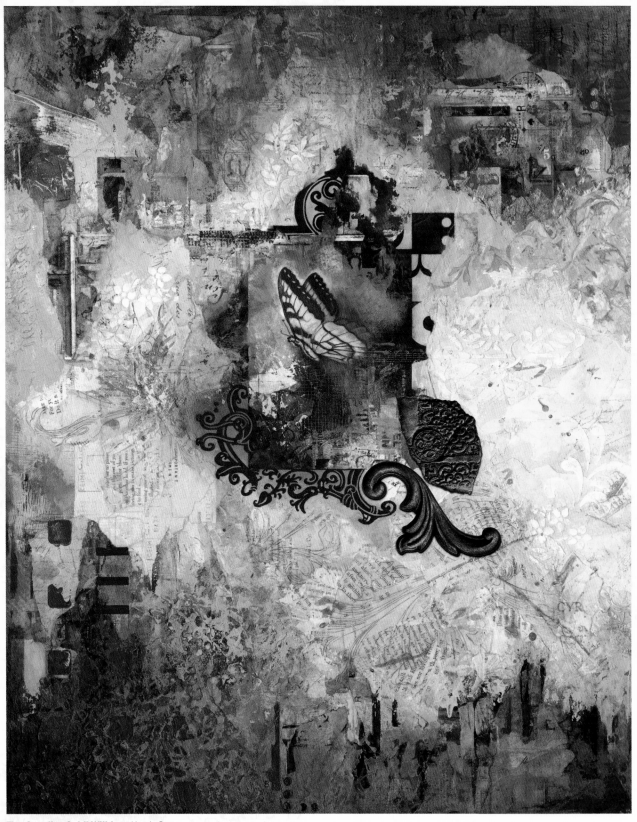

The Creative Spirit Within · Lisa L. Cyr
SIZE: 22" × 17½" × 1¾" (56cm × 44cm × 4cm) / **MEDIUMS:** acrylic, oil, ink, graphite, modeling paste and colored pencil / **MATERIALS:** textured paper, tissue, ephemera, die-cut paper, clay and wood / **TECHNIQUES:** collage, assemblage, sculpture, sanding, scraping, peeling back, spattering, palette knife and type transfer / **SURFACES:** linen canvas over Masonite panel with wooden framework / **COLLECTION:** the artist

INTRODUCTION:

reinterpret, reinvent and redefine

We are currently in the midst of an artistic revolution. No other time has seen such innovation in the way art can be intellectualized, produced and presented into the culture. Artists are breaking from conventional approaches, reexamining the fundamental methodology in which they work. They are becoming much more forward-thinking, almost entrepreneurial, venturing out with a content-driven approach to discover new pathways for their work to flourish and prosper. The traditionally accepted roles of art and the artist are being reinterpreted, reinvented and redefined to embrace a new paradigm, opening the door to a more progressive social consciousness.

Art Revolution is at the forefront in exploring alternative, innovative ways of conceptualizing and creating art that is on the cutting edge. Throughout this highly visual book, insightful and thought-provoking profiles of leading artists and illustrators accompany stellar, multimedia work. The book also provides insight into the historical influences behind contemporary thinking and approaches, investigating the origins of alternative, unconventional picture-making throughout the decades. In addition, exciting splash spreads featuring demonstrations and behind-the-scene looks at groundbreaking artists at work help shed light on signature processes and techniques.

There is a rich amalgam of media available to creatives today, offering a wide range of possibilities for exploration and experimentation. *Art Revolution* reveals how alternative, mixed-media aesthetics is uniting the disciplines of two-dimensional, three-dimensional, digital and new-media art in inventive combinations. For those wanting to venture outside the norm, the book includes a directory of the manufacturers and suppliers used by the featured artists so that sources for materials, access to health and safety procedures, and additional information on unconventional techniques and approaches are easily accessible.

The demands, distractions and challenges present in today's fast-paced, chaotic world make it ever more difficult to break through the sea of mediocrity to make a memorable, lasting connection with an audience. For artists who are looking for an edge, wanting to push their work further, this book will be a valuable asset and ongoing source of inspiration.

It's truly an exciting time to be an artist.

"Create from the heart, innovate without boundaries, strive for greatness and speak to the culture in ways that inspire and motivate."

Lisa L. Cyr

transcending
boundaries

The Modern Art movement was, by far, the most significant example of artists pushing beyond limitations, challenging the existing paradigm to discover a new language in which to communicate and define their existence in history. For the first time, representational, narrative-based art and its ideas were put into question. The monolithic, slice-of-life concept of picture-making was no longer the norm. New approaches in handling space and form, independent of nature, were being discovered. Painters Pablo Picasso and Georges Braque, inspired by the groundbreaking work of Post-Impressionist painter Paul Cézanne, took a leading role in the redefinition of art and the making there of. From 1908 to 1914, the two pioneers worked collaboratively in search of an alternative form of expression,

a different approach to seeing and interpreting the world. From their efforts, Cubism, an artistic vision that allows for multiple viewpoints to be shown simultaneously, was born. Renaissance-based pictorial theory was forever shattered, opening the floodgates to a new, more progressive ideology. In addition, the Cubist movement also gave birth to a more tactile approach to picture-making. With the invention of papier collé (collage), cut and torn paper as well as found materials were being layered and juxtaposed, often projecting from the support in a constructed relief, to realize a subject. With the introduction of matter painting, granular materials such as sand were brought into the paint mixture and applied to the working surface with unconventional tools, creating low-relief textural effects.

Graphique 1, 2 & 3 · Lisa L. Cyr
SIZE: 11" × 11" (28cm × 28cm) per triptych / **MEDIUMS:** acrylic and gel medium / **MATERIALS:** patterned paper / **TECHNIQUES:** palette knife, stenciling, scratching and collage / **SURFACE:** Masonite panel / **COLLECTION:** private collection

Under Cubist theory, pictorial reality became multidimensional, expressed in a multimedia format. The monumental discoveries introduced by Picasso and Braque profoundly impacted the visual vanguard for decades.

While the new language of Cubism resonated around the world, modern life was beginning to change as well. At the time, major breakthroughs and discoveries were being made in both science and technology. Artists of the revolutionary movement called Futurism embraced the inventive ideology and were eager to explore the dynamics of the emerging industrial age in which they lived. Fascinated by the power of the machine and the proliferation of mass media, progressive-minded artists sought to produce works that conveyed concepts rather than subjects. Motion, energy and speed as well as simultaneity and mass production became the thematic impetus for creative works. Artists, no longer constrained in approach, were now free to explore conceptual ideas without being locked into conveying nature as a subject.

The internationally recognized Dada movement further broke down the confines of traditional approaches and philosophies in art through its politically-charged, anti-art tactics. The works of Dada followers such as Marcel Duchamp were created as an active protest, a frontal attack on existing bourgeois interests. Dadaism also made popular the use of photomontage, making it a mainstay in the visual vernacular. The technique used photographic images that were disassembled and repositioned to create jarring associations. Simultaneously, developments in special-effects photography and cinematography were also having an affect on visual organization. The clever use of devices such as dissolves, montages and double exposures, as well as the use of unconventional lighting and extreme camera angles, further stimulated the fragmentation of naturalistic spatial relations.

Having pushed its propagandist ideas to the limit, Dada eventually led to Surrealism—a direct shift from concerns of the external world to that of the internal psyche. Surrealist artists, enchanted by Freudian psychology and the mysteries of

the unconscious dream state, produced work with strange and ambiguous metamorphoses, dynamic changes in scale and unexpected juxtapositions—creating a fine line between reality and fantasy. The dream landscape offered a very different perspective for artists to explore. It was highly imaginative, symbolic and often metaphorical. This new language introduced not only a new way of thinking but also revealed alternative approaches in the making of art. To stimulate creative and imaginative faculties, Surrealists exploited the art of chance. Low-relief rubbing (frottage), scraping back into a painted surface (grattage), making an impression into thick wet paint (decalcomania), smoking an image (fumage) and stream-of-consciousness drawing (automatism) were just some of the innovative methods that were employed. With the introduction of Surrealism, both artistic content and process had seemingly limitless boundaries.

Through the applied art practices of the Bauhaus, an influential art school in Germany, modern thinking was slowly introduced into mainstream popular culture. Consolidating many of the avant-garde ideas of the day, the Bauhaus saw no boundaries between craft and the arts of painting, sculpture, design and architecture. This multidisciplinary focus exposed creatives to a broad range of possibilities for art to move and grow. Many of the instructors were leaders in their field, teaching a cutting-edge curriculum that fused art with industry. This penetration into the cultural masses would continue until the close of the Bauhaus in 1933. Because of the rise of fascism and totalitarianism, many influential Bauhaus teachers and students fled Europe and came to America. Their Modernist ideas and philosophies came with them, dominating the art scene for the next two decades.

In America, artists wanted to break free from their European counterparts to assert a language all their own. From the late 1940s and into the 1950s, Abstract Expressionism became a dominant artistic movement. Abstract Expressionists were interested in conveying something more profound, more awe-inspiring. Artists such as Jackson Pollock, Willem de Kooning and Mark Rothko, some of the leading figures of the day, favored large-scale, completely abstract works that asserted the individuality of the artist, so the painting process and the artist's part in it became the subject. This was yet another radical change in

direction. In America, the shift was profound, as it turned the eyes of the art world from Paris to New York City.

By the early 1950s, Robert Rauschenberg would arrive on the scene, eager to create work that, in many ways, would push artistic boundaries even further. The young artist set out on a journey, a path of exploration in media and in concept. By challenging preconceived assumptions, Rauschenberg was able to discover a revolutionary new way of seeing and working. He later labeled this art form the Combine, a combination of two-dimensional techniques and three-dimensional assemblage. Rauschenberg's hybrids embraced found materials and objects from everyday life. Images and ephemera from mass media and popular culture—such as comic strips, signage and magazine clippings, along with diagrammatic and iconographic elements—were juxtaposed against objects that often projected off the picture plane, creating new relationships that challenged the viewer's mind to find alternative connections.

By the mid-1960s, Rauschenberg and the Modernists that came before him had collectively paved the way for artists to experiment as never before. Everything and anything was free game when it came to picture-making. In 1966, Rauschenberg and artist Robert Whitman co-founded a groundbreaking, non-profit organization called Experiments in Art and Technology (E.A.T.) with the assistance of Bell Laboratories' electrical engineer Billy Klüver and engineer Fred Waldhauer. The organization enabled the collaboration of artists and engineers through the assistance of corporate funding. Under this visionary program, Rauschenberg produced pioneering works, each requiring viewer interaction to create the experience. Rauschenberg's grand formats, multidimensional compositions and interactive works were in sync with a world that was, at the time, expanding and beginning to move faster than ever before.

With the postwar economic boom, a more progressive mindset became widespread. People were not only open and ready for change, they expected it. Big business also embraced innovation. Seduced by the advent of TV, advertisers jumped ship and moved their campaigns from print to television broadcast, causing many of the popular magazines of the day to fold. The demand for realistic, narrative illustration that once reigned on the covers and interiors of every major magazine was waning.

Poetry in Motion 1, 2 & 3 · Lisa L. Cyr
SIZE: 11" × 11" (28cm × 28cm) per triptych / **MEDIUMS:** acrylic, modeling paste and gesso / **TECHNIQUES:** palette knife, spattering, dripping and sponging / **SURFACE:** Masonite panel / **COLLECTION:** private collection

Photography had also taken a huge bite out of the illustration business. The change in the competitive landscape opened up an opportunity to introduce something new, something more personal when it came to imagery. Innovative, concept-based approaches to illustration were beginning to flood many of the underground publications, eventually catching the eyes of the mainstream publishing elite. Illustration no longer needed to be confined to a literal translation of narrative text, but instead could offer more to the printed page. At the close of the 1970s and well into the 1980s, pluralistic thinking and multiplicity in image-making was widespread.

With the 1990s came Adobe® Photoshop,® available through desktop publishing technology. The computer and this innovative software application opened up even more possibilities for artists to explore and experiment. Many artists were using digital processes to enhance their work and speed up their overall process. They were scanning, digitally manipulating, printing out and then reworking an image with other mediums, combining both traditional and electronic means in a seamless way. This practice persists today, but with a much higher level of sophistication. When it comes to digital output, major strides have been made. The advocacy efforts of Digital Atelier, a group of three artists, helped give a tactile presence to the virtual image. Since forming in 1997, Dorothy Simpson Krause, Bonny Lhotka and Karin Schminke have researched emerging technologies, trying to find new ways to get their work out of the computer and onto intriguing surfaces. Since the early 1990s, they have worked with state-of-the-art print equipment and manufacturers to explore the possibilities of using large-format printers for

outputting creative works. In exchange for access to equipment and technology, Digital Atelier would provide feedback to developers about how they could expand their product's capabilities and market. The group also exhibits work generated from the collaborative process at major industry trade shows, museums and universities worldwide, demonstrating the possibilities of digital output for creative means. Today, almost any surface can accept digital output as long as it is sealed with a receptive coating. Both large- and small-format ink-jet printers are readily available and affordable for artists who want to experiment, printing on a variety of customized surfaces. There are also products such as pigment-based inks, ink-jet receptive coatings and UV protective gels and sprays that can enhance the quality and look of the digital print. What was once achievable only in a large commercial print shop can now be done on a desktop in the confines of an artist's studio.

With the advent of the Internet and the sophistication of digital technology on the rise, new media art is at the forefront when it comes to engaging an audience. No longer confined to a static existence, today's images move, speak and are responsive to human interaction. Limited only by their imagination, artists are exploring and experimenting with this virtual art form in myriad ways. As new technologies emerge, alternative ways in which to embrace the high-tech aesthetic will follow.

For art to continue to transcend boundaries, creatives must take an active role in pushing artistic content to a higher level. An expansive ideology and inventive mindset are necessary in the pursuit. As artists push the envelope of visual expression, the world will be able to experience a dynamic, more robust existence.

content-driven
approach

Over the last two decades, technological innovation has virtually revolutionized the way we live. Yet, with all the advancements in productivity, the temperament of popular culture has never been more passive. The expectation of instant gratification has impacted the sociological consciousness, where everyone settles for the quick fix. In our time-is-of-the-essence ideology, it seems that the speed at which things are done is becoming ever more important, oftentimes trumping quality. We are seeing more and more prefab, formula-driven art enter into the social mindset, generating an almost homogenized aesthetic. To eradicate the complacency that exists, artists need to take a content-driven approach, producing imaginative and thought-provoking work that speaks to the culture in ways that inspire and motivate.

More than ever, creatives need to reexamine the fundamental methodology in which they work, taking an active role in pushing content to a higher level. To penetrate the indifference in the marketplace, artists must become more entrepreneurial in their approach, developing their own content and not simply relying on the market for guidance. They need to move outside their comfort zones, exploring untapped territory that crosses boundaries amongst the disciplines. When creatives are in control of the artistic content and direction of their work, they gain independence and no longer have to rely on an intermediary. To be successful in the pursuit, artists need to convince the visual

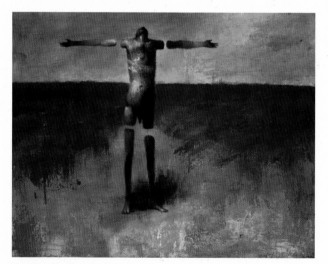

I'm Coming Apart · Brad Holland
SIZE: 24¾" × 28" (63cm × 71cm) / **MEDIUM:** acrylic / **SURFACE:** Masonite board
CLIENT: *Longevity* magazine

vanguard to buy into their vision, educating them about being open to new approaches and ways of interpreting the world. Success rewards innovators, those who are not afraid to break away from conventional thinking. Venturing out from the pack often puts one first in line while others merely stand in the back.

To move forward, artists must adopt a success-based work ethic. They have to be willing to strive for greatness every time, refusing to compromise and settle for the mundane. This means doing their best in every aspect of their work, regardless of the reward or accolades that may or may not come from their effort. Nobody knows when the door of opportunity will appear. Focusing one's state of mind on the high road results in actions that will ensure one's readiness when the time comes. Visionary artists don't limit themselves. They are always thinking ahead, seeking new ground for their work. Even in the face of adversity, artists who are determined to succeed do not give in to fear and anxiety or accept a state of defeat. They see the uncertainty of a situation as an opportunity to try new things, reveling in the potential it can bring for upward mobility. Instead of trying to fight adversity, they embrace it and use it as an incentive to move forward. Some have described the feeling as riding the wave of life. Maintaining self-confidence even through times of disappointment and rejection, and not falling prey to negative forces, separates the ones who will persevere and triumph from the ones who will merely exist.

If an artist does not have the background, knowledge or skill sets to fully sustain a self-initiated project single-handedly, she should consider creative collaboration. The dynamics of a multidisciplinary group endeavor create an environment that is conducive to the pursuit of ideas that are much more expansive and innovative in approach. Within a group endeavor, each contributor brings creativity and know-how to the table. Their combined efforts, energy and wisdom not only make a multi-faceted project possible but also, in the process, open the door for cross-pollination to occur, further expanding the boundaries of what is possible across markets. The results can be inspirational, uplifting and rewarding for all involved.

In a cultural landscape that is stagnant and craving distinction, artists need to take an active role in venturing outside

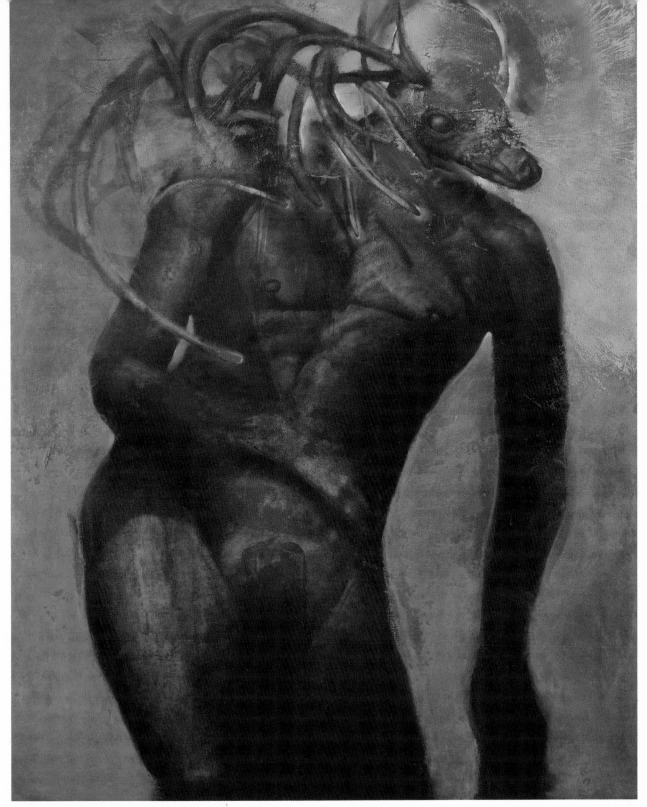

Black Elk: Deer Shaman · Marshall Arisman
SIZE: 68" × 48" (173cm × 122cm) / **MEDIUM:** oil / **MATERIAL:** gold leaf / **SURFACE:** canvas / **COLLECTION:** the artist

the confines of traditional approaches to discover new outlets that will allow their work to move and grow. They need to innovate, embracing entrepreneurial thinking and authorship as a way to penetrate the complacency that exists. They must seize the opportunity to turn the tide of mediocrity. To create a more vibrant and robust cultural exchange, artists need to become inventors of their own content, asserting a viewpoint all their own.

Marshall Arisman:

personally invested

Authenticity of style and the development of pure artistic vision begin with self-awareness and being honest about one's abilities, interests and aspirations. Knowing what feeds, motivates and nurtures the creative spirit within is essential to building a foundation from a place that is genuine. As an artist grows and matures, the work evolves naturally in a free and almost effortless way. Being self-aware and in touch with one's inner voice generates a pathway for creative aspirations to come to fruition.

Being authentic means having the courage to venture out on one's own creative path, attracting like-minded people who share the vision. For artist Marshall Arisman, this voyage of discovery began when he stopped doing what others wanted him to do and started focusing on work that he was personally invested in. Arisman started by taking an inventory of his own real knowledge and understanding, then decided how such insight could direct his picture-making. "I made a list of the things that I knew well. The first thing that came up was cows. I was brought up on a dairy farm and have milked cows my whole life. Yet, I had never drawn or painted a cow," says the artist. "Deer were the second on the list, psychic phenomenon was the third and the fourth was guns." These were the subjects that he knew best and if his work was to grow from a place of authenticity, the artist needed to embrace the familiar.

Drawing from his personal experience, Arisman produced a body of work built around his knowledge of guns. "I started these drawings having no idea they were going to turn into a series about violence," recalls the artist. "The School of Visual Arts, where I was chair of the undergraduate program at the time, published a book of the work, producing 900 copies. I sent the books out to art directors and by the next day, I was getting phone calls to do illustrations that I would've done for myself. I was stunned by the fact that this had become my portfolio." What Arisman realized is that one's personality, interests and experiences constitute a breeding ground for artistic content. Anytime you can tap into that internal source, you will find something that is unique and worth sharing with the culture. "If you are working on something that you know and care about, then the pictures you create from that knowledge and insight are going to be much more interesting," adds Arisman. "There is this illusion that you must put this sample case together to please them. Well, you will spend the rest of your life putting new pieces in a portfolio for them and go nowhere. But on the other hand, if you can find out what is driving you to make pictures, then you are going to find an outlet."

For Arisman, the energy, passion and drive for picture-making comes from making a personal connection with the work in a way that is meaningful. "It is important to be autobiographical," explains the artist. "The base of your work needs to be something you understand and are connected to, later expanding upon your knowledge over time. I see art as an evolutionary process that has to do with my life. If my life changes

"When you are involved with a subject matter that is important to you, the work is elevated to another place. It's hard to fake that. It drives the work ethic, taking you beyond where you become a star."

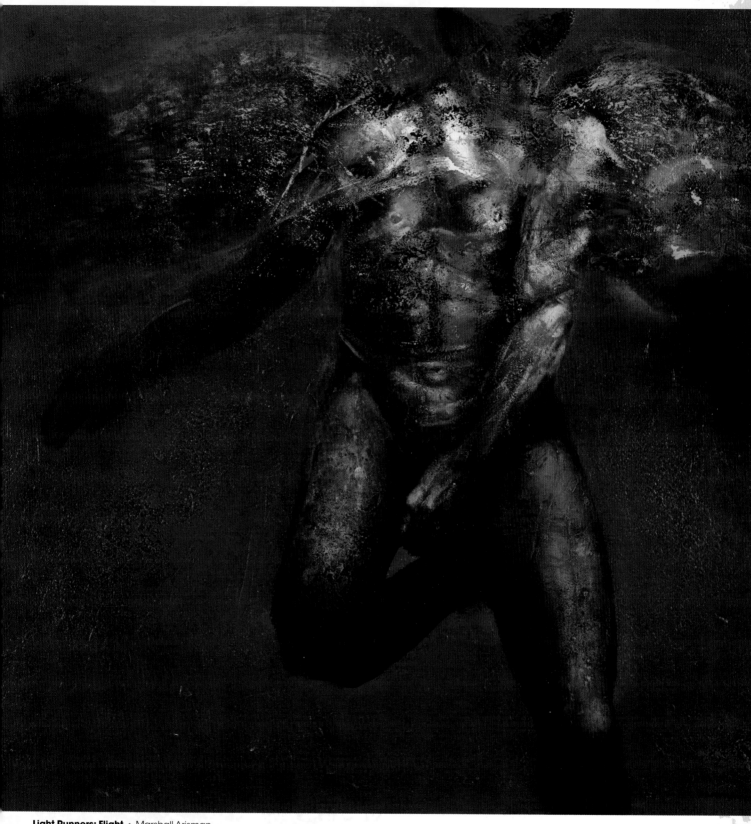

Light Runners: Flight · Marshall Arisman
SIZE: 38" × 38" (97cm × 97cm) / **MEDIUM:** oil / **SURFACE:** canvas / **COLLECTION:** private collection

and my art doesn't reflect that change, then something is really wrong." Staying true to oneself is essential for remaining steady on the course to discovering one's unique voice, vision and contribution to the world. "When you are involved with a subject matter that is important to you, the work is elevated to another place," observes Arisman. "It's hard to fake that. It drives the work ethic, taking you beyond where you become a star."

Working primarily on unstretched canvas tacked to a large wall in his studio, Arisman employs rollers, combs, rags, cardboard, brushes and his fingers to manipulate oil paint on the surface. When painting, he uses his entire body, climbing on ladders to access the entire surface. Since his art requires a certain physical stamina, the work flow is dictated by the amount of energy the artist has on any given day. To keep his interest piqued, Arisman works on at least three to four projects at a time. Much of his fine-art work is quite large in format, while his assignment work, mostly done on illustration board, tends to be scaled more to the reproductive page. "My gallery paintings are meant to be seen in person," says the artist. "I make them big so there is a physical connection between the work and the person looking at it." In addition to painting, Arisman's distinctive vision also embraces printmaking, sculpture and videography. His new-media work, viewable on the Internet, allows him to put content out to a broad, massive audience that spans several time zones simultaneously. "It's the best blank page in the world: seamless and endless with plenty of room to tell stories," he adds. "Exploring new outlets is about expanding your mailing list, selling

"There is this illusion that you must put this sample case together to please them. Well, you will spend the rest of your life putting new pieces in a portfolio for them and go nowhere. But on the other hand, if you can find out what is driving you to make pictures, then you are going to find an outlet."

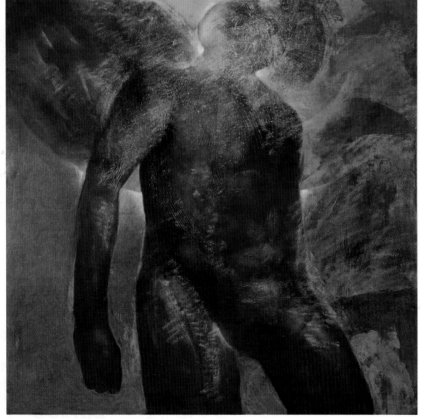

Light Runners: Pardigm . Marshall Arisman
SIZE: 79" × 79" (201cm × 201cm) / **MEDIUM:** oil / **MATERIAL:** gold leaf / **TECHNIQUE:** combing / **SURFACE:** canvas / **COLLECTION:** private collection

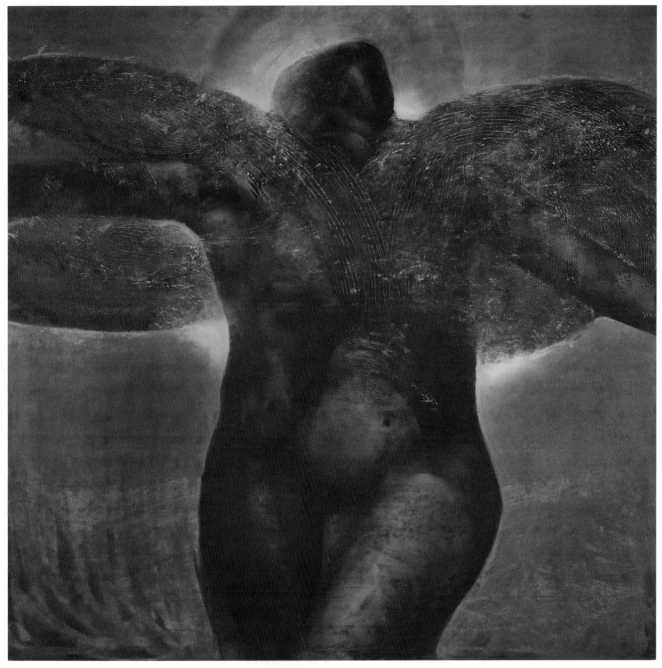

Light Runners: Transcendent · Marshall Arisman
SIZE: 79" × 79" (201cm × 201cm) / **MEDIUM:** oil / **TECHNIQUE:** combing / **SURFACE:** canvas / **COLLECTION:** private collection

your vision and not just a product. This allows people to come to you with a way to use your work. Your portfolio shouldn't be held together by the glue of your style but by the glue of your content."

Even today, Arisman draws from that original list of subjects he made back in 1971, using it as a guide on his journey to answer more profound questions. The artist's willingness to shape artistic content with the backbone of personal experience is exemplary. Arisman's unique insight, integrity and work ethic have inspired many to look inside themselves, to trust their instincts and to have the courage to make their own mark on the world—hopefully, in the process, inspiring others to follow suit.

Brad Holland:

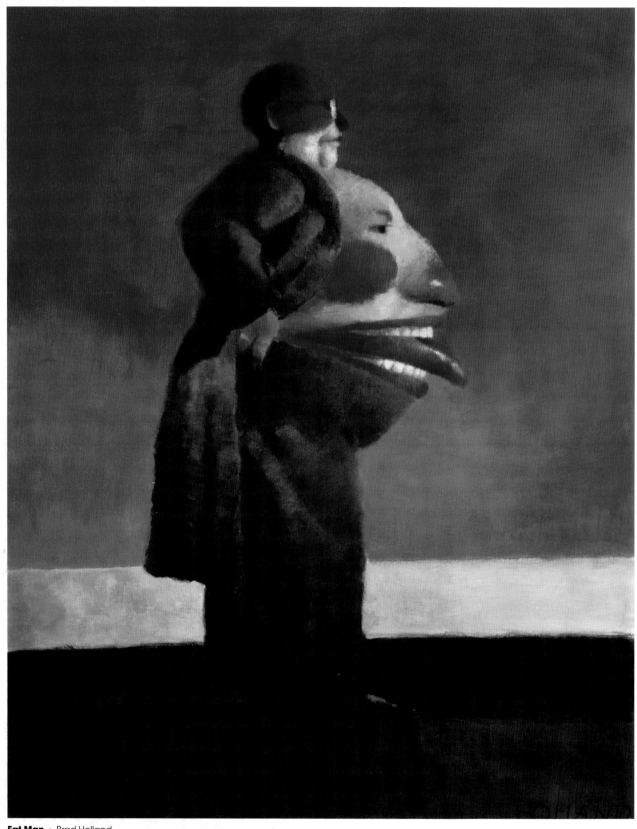

Fat Man · Brad Holland
SIZE: 18" × 15" (46cm × 38cm) / **MEDIUM:** acrylic / **SURFACE:** Masonite board / **CLIENT:** New Choices

rebel
WITH A
cause

In the 1960s, the illustration scene was in great transition. With the proliferation of television, many popular magazines of the day saw their demise and either closed or went searching for a new look, something that would appeal to a wavering audience. This period of transition opened the door for change. For illustrator Brad Holland, it was an opportunity to bring a more inventive mindset into the culture. In 1967, the artist headed to New York City to stake his claim.

At the time, art directors were hiring talent based purely on style. A regurgitation or literal translation of an existing text was all that was required of illustration; anything more was unheard of. Holland, who had always felt a deep passion for writing, thought that he could bring something more provocative to the printed page. "I didn't want to have to channel someone else's opinions. I wanted to have enough freedom to do something that came out of my own imagination rather than have to recycle what someone else had said," recalls the artist. "If I couldn't do what I wanted as an illustrator, then I would simply become a writer. You go into art to express yourself, and if you are told that you can't, then it's time to go to plan B."

Whether as an illustrator or as a writer, Holland was determined to do things on his own terms. To get his foot in the door, he began approaching smaller, special-interest publications that often showcased new talent. "What I learned was that most of the big magazines with budgets to do color work wanted to control what you did and the magazines that used black-and-white illustration tended to leave you alone," says Holland. "So, I began doing mostly black-and-white work on the principle that I was more likely to be left alone, and if I developed a niche for doing it, then I could translate the work into color later. My logic was to get the work published so that art directors would see it and begin to imitate the procedure." For Holland, breaking conventional thinking was no easy feat. With every assignment, the artist relentlessly used his powers of persuasion to convince art directors and editors to give him the opportunity to create work that was less literal and more interpretative in nature—a graphic commentary of sorts. "As I kept trying to explain what I wanted to do, I finally developed a talking point," says the artist. "I used to tell art directors to imagine if they locked a writer in one room and me in another, giving us both the same assignment. When we were through, they could marry the illustration with the text." If that wasn't enough, Holland would also use Michelangelo's *Creation of Adam* painting in the Sistine Chapel as an example. "If Michelangelo would've translated the Bible literally, God would've been giving mouth-to-mouth resuscitation to Adam," he chuckles. "Yet, no one has ever questioned the work even though it didn't illustrate the Bible text at all. You just take it for granted because it works."

From his ongoing passion for authorship, Holland's unconventional approach to picture-making evolved. Inspired by the highly imaginative twice-told tales of

"I didn't want to have to channel someone else's opinions. I wanted to have enough freedom to do something that came out of my own imagination rather than have to recycle what someone else had said. If I couldn't do what I wanted as an illustrator, then I would simply become a writer."

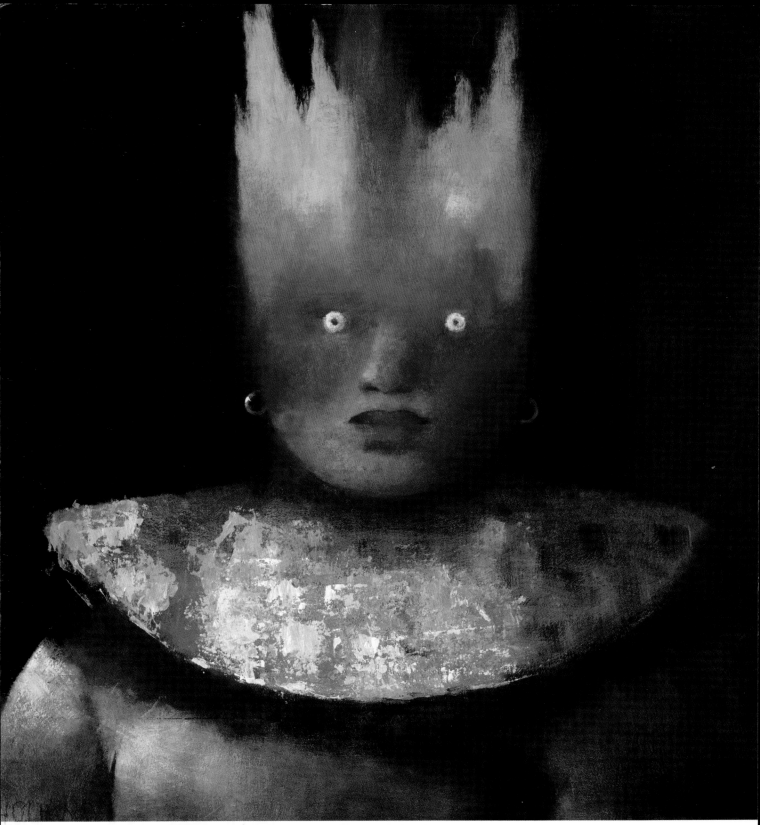

A Queen Briefly · Brad Holland
SIZE: 14" × 14" (36cm × 36cm) / **MEDIUM:** acrylic / **SURFACE:** Masonite board / **CLIENT:** Mirabella

Nathaniel Hawthorne, the insightful aphorisms of Mark Twain, and the lyrics of Bob Dylan, Hoagy Carmichael, Duke Ellington and George Gershwin, the artist sought to paint ideas rather than translate words. Like a writer, the artist uses narrative elements; but instead of arranging them in a slice-of-life scene or frozen moment, Holland layers, edits and recomposes the information into a more thought-provoking, conceptually-based image. "When you tell a story, it is a matter of arranging time where you have to figure out what order that you want to present information in," explains Holland. "My approach to illustration is to compress the sequential release of information that you would try to express over time, flattening it out into a single image."

With persistence and determination, the rebel with a cause eventually penetrated a once closed system, injecting his way of thinking into mainstream popular culture. "You have to create the market for your work," says Holland." If you just set out to change yourself to fit into what a market dictates, you will never have the time to ultimately find yourself." *The New York Times* op-ed page was the place where Holland's unique voice and vision really made its claim to fame. Known as a forum for viewpoints divergent from the editorial side of the paper, the op-ed page was a perfect breeding ground for artists who had something to say with pictures. For Holland, it became a regular showcase for his work and he relished the opportunity to visually comment on economic, political and social issues. The artist's graphic, highly iconic work proved to be a fresh break from the years of conventional, narrative illustration that came before it.

Holland's unique approach forged a new vitality in editorial illustration, putting him top of mind and leading the pack. "I just acted as if I had the freedom to do what I wanted and continued to act that way until people began to let me," admits the artist. "I was living in a world that didn't exist yet, I kept acting as if it did." Holland's revolutionary work not only dramatically changed the look of illustration but also the role of the illustrator in the process. "The only way to introduce anything new into the culture is to persuade clients to take on something that they haven't tried before instead of just going along with things," says Holland. "Asserting yourself doesn't mean you have to risk your livelihood. It just means you have to open a client's mind to other possibilities."

"The only way to introduce anything new into the culture is to persuade clients to take on something that they haven't tried before instead of just going along with things. Asserting yourself doesn't mean you have to risk your livelihood. It just means you have to open a client's mind to other possibilities."

Conscience · Brad Holland
SIZE: 13½" × 10¾" (34cm × 27cm) / **MEDIUM:** acrylic / **SURFACE:** Masonite board / **COLLECTION:** the artist

Dave McKean:

making a connection

Throughout history, art has been the vehicle by which creatives contribute to an ongoing, dynamic cultural exchange. Although the players and the mediums in which they work have changed over the years, the intent remains the same: to converse, participate and contribute in some way to an entity bigger than oneself. Dave McKean—comic-book creator, illustrator, concept artist, photographer, graphic designer, filmmaker, musician, record-label founder and director of TV and music videos—knows what it means to contribute to the larger dialogue of life. "I think everyone, in some way, tries to make a mark on the world and the people around them," says the artist. "Whether you are baking cakes, fixing cars, fishing, playing music or drawing comic books, it's a huge ongoing conversation where you get to say your bit and see if anyone else has shared that experience. Whatever we do affects the world a tiny, tiny bit. We become the butterfly effect, shaping evolutionary change in some small way."

For McKean, visual storytelling is a way of conversing with the world. "Stories shape and reflect our culture," he says. "We all tell them, respond to them and use them to understand our sense of history and self." Whether the story is presented as a comic book series, children's book, music video or film, McKean's images of surrealistic, dreamlike fantasy invite us into worlds unknown, stretching and expanding our imagination. We drift to another place and time, venturing outside ourselves and into the mind of the artist. "Through my films and illustrations, I try to explain the way I see the world: a tiny locus of the Now surrounded by a huge ball of fantasy, the interpreted past, the hopes and fears of the future and the dreams and fictions that puddle through our minds," he says. Not interested in achieving hyperrealism, McKean focuses more on appealing to the senses and translating feelings through the realm of abstraction. He delights in an image's ability to move beyond the surface to make an emotional connection with the audience that is engaging, lasting and memorable.

McKean's approach to picture-making is exploratory, embracing a multimedia aesthetic. He loves to experiment with alternative approaches, materials and media, keeping his process fresh and his mind fertile. An interesting fusion of drawing, painting, photography, collage, assemblage, sculpture and the digital domain, McKean's mixed-media work pushes the artist outside his comfort zone, challenging him to experience something new. "I prefer to make my own mistakes in a state of happy amateurism than learn the correct way to do things," he admits. "This means it takes me a long time to feel confident with a medium, but the lessons go in very deep." For McKean, the content of his work always drives the medium and the approach. "I'm interested in ideas and stories, so finding the ideal way of communicating those ideas

"Whether you are baking cakes, fixing cars, fishing, playing music or drawing comic books, it's a huge ongoing conversation where you get say your bit and see if anyone else has shared that experience. Whatever we do affects the world a tiny, tiny bit. We become the butterfly effect, shaping evolutionary change in some small way."

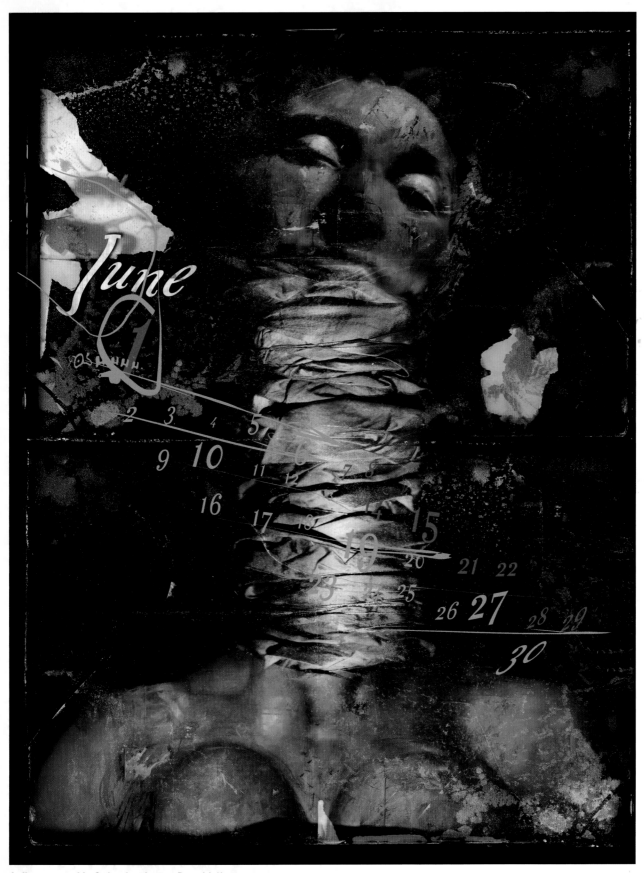

Anthropomorphic Calendar: June · Dave McKean

SIZE: 19" × 13½" (48cm × 34cm) / **MEDIUMS:** acrylic, photography and digital / **CLIENT:** Off Beat Records

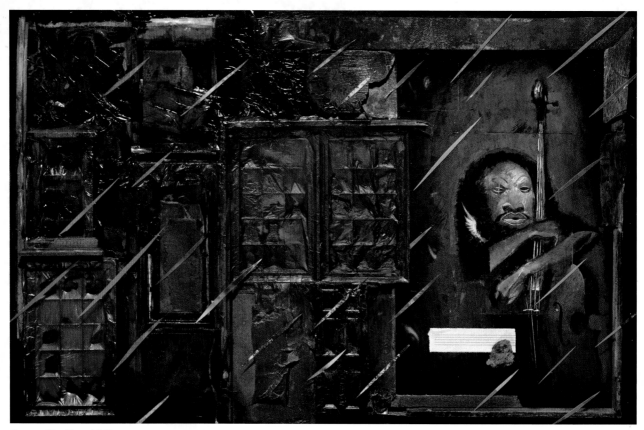

Cages #8 · Dave McKean

SIZE: 24" × 36" (61cm × 91cm) / **MEDIUMS:** acrylic and photography / **MATERIALS:** model windows, wood and paper / **TECHNIQUES:** collage and assemblage / **SURFACE:** mount board / **CLIENTS:** Tundra, Kitchen Sink Press, NBM Publishing and Dark Horse Publishing

leads to trying different media," explains the artist. "For instance, if an image is trying to express how strong and solid a man is, then maybe it should be a clay sculpture or a pile of stones. If it's trying to express his uncertainty, perhaps it should be a simple pencil drawing done with the left hand so it is awkward and wobbly. The form should always match the content."

Because many of McKean's projects are large in scope, collaboration is often necessary. The artist embraces joining forces with talented individuals in other disciplines, expanding his range of knowledge and insight. "I get a day pass into the head of a writer, an actor or even a chef. It's always great to try and understand someone else's world view," says McKean. "It's healthy to be challenged, working on things that are out of my immediate neighborhood." To ensure the overall integrity of his vision, the artist takes an active role in the various production aspects of his work. "The image doesn't stop at the drawing or painting, it continues on to the paper selection, typography, use of borders and the rest of the design elements. All of which carry meaning," notes McKean. "I think it is better to have a single clear idea communicated by an individual through all these stages, rather than a team, which often colors the work in different ways."

When it comes to developing new projects, McKean's mind is always on the hunt. "If an idea sits on my desk, in my laptop or on my mind for a while, then I know it has something to it," he says. "Some ideas for stories have been with me for ten years or more before I know enough about them to commit them to paper." For McKean, striking a healthy balance between personal and commissioned work is a must. "I need my

"Through my films and illustrations, I try to explain the way I see the world: a tiny locus of the Now surrounded by a huge ball of fantasy, the interpreted past, the hopes and fears of the future and the dreams and fictions that puddle through our minds."

own projects in order to grow and feel engaged with the world on my own terms," he says. "I'm pretty sure that if I love something, others will be interested as well. The only difficulty is finding them [an audience], but they are always there."

Ultimately for McKean, creative expression is an opportunity to make a connection, contributing something of oneself to a greater whole. "I believe that art can have a direct affect on the world. It's not as quick a solution as making a poster equals changing a policy, but it's a democratic process where each little weight, counterbalance and argument make a difference to the overall," he says. "It's an ongoing conversation not only within yourself but also between yourself and others: a mesh of ideas and opinions. You feed your brain, create beautiful, moving, wonderful things, plant your flag and shout 'I am here' in an attempt to connect and create a bond with your neighbors. You feel a little less alone, and maybe, in the end, you might actually say something new."

> "I need my own projects in order to grow and feel engaged with the world on my own terms. I'm pretty sure that if I love something, others will be interested as well. The only difficulty is them [an audience], but they are always there."

Café des Amis · Dave McKean
SIZE: 6" × 4" (15cm × 10cm) / **MEDIUMS:** acrylic, photography and digital / **TECHNIQUE:** collage / **CLIENTS:** The Café des Amis, Hourglass and Allen Spiegel Fine Arts

reinterpreting the
visual landscape

Life is not static but ever-changing and dynamic. As we move through space and time, our focus as well as our interpretation of reality is constantly in flux. Art that documents the single, slice-of-life scene is really recording only a minute portion of what we actually experience. Human perception is much more multidimensional, receiving input from all the senses. Sight, sound, smell, taste and touch form a cumulative sensation. Artists who choose to break away from the traditional, representational narrative approach to image-making opt to convey a deeper, more true-to-life impression, as opposed to recording the mere artifacts of the visual landscape.

When presented with a field of vision that we have not before experienced, we become curious, wanting to see and—perhaps—

Kabuki: The Alchemy #2 · David Mack
SIZE: 17" × 11" (43cm × 28cm) / **MEDIUMS:** acrylic and watercolor /
MATERIALS: wood, handwritten letter on aged paper and transparency film /
TECHNIQUES: xerography, collage and assemblage / **SURFACE:** illustration board /
CLIENT: Marvel Entertainment/Icon

know more. A conceptually-driven, pluralistic work challenges us, provoking thought and contemplation over time. Interpreting pictures that veer from naturalistic representation is not beyond human ability. From a very young age, we have the cognitive capacity to respond to shape and pattern, innately making sense of abstraction whenever it presents itself. Even as adults, we form pictures out of cloud formations, the bark of a tree or the grain in polished stone. The reinterpretation of fragments and chance juxtapositions is instinctual; dreams present themselves in a similarly distorted fashion. Out-of-scale relationships, shifting planes, ambiguous metamorphoses and unexpected relationships do not seem odd because we are accustomed to taking pieces of waking reality and rejoining them in another way while dreaming. Abstracting from real life, our dreams manipulate visual manifestations, sounds, smells, emotions and tactile sensations, recycling them into an entirely new, more profound reality.

Artists who adopt a pluralistic rather than naturalistic philosophy aspire to tell a different kind of story, one that is more poetic and oftentimes symbolic or metaphorical in nature. They are interested in emotionally, intellectually and sensually engaging the viewer, creating an experience rather than a scene. Within the concept-based realm, abstract ideas such as the passing of time or opposing themes such as life and death or disappointment and acceptance each can be presented simultaneously. Pictorial elements take on multiple roles and the visual field becomes a playground for the mind. Shape, color, texture, type and line transcend their graphic status to create an image that communicates more than the sum of its parts. Bright colors convey loud sounds, layered textures suggest tactile sensations, organic shapes express the natural environment, and geometric patterns evoke a more man-made, technical aesthetic. In addition, type can translate into dialogue, phrases or whispers to a story, and iconography—with historical, social or cultural connotations—can be very powerful, coloring the entire visual field with meaningful symbolism. Clever editing and composition create room for imaginative interpretation, inviting the viewer to personally invest in the work.

Deviating from the norm requires consummate design and visual communication skills. Because multisensual, multidimen-

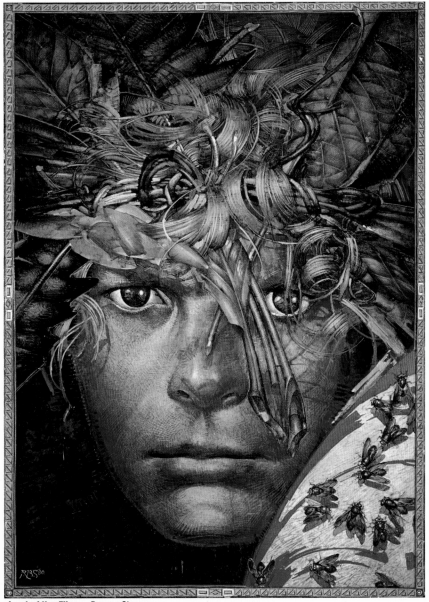

Lord of the Flies · Barron Storey

SIZE: 29" × 20½" (74cm × 52cm) / **MEDIUMS:** acrylic, ink, ballpoint pen, pen and ink, colored pencil, marker and graphite / **MATERIALS:** tracing paper (collage) / **TECHNIQUES:** cross-hatching, broken color and collage / **SURFACE:** illustration board / **CLIENT:** Putnum Publishing Group

sional works can become quite layered and complex, the artist needs to establish a hierarchy, an overall organizing principle to guide the eye. Most artists begin with a strong concept and central point of interest, forming the critical foundation from which everything else emanates. Choices in materials and technique are never random but deliberate and conscious, based upon their ability to communicate. When it comes to process, a non-linear approach is the direction of choice, as it leaves the door open for discovery. The subconscious works in tandem with the conscious to cultivate the unexpected. Employing both left- and right-brain thinking, verbal and visual brainstorming stimulates imaginative expansion—establishing connections

that may not have been previously realized. Through a process of progressive refinement, an image is revealed. Experience begets confidence, and trusting in one's intuition becomes a more viable and effective way of working.

To truly connect with an audience, the visual landscape must be continually reinterpreted, encompassing a broader, more dynamic pictorial idiom. Creatives must continue to pursue alternative approaches in visual expression, producing works that challenge, motivate and provoke viewers to participate in the overall messaging. For art to endure, the nature of pictorial thought needs to continually evolve, unfolding a new aesthetic for future generations to ponder, push and repurpose.

Barron Storey:
social consciousness

Throughout history, social, political and economic upheaval have altered the path of humanity. In the face of disasters, war and conflict, society is forever changed. Life as it was is no longer. A new road must be paved. Artists, in their angst, have always risen to the challenge, serving as pioneers on a new frontier. As active witnesses to the evolution of social consciousness, they use their circumstances as the impetus for creative output, producing works to become catalysts for change. For artist Barron Storey, creative expression serves as a way to hold a mirror up to society, opening people's eyes to the raw, uncensored truth.

Social responsibility has long been at the forefront of Storey's work. "I was always interested in public affairs," says Storey. "My parents were involved politically and they inspired me to pay attention." In addition, the artist was also highly influenced by the work of his mentor and teacher, reportage illustrator Robert Weaver. "Social consciousness was Weaver's thing," says Storey. "He always raised the roof to show issues that were of importance. He caught my attention doing serious topics that influenced public opinion."

As a visual journalist, Storey sees himself as a witness and not a commentator. His work is not about giving an opinion but providing an honest response to what he has experienced. The artist's process begins primarily in journals and drawing is always the conduit. When a topic or theme has held Storey's interest long enough to fill several journals, he switches gears and begins to synthesize what he has observed, seeing if it can translate into larger works in series. "The way I work is much like a filmmaker who shoots footage and then goes into the editing room to make a film," he explains. "When I get something interesting happening, I am motivated to use what I've developed, making a more formal statement." When it comes to picture-making, Storey pulls from his plethora of interests: drawing, painting, sculpture, theater and

"The way I work is much like a filmmaker who shoots footage and then goes into the editing room to make a film. When I get something interesting happening, I am motivated to use what I've developed, making a more formal statement."

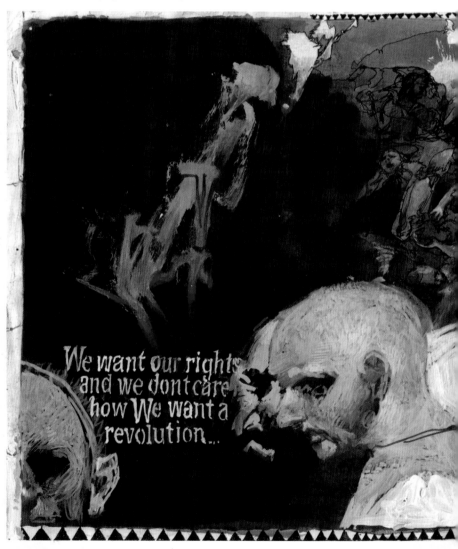

We want our rights and we dont care how We want a revolution...

music. The artist loves to experiment and considers each attempt at the board a new opportunity to explore. "I always want to approach things differently each time I work," says the artist. "I have never been one to fall in love with any one particular technique or way of working."

When building his highly complex, montagelike images, Storey begins by creating a visually dense, often tactile environment. He enjoys being inventive with his working surface and is always intrigued by the way it alters the imagery he paints on top. "I like the idea of working into a preexisting density instead of a clean piece of paper. Because a tactile surface has ridges, it catches the paint and has the feeling of a broken rather than continuous surface and I love that," he says. "It virtually transforms the image." Storey sees the creative process as an adventurous ride. He trusts his visceral approach and embraces the unexpected like an old friend. "While working, I affirm the happy accidents and deliberate corrections that go on," he declares. "There is an original intent that lies under the eventual resolution of fulfillment and I want all that to be perceptible in the work." If at any point Storey loses interest, he will often take drastic measures to reengage himself. He is known for tearing a work in half, painting most of an image out or putting something on top of a work that obscures it in some

"While working, I affirm the happy accidents and deliberate corrections that go on. There is an original intent that lies under the eventual resolution of fulfillment and I want all that to be perceptible in the work."

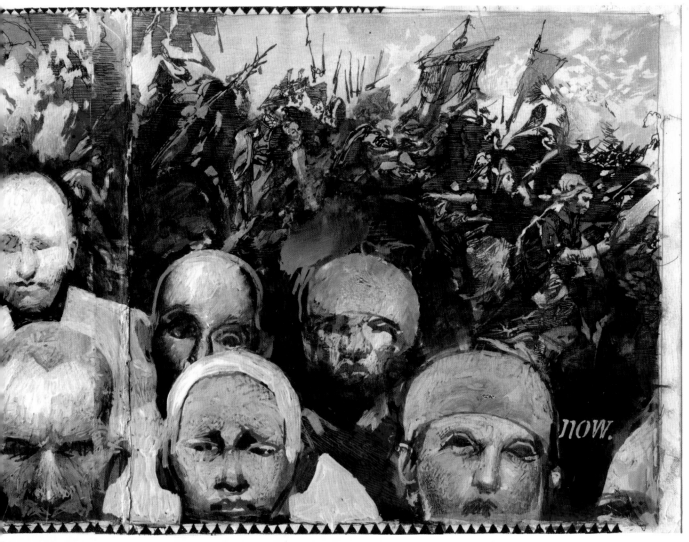

Marat/Sade: Revolution Now! · Barron Storey
SIZE: 6½" × 14½" (17cm × 37cm) / **MEDIUMS:** ink, graphite, colored pencil and acrylic / **SURFACE:** paper / **COLLECTION:** the artist

way. "I have to be totally engaged at all times," says Storey. "If I try to work when I am bored, then what will be put into the work is boredom."

Storey's multisensual, emotionally-inspired work forces us to stop, look and even listen. With subsequent visits, we become ever more engaged. A new layer reveals itself and a different dimension of the story is exposed. "I want people to look at my work and be inspired to stay with it somehow. Part of my layering process is to not only have elements that are apparent at first glance but also to have certain subtleties that would not be discovered until the work had been looked at for a while," explains Storey. "I am trying for something that is instantly sensational, yet inspires contemplation over time." When exhibiting his work, the artist likes to arrange the pieces in clusters so they read like images on a page of a book, resonating with one another.

A seasoned artist, Storey aspires to create work that will transcend time. "I am dealing with serious topics and am interested in the powerful impact that art can have on people," he says. In the works created for both the *Black Iraq* and *Victims* series, Storey presents images that are void of idealism and beauty. They veraciously expose the realities of war and other tragic events in a way that is emotionally driven and vividly compelling. "I am working with the grotesque, and a big motivator is to show images with the expectation that people will look at them and oppose the war," says the artist. Through his efforts, Storey hopes to break through the passivity that exists in the modern mindset to solicit a response, shifting the social consciousness and ultimately making an impact that will resonate with generations to come.

> "I want people to look at my work and be inspired to stay with it somehow. Part of my layering process is to not only have elements that are apparent at first glance but also to have certain subtleties that would not be discovered until the work had been looked at for a while. I am trying for something that is instantly sensational, yet inspires contemplation over time."

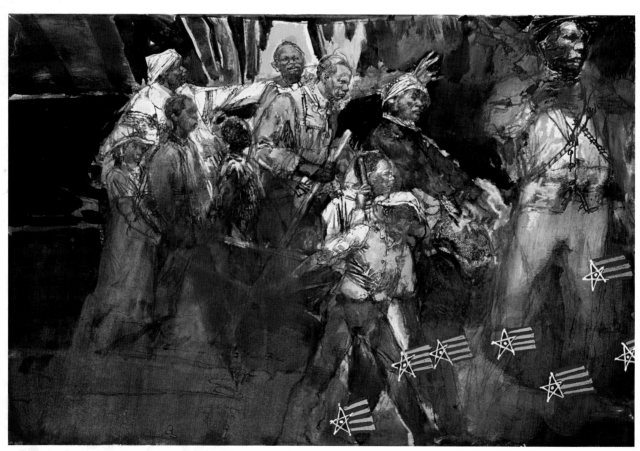

Underground Railroad: Drinking Gourd · Barron Storey
SIZE: 18" × 24" (46cm × 61cm) / **MEDIUMS:** ink, watercolor and acrylic / **SURFACE:** paper / **COLLECTION:** the artist

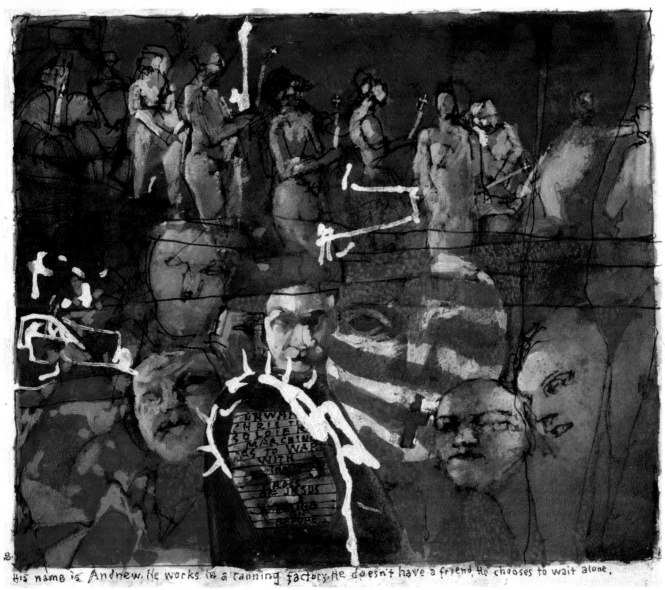

Black Iraq: Onward Christian Soldiers · Barron Storey
SIZE: 20" × 20" (51cm × 51cm) / **MEDIUMS:** graphite, ink and gouache / **TECHNIQUES:** digital printing and collage / **SURFACE:** canvas / **CLIENT:** the artist

sensory connection:
exploring graphic language

From birth to death, we experience an intricate matrix of observations, sensations and emotions, with each day providing a unique and distinctive piece to the overall three-dimensional puzzle of human experience. For multifaceted artist Barron Storey, art is about responding to life in all its complexities. Thoughts, sights, sounds, smells and tactile stimuli that make up the artist's everyday existence are religiously documented in his journals as a way to capture the dynamic eccentricities of observation, imagination and insight on paper.

Storey sees himself as a spectator who testifies to what has transpired. His visual diaries are the repositories of reality as he has witnessed it. "The journals are not areas where ideas are developed but instead are daily records of experience, real or imagined," he explains. "It's a great big stew, uniting the body, mind and senses." Fully present in the moment, Storey passionately records his day-to-day encounters—without editing. He adapts to the unexpected at every twist and turn along the way. "The books are done in the heat of the moment—a deliberate crudeness or Art Brut that I call punk energy," says Storey. "For me, it's important not to think first and draw after. I like to keep in the domain of the magic that happens when you are thinking, seeing and drawing all at the same time."

For Storey, the process of journaling is purely reactive, without overt concerns for stylistic interpretation or decoration. It serves as a way to take chances, pushing beyond visual limits and self-induced boundaries. Through years of diligent practice and experimentation, his visual language—a signature way of talking through drawing—has evolved. The translation of perception into a graphic form has created an expansive vocabulary for the artist. "When working, I am interested in the capacity of abstract mark-making to communicate," says Storey. "To liberate some kind of raw and primal response, I put myself through emotional experiences, deliberately trying to get into the moment. Extremity produces a lens in which we can see things that we can't otherwise. It is very much like acting." To keep his creative process fluid, Storey utilizes three distinct approaches. "When my mind knows what to do, my eye and body will follow. When my mind doesn't know what to do, my eye will get the job and I immediately look around, drawing whatever is there," the artist

explains. "If my eye is not getting it done, my body will take over and that is where abstract mark-making comes into play." To extrapolate his subconscious thought, Storey will often play a game he calls "find image." By drawing marks, scribbles and doodles on a page, the artist creates an environment in which imagery begins to present itself. "In the midst of the jumbled mess, I start to see things, especially faces, and I try and bring them out," says Storey. "If what I unearth becomes too cliché or predicable, I will push it back into the maze of marks and find something else."

Each journal is divided into chapters and given a title, usually something open for multiple interpretations. Type is present throughout, especially in the beginning of each book as a preamble. Storey's first-person approach and willingness to be open—mind, body and soul—to the process have allowed the artist to make a direct sensory connection with his audience, motivating them to look further and perhaps participate in the messaging.

"The journals are not areas where ideas are developed but instead are daily records of experience, real or imagined. It's a great big stew, uniting the body, mind and senses."

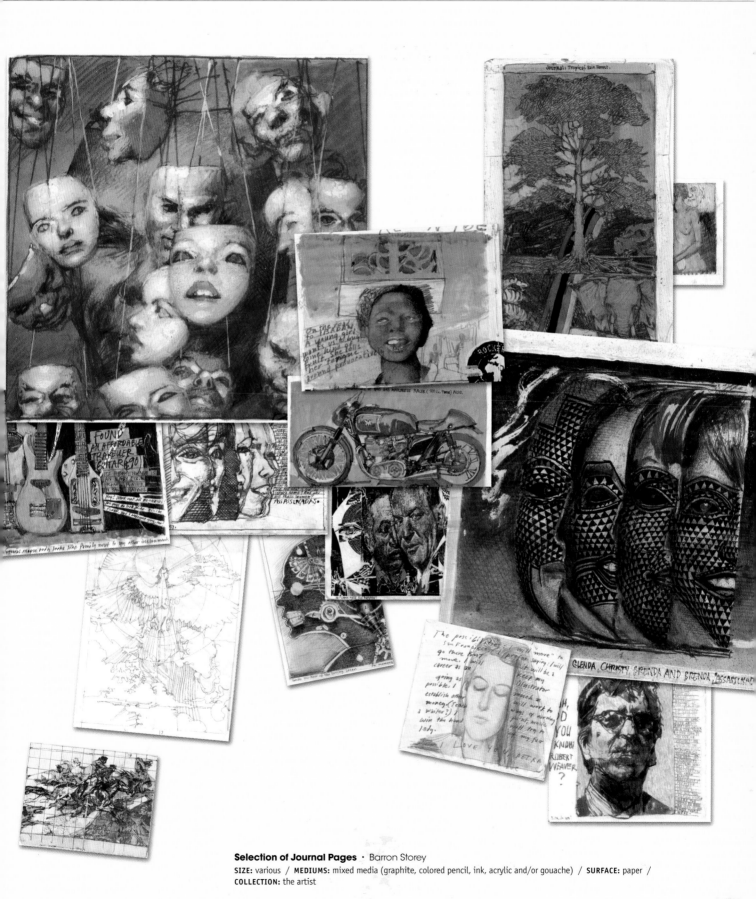

Selection of Journal Pages · Barron Storey
SIZE: various / MEDIUMS: mixed media (graphite, colored pencil, ink, acrylic and/or gouache) / SURFACE: paper /
COLLECTION: the artist

David Mack:

visualnarrator

Great innovation often comes when avenues outside the normal discipline are explored and new ways of thinking are put into the practice. When one is not limited by traditional approaches, an opportunity to introduce a different ideology may present itself. For artist David Mack, a willingness to try new things is a way of life. From an early age, he was taught by his mother to think outside the box and not to rely on the readily accessible. His resourcefulness and inventive mindset have allowed him to alter the traditionally accepted rules of linear panel design and character dialogue in comics, virtually revolutionizing the look of sequential storytelling.

The artist sees his approach as less about defying convention and more about clever problem solving. For Mack, visual narration is anything but static and linear. He likes to use word and image in a way that takes the reader on a dynamic journey. Throughout his seven-volume series entitled *Kabuki*, the artist uses various devices to establish contrasts, conflicts and areas of interest. "I've always thought that comic books are best when the art and the lettering work together to tell the story," says the artist. "I am always looking for ways to create a new graphic reality, pushing the story so it works on many levels both intellectually as well as visually." Mack employs metaphorical iconography, expressive typography, familiar perspectives and innovative panel design to create intriguing visual kinetics throughout his character-driven books. "In the course of a scene or conversation, I'll use a certain symbol or image, associating the meaning of what is happening to the context of the scene," explains Mack. "Later, I can bring that symbol back without saying anything extra and it carries all the implications that I established early on." Throughout the *Kabuki* series, the typographic integration into the sequential landscape differs greatly from the conventional word balloons used in traditional comic-book dialogue. Mack uses the organic quality and signature flow of handwritten text to convey inner thought, and the bolder, more geometric forms of type to express spoken dialogue. The placement, direction and movement of the words within each spread support the overall action as well as the personality of the characters or scene being conveyed. Another prominent deviation from common comic art practice found in Mack's work is his use of perspective. "When you think of comics, you think of dynamic, far-out angles," says the artist. "What I find is that so many different shots often distance the reader. If you put the characters in a framework that is more reflective of what we experience in real life, then you are better able to make an emotional connection that is more visceral."

To guide the reader through the story, Mack will alter the panel design and layout to fit the needs of each scene. "The smaller a panel is, the quicker the reader will move from one panel to the next. On the other hand, the larger a panel is, the more time it will command," he says. "You have moments that are fast talking and others when the reader is asked to pause and look further. I'll often use several small panels with whimsical and spontaneous drawings and then have the reader open to a double-page

> "I am always looking for ways to create a new graphic reality, pushing the story so it works on many levels both intellectually as well as visually."

34

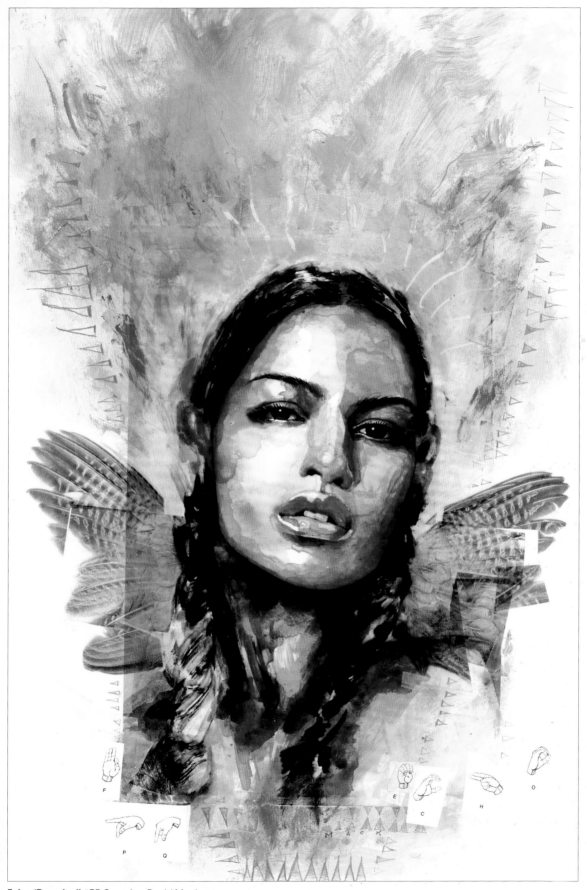

Echo (Daredevil #55 Cover) · David Mack
SIZE: 17" × 11" (43cm × 28cm) / **MEDIUMS:** watercolor, acrylic and graphite / **MATERIALS:** wings / **TECHNIQUES:** xerography, collage and assemblage /
SURFACE: illustration board / **CLIENT:** Marvel Knights

spread for a fully rendered, more contemplative panel." To further spark curiosity and interest, the artist will also play with the pacing and dynamics of the storyline, moving it backward and forward in time. For example, a character may be engaged in dialogue or an action scene, when something triggers a memory that sends that person's mind as well as the story itself onto a completely different tangent. I may also hint at something on one page and a few pages later, the reader will realize what it is, encouraging them to turn back to see where they saw it," adds Mack. "It's all about creating an experience."

It has been over fifteen years since the first *Kabuki* was published. For Mack, taking the risk of a self-initiated project has paid off in spades, and he doesn't regret taking that initial leap. "You can't wait for someone to come by and validate you, giving you the OK to make things happen," says Mack. "You have to take the initiative yourself, having faith that the path will ultimately materialize. It's like trying to get from one side of the river to the other. At the start, you see only one rock and know that you can jump from the bank to that rock. When you get to that rock, the next move appears. When you enter in the process, you always eventually find your way." By challenging the existing paradigm, Mack has been able to discover a new language in which to communicate and tell stories. His bold innovation has forever changed the visual linguistics of the comic genre, adding a new dimension to the sequential medium.

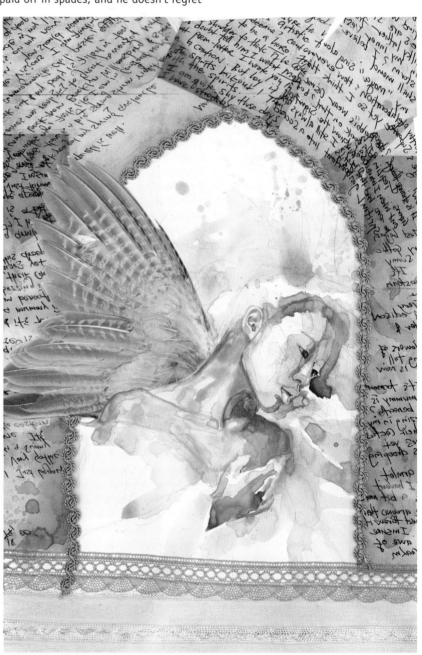

Kabuki: The Alchemy #1 · David Mack
SIZE: 17" × 11" (43cm × 28cm) / **MEDIUMS:** watercolor and acrylic / **MATERIALS:** letter on aged paper, decorative lace, trim and wings / **TECHNIQUES:** xerography, collage and assemblage / **SURFACE:** illustration board / **CLIENT:** Marvel Entertainment/Icon

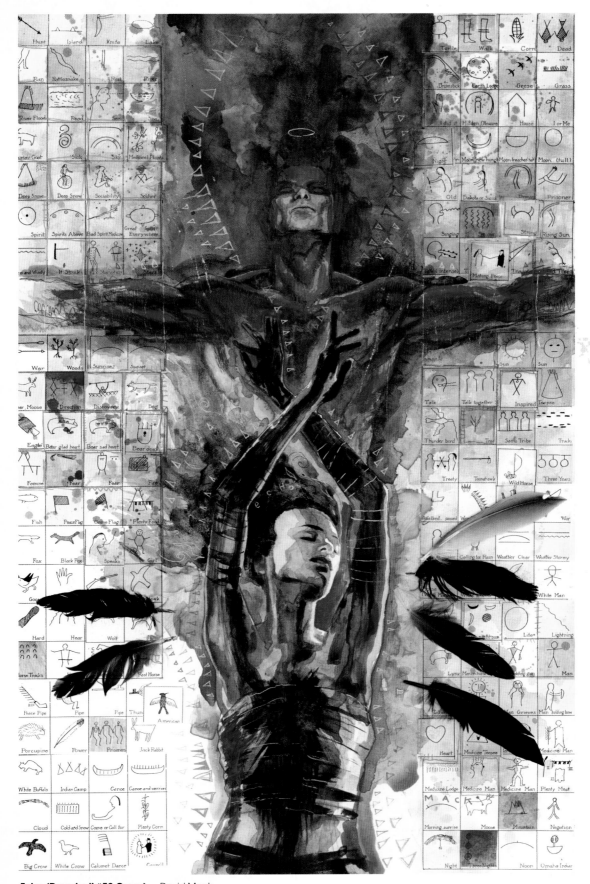

Echo (Daredevil #53 Cover) · David Mack

SIZE: 17" × 11" (43cm × 28cm) / **MEDIUMS:** watercolor, acrylic and graphite / **MATERIALS:** feathers, transparency film and clear tape / **TECHNIQUES:** xerography, collage and assemblage / **SURFACE:** illustration board / **CLIENT:** Marvel Knights

dynamic storytelling: the art of kabuki

Artist David Mack, known for his dynamic and innovative use of sequential storytelling, received his first job in comics during his freshman year in college. "It was an exciting step, as it helped me understand the tricks of visual storytelling and how to seamlessly merge the writing with the art," recalls the artist. "Once I did a few things, I got a sense of how the basics of the medium worked." With published work in hand, Mack had a passport to promote. "I started going to conventions, setting up my art, selling books, meeting publishers and talking with other artists," he says. "It was a grassroots effort to learning the business chain from the readers to the retailers, distributors and publishers." Mack's biggest breakthrough came when he was inspired to develop his own project. "On the drive back from a big convention in New York City, I decided to design a comic book that would be completely my own creation, something that I'd want to look at and read," says Mack. "I had lots of ideas swimming around in my head just waiting to be put in a context." In 1994, the creator-owned comic *Kabuki* began flooding the stands and filling the hearts of readers. Mack's efforts earned enough profit for the artist to work full-time on the series.

When developing the storylines and imagery for *Kabuki*, Mack pulls from his multidisciplinary background which encompasses art, literature, theater, history, mythology and world religions. He also finds inspiration from documentaries and biographies. "I listen and absorb all these facts while I'm working. They become little bricks that ground my stories to reality," says Mack. "I like creating parallels to the real world." Handwritten notations—ideas about potential scenes, character dialogue and visual aesthetics that permeate the artist's conscious and subconscious mind—begin to collect in file folders until a story beckons. "I am careful not to analyze too much at this stage. I don't censor myself on the initial drafts," says Mack. "I find that my process works best when I can get all my ideas out and then come back and edit, cut and change things."

When he feels comfortable with the storyline, the artist begins developing a manuscript, a working document for the layouts in the book. "From lots of little thumbnails of potential design solutions, I narrow things down to a certain storytelling direction in terms of rhythm, feel, pacing and atmosphere." While working, the artist sets up the various spreads vertically, with everything visible all at once. This allows him to make connections amongst the various pages. "I put the layouts next to each other and begin to move them around until each scene feeds off the next. Then, I alter the script to accommodate the changes," says Mack. "The process tends to make the story much more interesting in the end."

When it comes to choosing mediums, the artist uses whatever will best convey the personality of the story. Mixed-media drawing and painting as well as collage, assemblage, photography and xerography of layered transparencies permeate his work. The artist also likes to incorporate tokens, trinkets and letters sent to him by his fans into his multimedia aesthetic. "There have been times that I've struggled to solve a problem in a piece and after checking my mail, the perfect thing arrives for me to use." Mack enjoys hearing from his readers, garnering feedback as to how they react to and interpret the storylines. "What I do is not finished until someone reads it," explains Mack. "The experience that happens in one's head is the real art of the story. The pages that I write and draw are mere navigational instruments."

Since the inaugural *Kabuki* issue, over one million comic books have been produced and distributed worldwide, and Mack has received international acclaim. Today, the artist still actively works on expanding the series and cultivating its readership. A full-length, feature film is in the works and Mack looks forward to seeing his imagery and storyline translated into sound and motion.

1 David Mack begins his storytelling process with handwritten notes, shown here in an example of the manuscript draft of *Kabuki: The Alchemy* #1.

2 Mack develops his ideas with pencil sketches and comprehensive layouts.

3 Various collage and assemblage elements are combined to accent, call attention to and frame the interior panels and cover art. The cover image for *Kabuki: The Alchemy* #1 is shown on page 36.

building the
surface

Since the Modern Art movement, there has been an ever-growing interest in exploring unconventional surfaces and techniques to create a new vitality in painting. Artists who have ventured outside the constraints of traditional approaches have found more inventive ways of handling space, structure, form and content. Their eagerness to push boundaries has opened up a plethora of new possibilities in picture-making.

Today's artists are experimenting with a vast array of unorthodox surfaces, both flexible and rigid. From metal, wood, plastic, clay board and tile to handmade and custom paper, as well as woven and synthetic fabrics of every kind, alternative painting grounds are being explored. To build the working surface, artists are altering the once traditional gesso primer with sand, sawdust, wood chips, seeds and the like—giving the painting ground a much more expressive and symbolic role. In addition, substances such as plaster, modeling paste, wax and acrylic gel medium are being heavily applied to the working surface in both additive and subtractive methods, using unconventional tools such as combs, sticks, putty knives, serrated scrapers and other mark-making apparatuses to create a bas-relief, almost frescolike appearance. By dramatically altering the topography of the working surface, artists can create exquisitely tactile effects once drawing or painting mediums are applied on top.

To break away from the starkness of a white ground, artists are toning their working surfaces in a variety of innovative ways. Man-made and natural elements such as bubble and plastic wrap, crumpled aluminum foil, string, sticks, leaves and salt are being temporarily applied to a freshly painted, water-based ground, creating an imaginative underpainting that the artist can work back into. Dabbing the wet surface with paper towels, textured cloth, handmade paper and sponges can also infuse an underpainting with exciting and engaging patterns. In addition, resists that utilize masking tape, ripped and cut paper, wax or masking fluid are being employed with distinctive results. Artists are even taking their process outside into the cold winter temperatures, letting wet water-based paint freeze onto the surface of their work. The natural ice-crystal patterns that form are truly unique.

Printmaking can also provide a visually expressive, abstract field and overall tonal ground. From leaves, flowers, feathers and bark to man-made materials such as lace, decorative tile, corrugated cardboard and dimensional wallpaper, almost any low-relief surface can be used to create an imprint. To get a variety of different effects, artists are experimenting with altering the printing base, changing the mediums or pretreating the working surface before printing on it. To add decorative accents, custom stamping, woodblock and linoleum printing, dimensional stenciling and rub-on lettering as well as water and solvent-based transfers are being used. The application of custom imprints layered onto a painted surface creates visual depth where the illusion of three-dimensional space is revealed through the overlapping of shape, line and texture.

When it comes to creating a visually stimulating, pre-existing density with which to work, collage is being heavily exploited. Jarring juxtapositions and provocative combinations of disparate detritus and found ephemera create a dynamic syntax. Newspaper, sewing patterns, maps, diagrams, wallpaper, diary pages, postmarks and old engravings are all finding a new purpose in the collage continuum. For intriguing textural effects, artists are ripping, punching, wrinkling, creasing, distressing, torching, stitching, weaving, embossing and debossing various handmade and commercially available papers. They are also hand-coloring, tea-staining and weathering papers to give them a signature look. To show depth and dimension, unconventional procedures such as sanding, peeling-

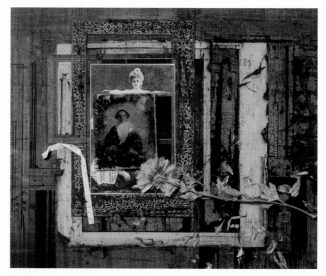

Untitled · Fred Otnes
SIZE: 22" × 30" (51cm × 76cm) / **MEDIUMS:** oil and acrylic / **MATERIALS:** vintage photography, decorative borders and dried flowers / **TECHNIQUES:** photo transfer, tintype, collage and assemblage / **SURFACES:** linen canvas on board / **COLLECTION:** private collection

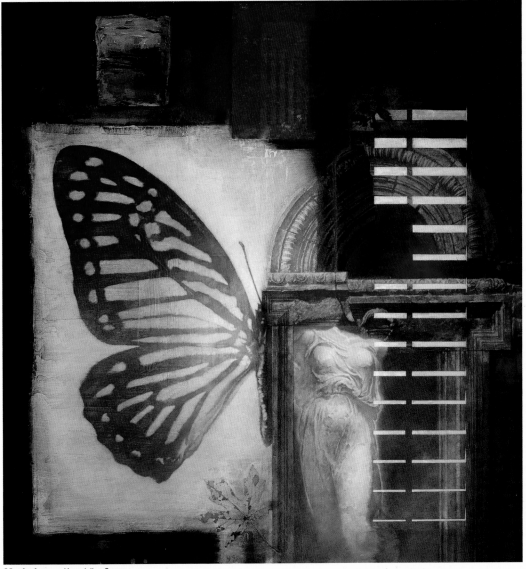

Mysterium · Kazuhiko Sano
SIZE: 28" × 24" (71cm × 61cm) / **MEDIUMS:** acrylic, plaster and gesso / **MATERIALS:** brown paper, watercolor board, corrugated cardboard, dried acrylic paint film and leaves / **TECHNIQUES:** dry brush, glazing, lifting, palette knife, sanding and collage / **SURFACES:** brown paper over Masonite / **CLIENT:** Sonic Atmosphere Records

back or scratching-in with a razor, compass point or nail are being employed as the layers of the visual landscape begin to build.

The application of paint has also evolved, becoming much more dynamic. With the advent of commercially available sealants and fixatives, artists are now able to work with various mediums in a variety of unorthodox ways—alternating not only from painting to drawing but also from water- to oil-based mediums within the same work. Paint has also evolved and is being infused with various property-altering substances. Metallic, interference, pearlescent and glitter-infused pigments further add distinction and visual intrigue. Paintlike properties are also finding their way into drawing mediums. Water-soluble pencils and crayons offer a wide range of possibilities. They can be applied to the surface in a drawn fashion and then altered with

the introduction of a wet brush, creating an interesting tension. Oil sticks thinned with a solvent or an oil-based medium provide a similar look and feel. In addition, the set of tools available to the painter has expanded far beyond the traditional. Trowels, sponges, drip bottles, toothbrushes, rollers, technical and calligraphic pens, corks, rocks and a smorgasbord of custom-made instruments are being used alongside brushes to achieve intriguing effects.

Artists have a vast visual vernacular at their disposal. The tendency to limit a medium to a specific task has forever faded. Artists are rethinking their approaches, making great strides into what is possible in terms of technique. As creatives continue to push the envelope, art and art-making will evolve and grow, elevating the visual experience for all.

Kazuhiko Sano:
illustrated haiku

Storytelling is the art of creative observation uniquely translated and shared with an audience. In the recitation, all of the senses spring into action. Sights, sounds, fragrances and tactile references illuminate sensations, thoughts and feelings to form a new existence, one that is born of the intellect, ingenuity and imagination of the storyteller.

Telling tales is something that artist Kazuhiko Sano knows how to do quite well. In the artist's pictorial world, every painting provides an opportunity to narrate, converse and communicate. To create believability in his work, Sano infuses his pictures with a story. He gives his characters names, creates an engaging dialogue, looks at their motivations and ambitions and tries to think from their point of view. "Creating stories is a meaningful act. It allows me and the viewer to connect with the characters in my work, experiencing their life in a way that people of this century can relate to," explains Sano. "It's very important to have knowledge about what you are painting. Beyond research, I always try to find a way to relate to my subjects." Whether it's in the facial expressions, hand gestures and body language of his subjects, or through the subtle nuances captured in his intimate environments, Sano's pictures communicate without the use of words. "Our perception of time and place does not come exclusively from our vision. We can also hear, smell, taste and feel, forming a cumulative experience. As an artist, it's very important to be sensitive to that," says Sano. "One must pierce through the surface of subject in order to be convincing." By being sensually open and curious to what surrounds him every day, the artist has created an antenna, an internal device that he uses to record life's innate mannerisms with acute accuracy.

Rising from his experiences, memories, dreams and all things rooted in his past that have defined him as an artist and a human being, Sano's stories come to him unbidden, flowing out in a stream of consciousness. "The very first conception usually comes completely out of nowhere," explains the artist. "Like in the Bible (Genesis), 'Let there be light'. So, let there be an idea, and then there is an idea!" An initial spark of inspiration sets Sano's imagination soaring and he is drawn in. An engaging story begins to unfold, and the artist diligently follows its lead. "Trusting my intuitive nature, I always try to come up with a vision of fascination and intrigue," he says. To create mystery, suspense and wonder, Sano's epic works never reveal a complete story but instead show only bits and pieces, leaving room for

> "Our perception of time and place does not come exclusively from our vision. We can also hear, smell, taste and feel, forming a cumulative experience. As an artist, it's very important to be sensitive to that. One must pierce through the surface of subject in order to be convincing."

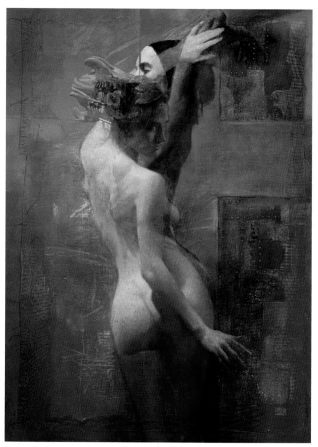

Atonement · Kazuhiko Sano
SIZE: 38" × 28" (97cm × 71cm) / **MEDIUMS:** acrylic and gesso / **MATERIAL:** ephemera / **TECHNIQUES:** dry brush, glazing, lifting, stitching, spattering and collage / **SURFACE:** cotton canvas over Gatorboard / **COLLECTION:** the artist

The Relic · Kazuhiko Sano
SIZE: 20" × 16" (51cm × 41cm) / **MEDIUMS:** acrylic and gesso / **MATERIALS:** brown paper, ephemera and leaves / **TECHNIQUES:** dry brush, glazing, lifting, palette knife and collage / **SURFACES:** cotton canvas over Masonite / **CLIENT:** Society of Illustrators of San Francisco

the viewer to cognitively participate. "Only the essence should remain, and if you are a master, you say things in a minimal way, like in a haiku," he adds.

Intrigued by the richness and depth of his subject matter, Sano is compelled to paint, figuring out how he can translate his vision onto canvas. He begins by creat-

ing a textural environment where every element within the composition takes on a meaningful, symbolic role. Using gesso, modeling paste and collage on canvas over Masonite, Sano creates a landscape that is not only visually compelling but that also communicates a central theme or concept. "I like to put some kind of creation on the foundation," he says. "The materials have to be simple enough, yet coordinate with the other elements in the picture. They also have to enhance the viewer's experience in some way." The artist works primarily in acrylics and finds the medium to be very versatile. Working in transparent and opaque layers, he employs sponges as well as brushes and a palette knife to get provocative transitions from areas of realism to sheer abstraction. Sano's approach, especially in his developmental years, was highly influenced by the works of masters like da Vinci, Rembrandt, Vermeer and Monet. "I look at their paintings as if I am licking the surface with my eyes," says Sano. "I admire Rembrandt's complex use of transparent layers, which, when magnified, look like a Mexican opal. I also like Monet's opaque layers, which magically connect the surface

> "We are so bombarded with stimulation that we often forget the power of minimalism and Zen."

directly to the theme of the work." In more recent times, the artist has found himself looking at the works of Bonnard, Matisse and Klee for inspiration.

Sano's highly thought-provoking and interpretive works evoke beauty through simplicity. In a world that is inundated with distraction, the ability to break through with clarity and intense focus is truly a gift. "We are so bombarded with stimulation that we often forget the power of minimalism and Zen," observes Sano. "Because of convenience, many artists don't go outside the studio as much, relying on technology to feed them. That's very limiting. It's important to be attentive and to experience life firsthand." Sano, always open, aware and tuned-in, draws from his keen observations and insight to enhance and enrich his story-driven works of art, elevating them to a higher level of consciousness. His enlightenment yields a stronger, more profound picture, one that will leave a memorable impression for generations to come.

Mozart and Angel · Kazuhiko Sano
SIZE: 24" × 18" (61cm × 46cm) / **MEDIUMS:** acrylic and gesso / **MATERIALS:** brown paper, ephemera and decorative die-cut doily / **TECHNIQUES:** dry brush, glazing, lifting, palette knife and collage / **SURFACE:** Masonite / **COLLECTION:** Los Angeles Mozart Festival

altering the working ground

When the working surface is built up, layers of texture, pattern and shape become more than they appear to be. The context in which they are placed transforms the textural environment into something more profound. Throughout this demonstration, artist Kazuhiko Sano uses gesso, modeling paste, acrylic, colored pencil and graphite to create an imaginative and visually expressive portrait of the singer and songwriter Tori Amos.

MATERIALS

Raw cotton duck canvas: 18" × 24" (26cm × 61cm)
Tempered Masonite: ⅛" (3mm)

White gesso
Acrylic paints: heavy body
Modeling paste
Acrylic matte medium
Fixative
Rubbing alcohol
Graphite pencils: 2H, HB, 2B and 5B
Prismacolor pencil: blue

3-inch (76mm) Luco brush
Dropper
Disposable palette: 11" × 17" (28cm × 43cm)
Squeegee
Synthetic sponge
Synthetic brush

1 Building the Foundation

Raw cotton duck canvas is soaked in warm water and air dried. Masonite is cut and the raw canvas is adhered on top using acrylic matte medium, leaving the edges frayed so the strings can be used as compositional elements. Once dry, the entire surface is coated with acrylic matte medium. Later, just the canvas area is evenly primed with modeling paste, using a squeegee.

2 Creating a Textural Environment

Using a blue colored pencil, the basic composition is established and becomes a guide when texturing. Gesso is introduced throughout the composition using a brush. Before it dries, a squeegee is employed to distribute the gesso across the composition in a visually dynamic way. The pointed back of a brush is used to make marks into the wet surface. In addition, water is dropped onto the wet gesso with a dropper to create strategically placed, recessed circles throughout. Workable fixative is sprayed to seal the foundation.

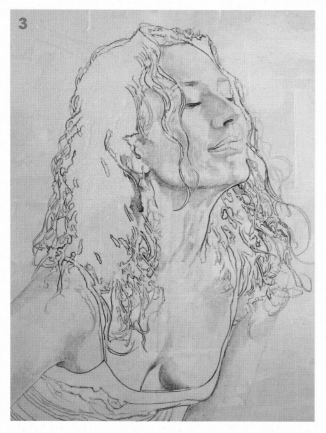

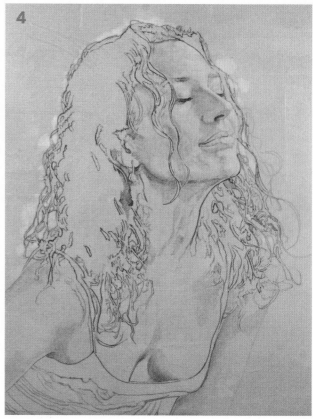

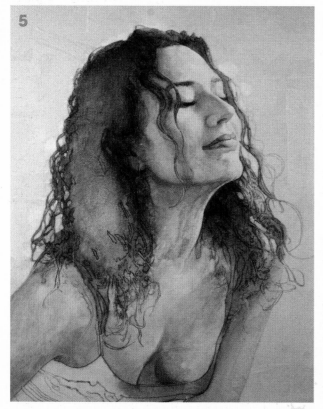

3 Setting the Tone

Blue-gray acrylic mixed with water is applied to the working surface with a soft Luco brush and then evenly distributed throughout the composition with a synthetic sponge. Two coats are applied. Using various graphite pencils and a blue colored pencil, a base drawing is created on the surface. The middle tones and darks are executed in crosshatching while the rest of the drawing is done in line.

4 Bringing Out the Lights

Using rubbing alcohol and a soft synthetic brush, areas of light are lifted out of the composition.

5 Illuminating the Figure

To draw attention to the figure, vibrant acrylic washes are applied to the portrait so it contrasts with the more subdued colored background.

6 Making a Connection With the Subject

Decorative Hawaiian architectural motifs are added in graphite and colored pencil to set the figure in a meaningful environment. Within the architectural structure, areas are modified to include some erotic imagery, symbolizing the more sensual side of the performer and her music. Flaming orange-red hair vibrates against the blue-gray background, highlighting the artist's energy and inner fire.

7 Painting With Additive and Subtractive Processes

Within the figure, opaque acrylic is applied in a cross-hatching fashion over the underlying pencil rendering. In the background, areas of light are lifted with rubbing alcohol, completely removing the local color and graphite underneath. An additional piece of architecture is added to the composition as a supportive element.

8 The Finished Work

To bring out the border, the Masonite is painted dark blue. String is pulled from the woven edge of the canvas to create an interesting organic border. Any misapplied paint is removed from the accent strings with rubbing alcohol. The finished piece captures the classical and technical proficiency of the performing artist while highlighting her more radical, expressive side. The art is featured in the 2009 Tori Amos fan club calendar. Twelve different artists were selected to produce a signature piece, one for each month.

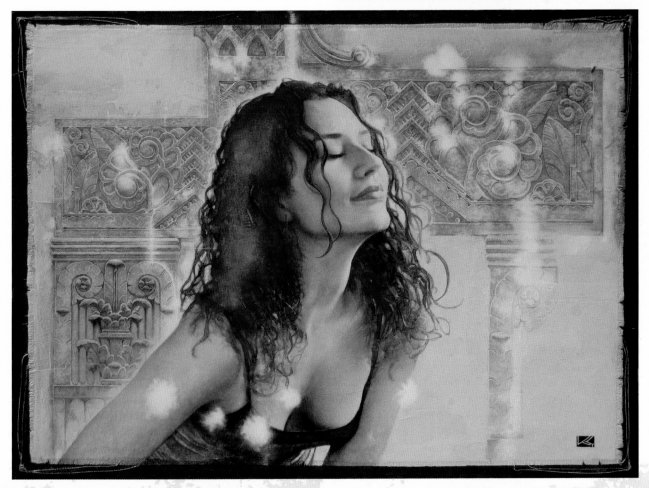

contemporary nostalgia

Anything that is notably in vogue will have its reign and then will gradually dissipate from the public eye, only to revisit decades later in a new, often more exciting way. Artist Michael Mew embraces this process of recycling and has used it in his work. He pilfers from the avant-garde of the past and recasts the remnants, giving them a whole new role to play.

A celebration of vintage pop culture graphics and iconography, Mew's mixed-media aesthetic recomposes relics of the past into a more contemporary arrangement. Aged ephemera, old comic strips, classic soda-pop labels, antique apothecary labels, star charts, decayed signage and the like have all found their way into the artist's collage-based work. "I grew up in the metropolis of Los Angeles when suburban living was altering the American popular culture. The neighborhoods were arranged with alleys running behind the houses to service the trash pickups. This afforded me the opportunity to explore," recalls Mew. "My wanderings took place as I walked the alleys, studying the castoffs and picking up the discards."

Drawing inspiration from the vast collection of timeless iconic treasures that surround his studio and permeate his mind, Mew begins his creative process. To find his muse, the artist begins to play, creating small-scale collage studies that are later assembled into a book format. "Although these more intimate collages are mainly exercises in process and composition, there are themes that develop and many translate later into larger works," says Mew. The artist prefers to work in a series and will often tackle several pieces at once, alleviating any downtime during drying sessions. His process, always working from panel to panel, has established a mindset that encourages work in succession. Much of Mew's art is quite large. He finds working on a grand scale to be both a challenge and a blessing. "It is hard to go from working 11" × 14" (28cm × 36cm) to 4' × 5' (122cm × 152cm). It takes a lot more time and effort. Plus, your body movement, your tools and how you approach the work are all very different. You almost have to relearn your process," admits Mew. "But, it's the larger works that have that wow factor that really grabs people."

Mew's signature process always commences with the creation of a dense, tactile and time-weathered environment. He will tear and cut up imagery from vintage magazines and adhere it to his working surface, establishing a graphic, color-infused ground. To further build the topography, the artist will layer aged newsprint over the matrix of magazine ephemera. "At this point, everything is random. I try not to think too much about what I am doing," says Mew. "I've always found that it's best to just let it happen." The artist will then work into the tactile surface with drawing materials and paint, defining the subject of the work. "Sometimes, I'll pencil in the composition and then paint around the line," notes Mew. "Other times, I may want to be more expressive so I'll put paint onto the surface in big broad strokes, working back into it later with pencil."

"I use images as visual embodiments of cultural clichés in combinations or odd juxtapositions, with the ambition of reinventing a setting and setting up an invention."

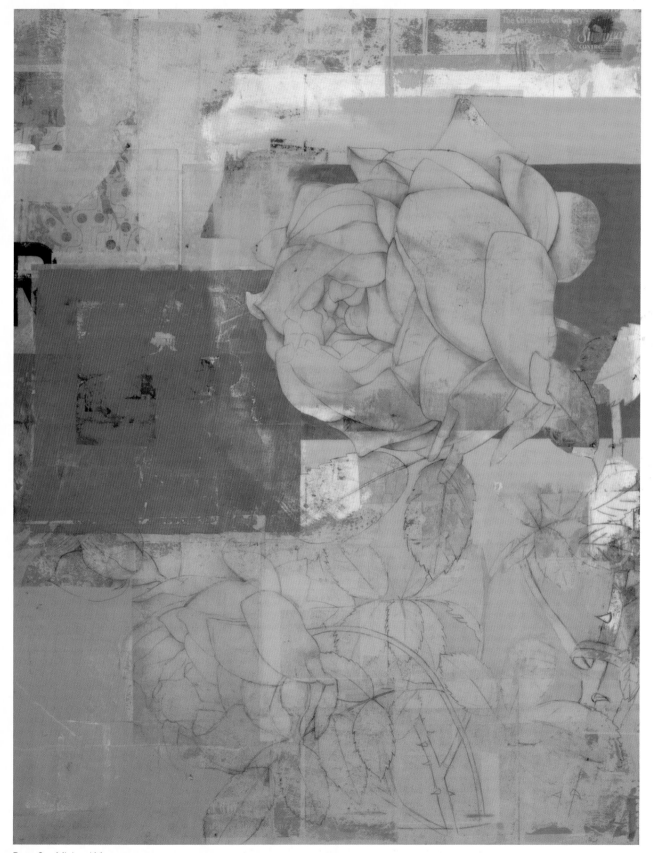

Rose 2 · Michael Mew
SIZE: 60" × 45" × 2" (152cm × 114cm × 5cm) / **MEDIUMS:** acrylic, graphite and resin / **MATERIALS:** magazine pages and weathered newsprint / **TECHNIQUES:** collage and sanding / **SURFACE:** wood panel / **COLLECTION:** private collection

Lily 2 · Michael Mew
SIZE: 60" × 45" × 2" (152cm × 114cm × 5cm) / **MEDIUMS:** acrylic, graphite and resin / **MATERIALS:** magazine pages and weathered newsprint / **TECHNIQUES:** collage and sanding / **SURFACE:** wood panel /
COLLECTION: private collection

"The meaning of a piece often becomes apparent only in the end. It's like finding a secret message that you unknowingly sent yourself."

To add a graphic flair, Mew will look through his collection of iconic imagery and select pieces to be brought into his work. "I use images as visual embodiments of cultural clichés in combinations or odd juxtapositions, with the ambition of reinventing a setting and setting up an invention," he says. He often chooses highly graphic elements, as he likes the contrast between the bold, flat color and the subtly rendered, organic quality of the subject matter he paints. Ephemera of the past is scanned into the computer, blown up and printed out on aged newsprint. "When I put the paper in my ink-jet and print on it, the surface looks like pages out of an old book," observes Mew. "I really love the quality of that." Since the artist's Epson Stylus Photo 1280 ink-jet printer can print only up to 13 inches (33cm) wide, Mew often needs to tile his collage images. "At first, I was worried about the seams showing but now I just let it go," he explains. "I found that the work ended up being more successful when I showed the piecing." To unify the various elements within his work and reveal subsequent layers that lie below, the artist will sand or scratch into the surface

with a nail on the end of a stick. Mew's process of collage layering, painting and sanding continues until a fulfilling end somehow presents itself to the artist. The evolution of Mew's journey has been about learning to let the work speak for itself. "The meaning of a piece often becomes apparent only in the end," he says. "It's like finding a secret message that you unknowingly sent yourself." Through a process of recycling, reworking and rediscovery, the artist presents a new way of celebrating nostalgia, one with a modern-day mindset. In Mew's artistic oeuvre, what was once old has now become new again.

Peony 3 · Michael Mew
SIZE: 48" × 36" × 2¾" (122cm × 91cm × 5cm) / **MEDIUMS:** acrylic and graphite / **MATERIALS:** magazine pages and weathered newsprint / **TECHNIQUES:** collage and sanding / **SURFACE:** wood panel / **COLLECTION:** the artist

creating a tactile environment through collage

When it comes to infusing the pictorial landscape with texture, collage can offer a visually stimulating, highly-tactile density in which to work. Various ephemera, cheesecloth, handmade and hand-colored papers, tissue and the like can be layered onto the working ground in myriad ways, adding depth, dimension and visual interest. In this demonstration, artist Michael Mew uses collage along with distressing and aging techniques to create intriguing textural effects.

MATERIALS

Birch panel: 48" × 36" × ⅛" (122cm × 91cm × 3mm)
Poplar strips: 1½" × ¾" (38mm × 19mm)
Old magazines and ephemera
Weathered newsprint
Tracing paper

Nova Gel (acrylic polymer gel medium)
Acrylic paints: soft body
India ink
Black enamel spray paint
Acrylic gloss medium and varnish
Yes! Paste
Wood glue
Nails
Polyurethane (water-based)
Graphite pencils (7B–9B)

Synthetic brushes: round and flat
Blending stump
Craft knife
Pink Pearl eraser
Dropper
Nail gun
Putty knife
Medical tweezers
Orbital sander, sanding block and sandpaper: 80 and 100-grit
Ink-jet printer and scanner

1 Constructing the Working Ground
A birch panel is adhered to a 1½" (38mm) poplar framework using wood glue and a nail gun.

2 Establishing a Bold Color Field
Cut and torn pages from vintage magazines are adhered to the rigid working ground using gel medium and a putty knife. To seal the surface, acrylic gloss medium is brushed on top.

3 Building the Visual Landscape
To build the topography, weathered newsprint is randomly placed over the boldly colored matrix of magazine imagery and glued in place using gel medium.

4 Aging and Distressing the Surface

Piles of newsprint paper are clipped together and left outside, turning the surface yellow and brown when exposed to the natural elements. The aged surface is further distressed using a sanding block and 80-grit sandpaper, creating a unique collage element.

5 Establishing the Composition

With a color study as a reference, a line drawing of the composition is established in graphite with a soft 7B pencil.

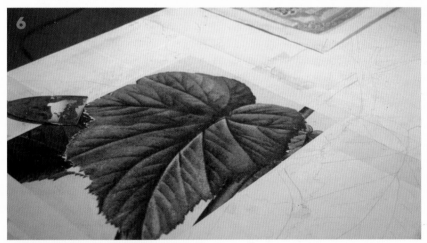

6 Printing Collage Elements

Various ephemera are scanned into the computer, blown up and printed out on weathered newsprint. Once dry, the prints are adhered to the composition using gel medium and a putty knife. Light sanding with 100-grit sandpaper aids in blending the printed surface with the base art. Special care is taken when printing on aged paper, as the paper may break apart in the printer.

7 Working Around the Subject

A pencil tracing is used as a guide to cut through collage ephemera that would cover up the main floral subject.

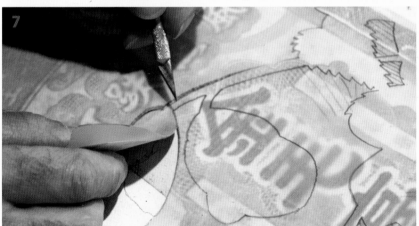

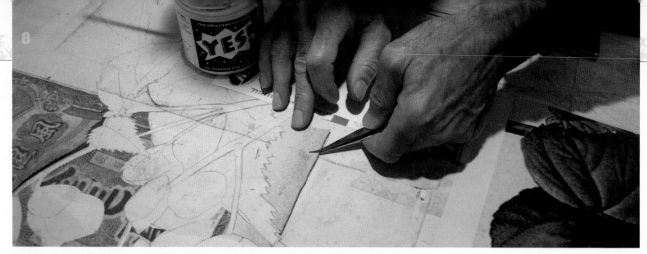

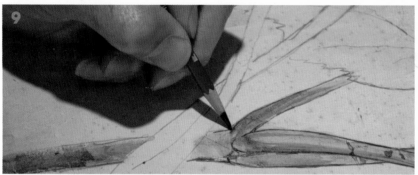

8 Adhering Collage Pieces to the Surface

The deconstructed pieces of collage are reassembled and adhered to the working surface using Yes! Paste, a flat synthetic brush and medical tweezers. Once this is dry, more light sanding is done.

9 Rendering Form

In select areas, the base drawing is rendered in graphite with 7B, 8B and 9B pencils, using a stump to blend and an eraser to lift. To add color, thin washes of acrylic paint mixed with water and acrylic gloss medium are applied using a soft round brush. When this is dry, water-based polyurethane is applied to seal the entire piece, protecting this stage from any further distressing.

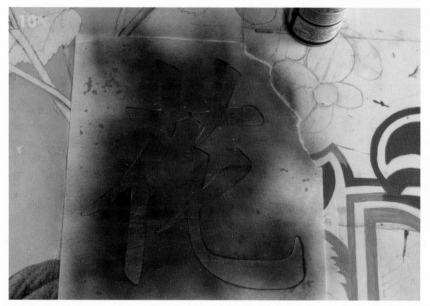

10 Adding Graphic Accents

The Chinese symbol for flower is applied using a hand-cut stencil and black enamel spray paint. To create a spatter effect, the painting is placed on the floor and black India ink is dripped onto the surface from approximately a six-foot (two-meter) distance using a dropper. Once the ink hits the piece, the impact spatters the fluid medium in a dynamic way.

11 Layering Color

The background is built up in several layers of acrylic paint using a flat synthetic brush.

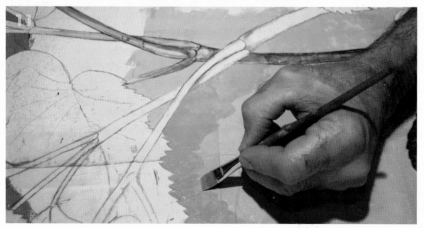

12 Exposing the Layers
To reveal the layers that lie beneath, the working surface is distressed with an orbital sander and 80-grit sandpaper.

13 Signing the Artwork
To finalize the piece, the artist signs the work on the back with his custom logo in red.

14 The Finished Work
The finished painting is entitled *Begonia*.

"Multiple layers sanded back and painted over create a sense of time, history, memory and mystery. Working with buried images creates an exciting excavation, one that I can build on until the story is complete."

Kathleen Conover:

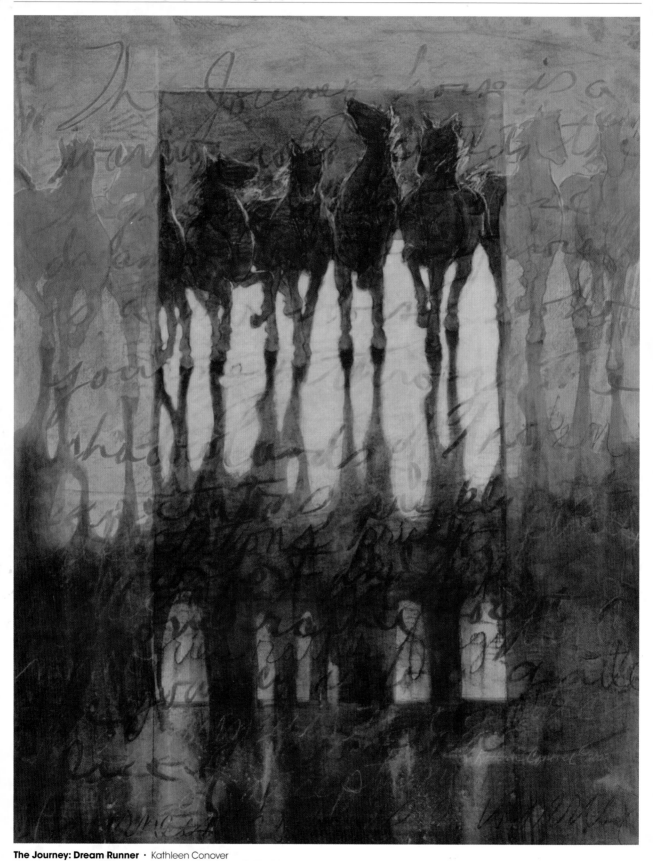

The Journey: Dream Runner · Kathleen Conover
SIZE: 30½" × 22½" (77cm × 57cm) / **MEDIUMS:** watercolor, acrylic, graphite and charcoal / **TECHNIQUES:** monoprinting and journaling with a cork / **SURFACE:** Arches 140-lb. (300gsm hot-pressed watercolor paper / **COLLECTION:** private collection

transformations:
from **chaos** to order

When turmoil finds its way into our lives, we are taken completely off balance. We become confused and no longer feel stable. Yet, it is during those times of conflict and struggle that we learn the most about ourselves. Forced to move outside our comfort zone, an inner strength often emerges, allowing us to cope and break through obstacles. The process of internal growth gained by life's ongoing challenges, whether great or small, is what inspires artist Kathleen Conover to paint her highly symbolic, mixed-media works.

Conover's creative process, much like life, goes through a transformation from chaos to order. Working spontaneously and in the moment, the artist begins by creating richly textured environments that are completely unplanned, uncontrolled and unexpected. "I don't work well in front of a blank piece of paper where everything is predetermined," shares Conover. "Instead, I like working in a state where the paint is allowed to flow and move naturally around the surface of the paper, establishing a graphic reality beyond what my own hand or patience can create." In the initial stages of her process, the artist surrenders control and allows the work to dictate the rhythm, energy and flow. "I call this the inspiration stage," says Conover. "It's the thing that gets me going." To enliven the surface, the artist uses water-based mediums, often placing natural elements such as sand, leaves and fronds into the wet paint as resists. For even more wondrous results,

"I like working in a state where the paint is allowed to flow and move naturally around the surface of the paper, establishing a graphic reality beyond what my own hand or patience can create."

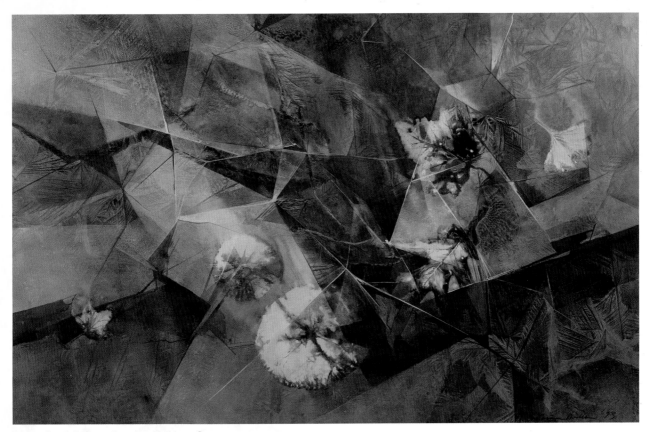

Frozen Crystals: Inner Facets · Kathleen Conover
SIZE: 22½" × 30" (57cm × 76cm) / **MEDIUMS:** liquid watercolor and gouache / **TECHNIQUE:** frozen ice crystals as a resist / **SURFACE:** Arches 140-lb. (300gsm) cold-pressed watercolor paper / **COLLECTION:** the artist

Conover takes her materials outside into the subfreezing temperatures of winter to capture the beautiful, intricate patterns that are made by the formation of ice crystals in the frozen paint. Printmaking, image transfers, weaving and collage techniques have also found their way into the artist's visually expressive work. To transform her work into the realistic realm, the artist will paint back into her lively, abstract environments with watercolor, acrylic, gouache and gesso, defining the areas of light and dark and strengthening the overall design. Conover's paintings evolve from a state of chaos to order and through the many layers of color, line, shape and texture, a subject emerges.

Conover primarily works in series and has explored the same topics since the beginning of her thirty-year career. "In various stages of my life, the same themes have been revisited," says the artist. "If there is repetition, it is always with variety as the concept evolves, expands and deepens." In her *Contemplation of Flight* series, Conover explores flight as a metaphor for freedom, transformation, change and transcendence. Angels, dragonflies and feathers act as iconic symbols throughout the body of work. "I believe as humans we continually strive to transcend our constraints and limitations through flight, whether it is physical, mental or spiritual," says Conover. In the series entitled *The Journey*, the artist further investigates the desire to soar beyond earthly limitations. Conover uses a horse as a symbol of man's spiritual journey from disappointment to acceptance. "The horse is a warrior that travels through the shadow lands of broken expectations, prickly places of discomfort and dark memories rather forgotten—leading to a gentle place of acceptance," explains the artist.

Living near the shore of Lake Superior in the upper peninsula of Michigan, Conover looks toward nature to fill her spirit and enliven her creative process. "A walk on a crisp morning to see what new abstract patterns nature has given me is all I need to renew an old inspirational friend," she says. The dramatic and ever-changing landscape provides Conover with invaluable material with which to work. Conover's relationship with nature has generated two bodies of work, *Frozen Crystals* and *Life Cycles*. Each series examines the natural world and its ever-evolving properties. *Life Cycles* draws inspiration from nature's beauty in all its wondrous stages from dormancy to renewal, symbolizing man's life, death and rebirth cycle. *Frozen Crystals*, on the other hand, explores the winter environment as a metaphor for man's multidimensionality. "Looking through the layers of ice is like looking into ourselves. The surface layer is easily recognized and understood," explains Conover. "But, as the water deepens, it is darker and not as easily identified. Further exploration is needed to reveal the complex facets of the environment and the veiled richness of the wonders within." To maintain a fresh perspective, the artist travels the United States—from Florida to Arizona—in a motor home for four months out of the year. "I love to immerse myself in the natural environment," says the artist. "Seeing new places and things is mentally and visually stimulating." With the dawn of every day comes an opportunity to experience anew and the artist embraces this calling wholeheartedly.

For Conover, art truly mirrors life, and the creative act becomes a transforming visual rite of passage, a vehicle in which to find meaning, understanding and insight. Through her intrinsically metaphorical work, the artist heightens our perception of what challenges us and provokes us to move forward from a place of strength and vitality. From chaos to order, we become a witness to our own evolution.

"I think it is important to allow some of what is underneath to show through in the end. By exposing the layers below, we show our decision-making, our mistakes, our progress and our growth."

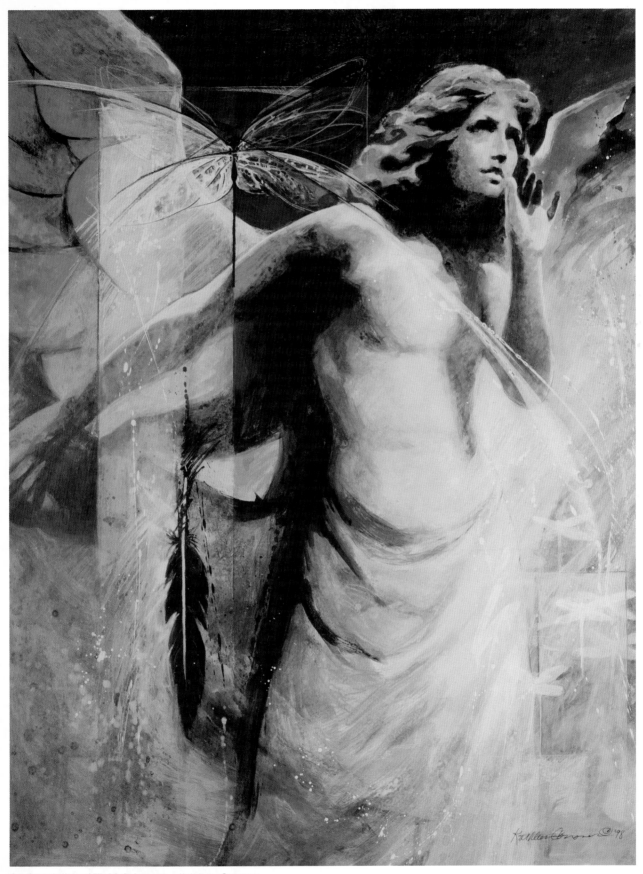

Contemplation of Flight: Sojourner · Kathleen Conover
SIZE: 30½" × 22½" (77cm × 57cm) / **MEDIUMS:** watercolor, acrylic, graphite and charcoal / **TECHNIQUE:** spattering / **SURFACE:** Arches 140-lb. (300gsm) cold-pressed watercolor paper / **COLLECTION:** private collection

toning the surface in inventive ways

To create an environment that tantalizes the creative juices, begin by toning the surface in inventive ways. There are many ways in which a working surface can be made more expressive. Explore materials and techniques outside your creative repertoire to jump-start your process and approach. In this demonstration, artist Kathleen Conover uses monoprinting, dripping, collage, custom stamping and painting to enliven her work.

MATERIALS

Plastic sheeting
140-lb. (300gsm) hot-pressed watercolor paper:
 22" × 30" (56cm × 76cm)
White tissue paper
Mat board
Craft foam: ⅛" (3mm)
Clear transparency film

Black gesso
White gesso
Acrylic paint: Quinacridone Gold and Red Oxide
Acrylic matte and gloss mediums
White chalk

Bristle brushes: 3-inch (76mm) and 1-inch (25mm)
Two brayers
Scissors
Masking tape
Foam glue

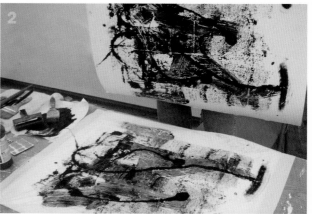

1 Setting the Tonal Range for a Monoprint
A nonabsorbent piece of plastic sheeting is folded and unfolded to give it a gridlike pattern. Black gesso is dripped on the sheeting and spread around with a brayer to create a visually dynamic understructure.

2 Pulling the Print
A sheet of untreated 140-lb. (300gsm) hot-pressed watercolor paper is laid face down on the wet gesso surface. The transfer is made using a brayer and the palm of the hand.

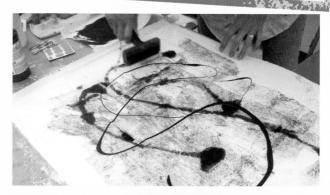

3 Customizing Tissue Paper
Quinacridone Gold acrylic paint thinned with water is brushed on one side of plain white tissue paper. Plastic sheeting is placed under the tissue to trap and puddle the paint in intriguing ways. Once dry, the tissue paper is turned upside down to reveal the abstract patterns made by the paint pooling. Further detail and interest is added by dripping black gesso on top and leaving it to harden.

4 Adding Surface Texture With Collage
Selected pieces of the custom-treated tissue are applied to the working surface using a mixture of two-thirds gloss medium and one-third water. A paintbrush is used to apply the mixture.

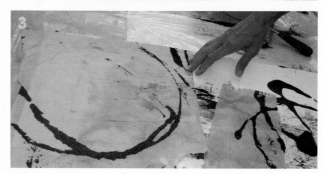

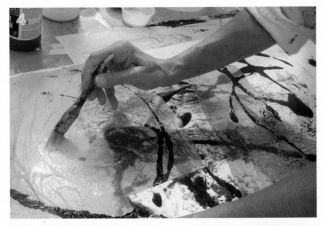

5 Custom Stamping: Creating Rhythm and Flow

Craft foam is cut into nine squares. Using foam glue, they are adhered in a gridlike fashion onto a piece of mat board that has been sealed with acrylic gel medium. A handle is made out of masking tape and placed on the back of the mat board. A brayer is used to cover the foam stamp with Red Oxide acrylic and the custom stamp is pressed onto the working surface several times, inserting a geometric element into the predominately organic composition.

6 Unifying the Composition

A mixture of Quinacridone Gold and Red Oxide acrylic is thinned with water. A wash is applied to the working surface using a 3-inch (76mm) paint brush, infusing warmth, color and visual harmony into the composition.

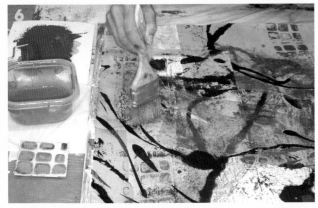

7 Establishing a Focal Point

A larger gridlike custom stamp is produced following the same procedure as in step 5. With a brayer, black gesso is applied to the stamp surface, which is then pressed onto a sheet of clear transparency film.

The ideal focal point is chosen by moving the imprinted transparency around the composition. To properly secure the placement of the stamp, white chalk is used to mark the corners of the transparency on the working surface.

8 The Finishing Touches

The piece is finalized with minor adjustments, including the application of white gesso to key areas. A final varnish is mixed using one part each of gloss medium, matte medium and water. This mixture is applied on top to seal and unify the surface.

The title of the finished painting, *Wabi-sabi*, comes from a Japanese term that centers on the acceptance of transience. The artwork's aesthetic refers to finding beauty in the imperfect or incomplete.

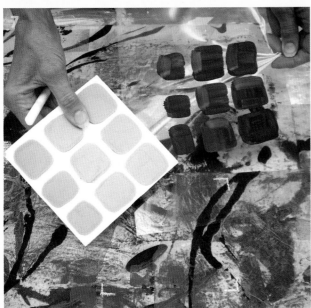

Rudy Gutierrez:

wall**medicine**

More than any other era, the 1960s was a time of great transition in America—politically, socially, culturally and economically. The decade marked the beginning of the Civil Rights Movement, the Vietnam War and the election of one of the country's youngest presidents, John F. Kennedy. Great strides were being made in science, technology and space travel. When it came to fashion, psychedelic colors, miniskirts and long hair were in vogue and Beatlemania had begun to permeate the culture. By the close of the decade, man had walked on the moon, and Woodstock would forever be remembered as a sanctuary for music, love, peace and liberation. A progressive mindset dominated and a younger generation was at the forefront, wanting to make a difference in the world around them.

Coming of age in the late sixties made an incredible impact on the life and work of artist Rudy Gutierrez. From an early age, he witnessed the plight of the Black Panthers, the Young Lords and later the AIM (American Indian Movement). At the time, there was a tremendous sense of honor and pride for one's heritage among people of all backgrounds. "I was part of a certain consciousness. It was about looking at things differently and searching within to see if you are doing what you can as an individual," says Gutierrez. "It's an awareness of people coming into their own culture and that has always stayed with me. It has influenced my dress, the music I listen to and my art. To this day, I am just trying to live up to those standards."

Fighting the stains of oppression, indifference and inequality, Gutierrez's provocative social commentaries shed light on tough socioeconomic issues. "Growing up, I saw injustice all around me," says the artist. "If I'm being true to myself, my work will be used to speak certain truths." Gutierrez's emotionally-driven, socially-responsible work promotes spirituality, equality and understanding. It has often been referred to as "wall medicine." His universal message is to empower, strengthen and uplift. "I believe that I am put on this earth to give," says Gutierrez. "I want my work to touch people, affecting them on some kind of healing level. I believe that I've been given a gift and I must honor that gift by using it to inspire people." Before commencing a piece, Gutierrez will often meditate or pray, asking to be used as a vessel. "I want to be open to receive what is right for what I want to say in terms of direction and flow," he explains. "I believe in spirituality and when I'm in tune, I can feel it. There is a certain divinity that we all have within us."

Gutierrez's visual vernacular is derived from his diverse ethnic roots. Mainly Puerto Rican with African, Spanish and indigenous Indian influences, the artist explores his own cultural heritage to create a signature style of realism and abstraction, rhythmically layered with spiritual symbols and icons. The artist describes his styles as "a mixture of different languages coming together." He adds, "I think of it as a gumbo, reflective of who I am, what I love and what I don't like." Culturally rich books, music and art abound in Gutierrez's studio, enlightening his spirit and soothing his soul. "The pictures on the wall and music that I play help to create a certain vibration in

"I think of it as a gumbo, reflective of who I am, what I love and what I don't like."

Night Blossom · Rudy Gutierrez
SIZE: 48" × 29" (122cm × 74cm) / **MEDIUM:** acrylic / **TECHNIQUE:** dry brush / **SURFACE:** black table top with pattern / **COLLECTION:** the artist

the room," says the artist. "I am always looking, listening and reading. It's not just about doing the art but it's about feeding your mind and your heart." When it comes to process, Gutierrez sees his work as a kindred spirit to the art of music. "There are rhythms and melodies in the work with areas that I leave for riffing, improvising and adding flavor to the mix," he explains. "For instance, I find myself starting out somewhat realistically, stating the melody, and then departing to become more distorted and abstract. To make sure I don't lose the audience, I always come back to the melody, pulling the viewer in with something that they can relate to. The realism opens the door for the viewer to enter and the abstraction takes them on a journey."

As Gutierrez's vision evolves, he finds himself working on a much grander scale in both the content and the physicality of his work. With the passing of each day, his voice becomes bolder and more direct. Not afraid to speak his mind, Gutierrez shows us his courage and perseverance by continuing to take the road less traveled, inspiring us to follow his lead. "As you get older, you realize time is shorter," he says. "Over the years, I've gotten much more confident about expressing how I feel. I've got stuff to say and I've got to get it out, letting the chips fall where they may. In the end, life is about being true to yourself, walking your own path and, ultimately, making a difference."

"In the end, life is about being true to yourself, walking your own path and, ultimately, making a difference."

Malcolm X · Rudy Gutierrez
SIZE: 16" × 12" (41cm × 30cm) / **MEDIUMS:** oil, acrylic and water-soluble colored pencil / **TECHNIQUES:** oil wipe-out, dry brush and rock scraping / **SURFACE:** illustration board, vellum heavyweight / **COLLECTION:** the artist

Carlos Santana – Rainbow Warrior · Rudy Gutierrez
SIZE: 20" × 14" (51cm × 36cm) / **MEDIUMS:** oil, acrylic, water-soluble colored pencil and oil pastel / **TECHNIQUES:** oil wipe-out, dry brush and rock scraping / **SURFACE:** illustration board, vellum heavyweight / **COLLECTION:** Carlos Santana

mixing media

When artistic mediums are combined in interesting ways, they can create an engaging multitextural, multisensual environment. The application of multiple mediums using a plethora of mark-making tools not only visually ignites the surface but also presents alternative ways of handling space, structure, form and content. In this demonstration, artist Rudy Gutierrez uses graphite, oil, acrylic, water-soluble colored pencils, wax crayons and collage to send a culturally-inspired vibe through his mixed-media mural.

MATERIALS

Bainbridge 80-lb. (170gsm) cold-pressed illustration board
Strathmore 400 Series Bristol Vellum (2-ply)
Tracing paper
Foamcore board
Decorative floral paper

Acrylic paints: heavy body
Water-soluble colored pencils
Wax crayons
Acrylic matte
Oil paint: Burnt Sienna
Odorless turpentine substitute
Fixative: clear matte
Graphite pencil

Watercolor brushes: round, filbert and flat
Nylon brush: flat
Moisture-retaining palette
Palette knife and plastic knife
Various rocks
Wooden sculpting tool
Double-sided mounting tape
Paper towels
Pink Pearl adjustable eraser
Kneaded eraser
Adobe® Photoshop®
Scanner

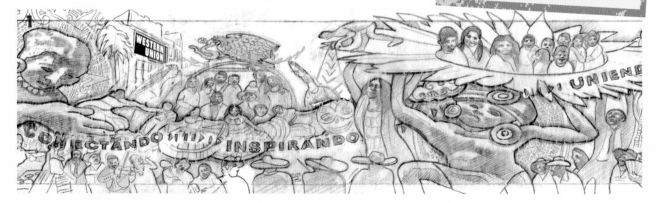

1 Building the Composition
The photographic reference is scanned into the computer and altered in Photoshop to create a montage-style composition. The layout serves as a visual reference for a presentation sketch that is produced in graphite on tracing paper.

2 Transferring the Drawing to the Board
The graphite line drawing is transferred to cold-pressed illustration board. For a rigid working surface, the board is temporarily adhered onto foamcore board with double-sided mounting tape. Workable fixative is used to set the drawing. A respirator and proper ventilation is used.

3

4

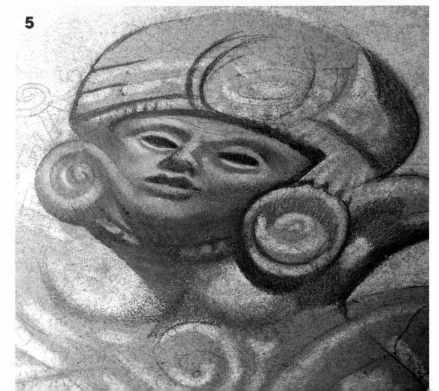

5

3 Blessing the Creative Process With a Ritual

To bring in positive energy into the creative process, the smoke of sage is used. The Shamanic smudging ritual of wafting the smoke of sage over oneself and one's possessions has been used for centuries as a purifier, a way to drive out negative energy and bring about clarity and insight. Once the work is blessed, the artist gains guidance along the journey yet to come.

4 Establishing the Values

To establish the middle tones and areas of light, Burnt Sienna oil paint, thinned with an odorless turpentine substitute, is evenly applied over the entire surface using a paper towel. Proper ventilation and protection are imperative when working with all solvents and sprays. Once the surface is dry, the areas of light are softly lifted using a pliable kneaded eraser. An adjustable eraser is employed for the really sharp highlights.

5 Building Color and Value

To add color as well as define the darks, water-soluble colored pencils are employed throughout the piece. In some areas, the pencils are used as in a drawing. In other areas, the pencil marks are altered by utilizing a wet brush or finger on top. Wax crayons are also used to bring out color and add texture. Workable fixative is sprayed over the entire surface to prevent the water-soluble mediums from reactivating.

6

6 Stylizing the Work

To further give character to the work, acrylic paint is applied to the working surface using a variety of tools from brushes, palette knives and plastic knives to the artist's own fingers and hand. A moisture-retaining palette, which allows acrylics to stay moist for a long period of time, is used for mixing. No water is added to the paint. Once the layers are built, a wooden sculpting tool is used to scrape back into the surface, allowing the layers underneath to show through. By employing a variety of mark-making tools, the artist is able to deconstruct and distort, adding a signature look to the work.

7

7 Introducing Collage Into the Mix

Acrylic paint is loosely applied onto bristol vellum using a flat nylon brush. Once this is dry, the colored paper is torn into petal-like shapes and adhered to the surface with acrylic matte medium. Using the same process, simulated feathers are created and positioned onto a headpiece. In addition, decorative floral paper is carefully cut and used as the pattern on a dress.

8 Scratching-In

Various rocks are used to scrape areas of the mixed media painting, giving it a more textural look and feel.

9 The Finished Work

The finished painting is entitled *Conectando, Inspirando, Uniendo (Connecting, Inspiring, Uniting)*. Commissioned by Dieste Harmel & Partners, the piece was digitally scanned and reproduced in various sizes on vinyl and used as large public murals in Dallas, Los Angeles and Miami to promote Western Union. After the work was reproduced, the original art was coated with acrylic gloss medium to bring out the intensity of the colors. Note: prior to the final reveal of the mural, the art was slightly altered to accommodate local laws.

"The addition of different textures and layers of mixed media allows me to find new directions, keeping my interest and creating a more flavored conversation."

Conspicuous Consumption: Conversations on Body Image · Lynne Foster
SIZE: 18" × 15" (46cm × 38cm) / **MEDIUMS:** charcoal and acrylic / **MATERIALS:** sewing patterns and tissue / **TECHNIQUES:** xerography, image transfer and collage / **SURFACE:** illustration board / **COLLECTION:** the artist

inside **out**

Living and working in New York City, artist Lynne Foster is surrounded by both the triumphs and the tragedies of society. This sense of contradiction inspires her to look deeper into the human condition to reveal certain truths. "I can never be satisfied with merely painting what I see. I have to be able to look under the surface to expose the jewel," says Foster. "By stripping away the many layers of concealment, I allow the viewer to enter into an intimate journey. Through internal investigation, I am able to translate raw emotion into a visual language that can be enlightening, amusing or even disturbing." It's the play between the physical and the psychological that drives the artist to create her provocative portraits of social injustice and the everyday struggle to survive in a world that is often unfair.

For Foster, the creative muse is ever present and each day reveals a different story waiting to be told. "I am moved by the people on the street and the everyday characters that surround us, whether it is the man who cries out to his God as he walks up Broadway, the transvestite and her white poodle who sit in a cobalt blue 1955 convertible waiting for the alternate side of the street parking hour to end, or the woman who looks through my garbage hoping to find breakfast," says Foster. Influenced and inspired by her environment, the artist takes the realities of everyday urban life and reassembles them into a new structural form all her own. Her narrative social commentaries open our minds to experiences that we would not have otherwise.

Foster's approach to the creative process parallels that of an actor preparing for a role in a film or play. "I like to find out as much as I can about my characters in order to give an honest response," says the artist. "Through my research, I uncover a symbol or image that can bring the concept to life—the essence of which can come from a simple prop such as a hat, scarf, trench coat, or glove or it can evolve from an emotional response to a past experience." Like a master performer, Foster draws from her day-to-day observations to achieve believability and provoke interest. "I like it when the line between the actor and the character blurs, leaving the observer unable to distinguish the difference between the two," she says. When drawn to a particular subject, Foster typically produces a series of works. "I do not buy into the theory that one image can tell a thousand words," she explains. "If an idea can yield only a single work, then it does not hold enough staying power for me to remain curious."

When it comes to art-making, Foster prefers to work in the moment, allowing for accidental discoveries to happen along the way. Without overt concerns for stylistic interpretation, the artist begins to draw, letting her experience with the subject at hand come through. In search of a fresh perspective, Foster will often work on multiple studies before determining

"I can never be satisfied with merely painting what I see. I have to be able to look under the surface to expose the jewel. By stripping away the many layers of concealment, I allow the viewer to enter into an intimate journey."

Date Rape · Lynne Foster
SIZE: 11" × 10½" (28cm × 27cm) / **MEDIUMS:** charcoal, acrylic and oil stick / **MATERIALS:** tissue, paper and ephemera / **TECHNIQUES:** xerography, image transfer and collage / **SURFACE:** illustration board / **CLIENT:** *Delaware Today* magazine

a direction. To set the scene, the artist brings her drawings into the computer, then combines them with photography, textures, type and various ephemera to create a multilayered environment for her characters to interact in. Once she establishes a composition that ignites her imaginative faculties, Foster will employ xerography as a way to obliterate subtle changes in tone. "I am really fascinated with the idea of reproduction, xerography and digital manipulation," says Foster. "What the machine can do to my line is something I find truly magical." When a work is composed purely of light and shadow, it becomes incredibly graphic and dynamic. It no longer blends in but instead begins to stand out, much like the outcasts of society that the artist finds so fascinating. Foster continues to develop her work using collage, transfers, gold foil, drawing and painting. "I am trying to build a structure with enough

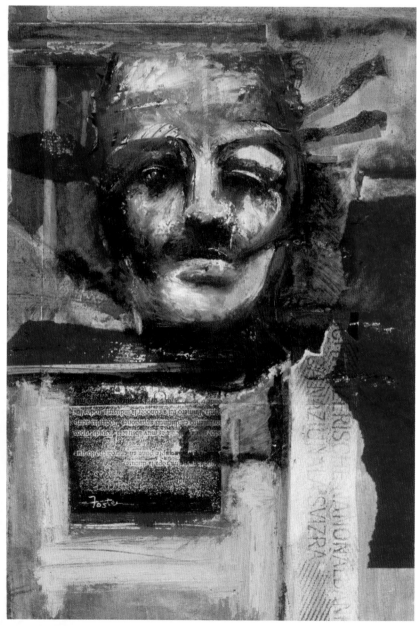

open doors for me to let myself loose," the artist notes. "I am creating a world of my design." Around and through the central image, the artist builds the spatial landscape. She will intuitively work and rework areas until the piece reveals itself. "There is always a moment when things start to come alive and that's when it gets really exciting," she adds. From the hand to the machine and back to the hand, Foster's artistic process continually moves.

The artist's firsthand knowledge and engagement with the world allows her to visually communicate from a personal, unique perspective. It captures life in a way that is passionate, emotionally driven and vividly compelling. To push her vision to the next level, Foster is exploring motion-picture media. "My aim is to ultimately blend the aesthetics of paint with the power of modern technology through multimedia," she says. "I want to pursue projects that incorporate my work into a 4-D environment, expressing the emotional vigor of my drawing into film and video." By embracing new media, Foster believes she will have come full circle as a visual storyteller.

> "I am trying to build a structure with enough open doors for me to let myself loose. I am creating a world of my design."

Mardi Gras · Lynne Foster
SIZE: 10" × 5½" (25cm × 14cm) / **MEDIUMS:** charcoal, acrylic and oil stick / **MATERIALS:** tissue, paper and ephemera / **TECHNIQUES:** xerography, image transfer, gold foil transfer and collage / **SURFACE:** illustration board / **COLLECTION:** the artist

using custom transfers and xerography

Outside the confines of the studio, intriguing textures and iconography can be found almost anywhere. Whether it is the color and tactile quality of a rusted piece of painted metal, the pattern of a broken chain-link fence, the graphics of a weathered and torn billboard or the signature type on a graffiti wall, each inspires. Elements, natural or man-made, can be transformed by the process of xerography. Manipulating them through overlapping various printed transparencies, greatly enlarging or reducing portions, bending, creasing, fragmenting, multiplying sections or moving elements—either fast or slowly—across a photocopy machine while in operation can yield exciting, unexpected results. In this demonstration, artist Lynne Foster draws inspiration from her urban surroundings, employing xerographic techniques to give her work a graphic edge.

MATERIALS

Beinfang No. 360 graphic layout paper
Crescent 140-lb. (300gsm) watercolor board
Colored tissue paper
White bond paper
Brown Kraft paper
Gold foil stamping paper
Ephemera

Charcoal pencil: HB
Compressed charcoal stick: soft
Latex paint
Acrylic paint: medium viscosity
Acrylic matte medium

1-inch (25mm) flat nylon brush
Round nylon brushes: various sizes
Bienfang Sealector tacking iron
White artist's tape
Decorator's comb
Textured paper towels
Cotton cloth
Photocopy machine
Ink-jet printer
Adobe® Photoshop®
Scanner

1 Igniting the Process With Drawing
Using photographic reference, the main figure is sketched onto layout paper with an HB charcoal pencil. Several studies are made in order to get a feel for the subject.

2 Manipulating the Image
The charcoal drawing is scanned into the computer, combined with photography, various textures and type using Photoshop and printed out onto paper. The ink-jet print is then photocopied onto white bond paper, reducing the tonal range to darks and lights. Using acrylic matte medium brushed on both sides, the photocopy is adhered to watercolor board. Artist's tape is applied to the outer edges to mask around the image area.

"The magic in my work begins to happen when I start to work with photocopies. The areas of gray become amazing textures in black, simplifying all my shapes into light and dark."

3 Applying Paint

Water-thinned washes of acrylic paint are applied throughout the entire piece. While wet, some areas of color are lifted using a paper towel, leaving a textural impression on the surface. As the painting progresses, more opaque applications are introduced. To redefine any line work that may have gotten lost in the painting process, a soft compressed charcoal stick is used.

4 Adding Collage Elements

Colored tissue, printed papers and various ephemera are torn up and applied to the painted surface using acrylic matte medium. Any areas that overlap the figure are trimmed away. Collage elements that extend beyond the taped boundaries are left untouched. They will be used later to create a deckled edge.

5 Printing Custom Papers

Custom-printed collage elements are created by running various papers such as tissue and kraft paper through a photocopy machine. For delicate papers, the edges are carefully taped down to a piece of copy paper before photocopying.

6 Using Graphic Transfers

Transfers are created by photocopying various letters and graphic images in reverse onto layout paper. The image side is coated with acrylic matte medium and laid directly onto the working surface, face down. When it is completely dry, the back of the transfer surface is rubbed with a damp cloth until the paper is completely removed and the image is revealed.

7 Adding Texture

A decorator's comb is run through wet acrylic to further develop the surface texture and to break up heavy impasto areas of paint.

8 Applying Foil Transfers

Foil accents are applied using a sheet of gold foil stamping paper and a tacking iron set at 220°F degrees (104°C). The heat melts the foil onto the surface. If the foil has been previously die-cut, punched or stamped, the painting surface will come through the negative areas once applied.

9 The Finished Work

The process of layering collage, type and graphic transfers, painting and drawing continues until the piece speaks to the artist in some way. The finished mixed-media work is entitled *Ska Princess*.

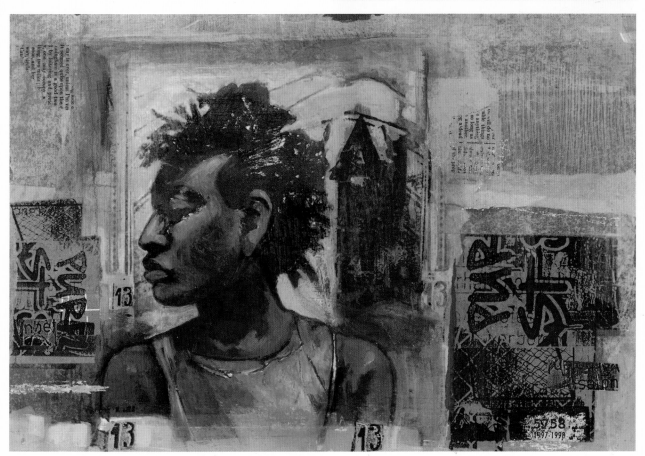

Fred Otnes:

sum OF THE parts

Life is the summation of a multitude of experiences. Each encounter is influenced by the one that came before it, and the whole becomes greater than the sum of its parts. Such is true for the work of collage artist Fred Otnes. Texture over surface, pattern over image and line over tone, the layers build to create a new reality, one that has evolved over a lifetime. "I've grown tremendously as an artist throughout the years," says Otnes. "I have more depth as a person and therefore have more sensitivity and understanding of what I am doing." As one looks deeper into the work, the history of the artist and his artistic journey is revealed, one layer upon the next.

In Otnes's intricately detailed work, the viewer is invited into a world where organic and geometric elements—architectural details, mathematical expressions, delicate floral accents, ornate tapestry, sheet music and old manuscript text—eloquently dissolve in and out of a central figure or subject in an almost poetic fashion. Frame-like borders become windows to the past, provoking thought and encouraging further inspection. Throughout the visual landscape, the artist presents relationships that do not ordinarily coalesce, challenging the mind to find a connection. "I like when you can look at a piece and see many things in it," adds Otnes.

Within the same pictorial environment, the artist brilliantly fuses collage, assemblage, photoengraving, etching, image transfers and painting. Otnes uses a limited palette, consisting exclusively of rich, muted earth tones, that is reminiscent of traditional chiaroscuro. His monochromatic use of color establishes a unified atmosphere, creating visual harmony among the plethora of disparate fragments and ephemera that lie beneath. On oil-primed linen canvas over board, the artist uses both acrylics and oils and enjoys combining the inherently different painting mediums in the same work. The opposing properties of water-based acrylics and oil-based paint create a tension that the artist finds fascinating. "I may roll on some acrylics to an oil surface and then begin to lift and pull up certain areas using tape," explains Otnes. "I like to take advantage of the fact that some of the acrylic surface adheres and some does not, leaving areas that are somewhat hidden. You are left wondering what is underneath, and I like that." To reveal his hand, Otnes will often scratch into his highly tactile surfaces with various mark-making tools. With a wash and wipe-out application of turpentine-thinned oil, the artist enlivens the textural landscape. Every detail of the topography is revealed, establishing an almost timeless quality. To further alter the pictorial dynamics, Otnes will juxtapose his many fragments of ephemera against three-dimensional form. The artist's unique assemblage accents are cast, distressed, pilfered and remade into something all his own. If, at any point in the process, Otnes finds that the work is not speaking to him, he will take measures to reengage his imaginative faculties. "I'll sand down an image or even pour something on top of it, just doing something so that I have a new surface to work into," he says. "If something really isn't working, I'll just put the work aside, getting up the next day with a whole new opportunity just

"My work is different than someone who has a nailed-down technique. When I'm creating, I don't really think very much about what I am doing because my work moves all over the place. My theory is to never get too concerned with what I am up against but instead to let everything evolve and develop as I am working."

On Being 100 · Fred Otnes

SIZE: 24" × 32" (61cm × 81cm) / **MEDIUMS:** oil and acrylic / **MATERIALS:** artist reproduction, tape, cigar mold, wood and ephemera / **TECHNIQUES:** collage and assemblage / **SURFACES:** wood and linen canvas over board / **CLIENT:** Deloitte & Touche

to play." The mystery that each new day presents intrigues the artist and has kept him fully engaged since he began working in his signature style.

For Otnes, the creative process is an ongoing game of exploration and experimentation, where the unexpected is always welcome. His intuitive, stream-of-consciousness approach provides the artist with the freedom to take chances without limitations. Always open to the process, Otnes is not afraid to let the painting be his guide. "My work is different than someone who has a nailed-down technique. When I'm creating, I don't really think very much about what I am doing because my work moves all over the place," he says. "My theory is to never get too concerned with what I am up against but instead to let everything evolve and develop as I am working."

The artist's keen command of the visual language has made him a master at pictorial composition. He sees himself as a kindred spirit to designers and architects and the connection is quite apparent in his work. For inspiration, Otnes loves to collect art

books and magazines and spends a lot of time looking at art in museums and galleries. "The moment I went to New York and started covering the galleries is when my work began to improve tremendously. It opened me up to what art can really be," recalls the artist. "There is a big advantage in being in New York City. Sometimes you can go all day and you don't see anything. Other times, you see things that change your life." Art Brut, also known as Outsider Art, attracts his attention lately. "I love all contemporary art of the last century," he says. "But I look at everything, as almost anything can be an influence. It's important to remain curious and to try as much as you can, just to see where it can take you. The more you do, the more you learn and the better you become. I have always felt, even now, that I'm on the edge of something new."

"It's important to remain curious and to try as much as you can, just to see where it can take you. The more you do, the more you learn and the better you become. I have always felt, even now, that I'm on the edge of something new."

Mirifici · Fred Otnes
SIZE: 20¾" × 22½" (53cm × 57cm) / **MEDIUMS:** oil and acrylic / **MATERIALS:** artist reproduction and ephemera / **TECHNIQUES:** collage and type transfer / **SURFACES:** linen canvas over board / **COLLECTION:** private collection

The G Tree · Fred Otnes

SIZE: 60" × 48" (152cm × 122cm) / **MEDIUMS:** oil and acrylic / **MATERIALS:** decorative borders and ephemera / **TECHNIQUES:** collage, photo transfer and spattering / **SURFACES:** linen canvas over board / **COLLECTION:** private collection

projecting
forward

The architecture of the painted surface is being redefined, as mixed-media aesthetics are uniting the disciplines of painting and sculpture in inventive combinations. Three-dimensional art captivates an audience with its engaging constructs, intriguing enclosures, tactile surfaces and custom add-ons, in which sculptural projections add not only depth and dimension but also meaning to the work.

Because they can be seen from a multitude of angles, artistic constructions create a unique experience for the viewer. To captivate the audience and draw the eye in from any direction, artists work on all sides of the dimensional picture. When working with three dimensions, artists employ a variety of materials and processes. Substrates such as metal, wood, wax, handmade paper, glass and plastic defy their flat origins when they are cast, molded, wrapped, embossed, carved or embellished. Accents such as decorative trim, ribbon, lace and fabric can also be transformed when treated with acrylic gel medium, gesso or encaustic and left to harden after they are shaped. To add mystery and intrigue, artists are penetrating the picture plane with clever enclosures. Cages, inlaid boxes, frames and slotted windows are being used in myriad ways, creating an entirely new spatial arrangement. With the addition of living creatures and kinetic objects, an artistic work becomes dynamic and sensory-charged. Black widow spiders, snakes, rats, butterflies and doves as well as pendulums, candles and clocks each have made an appearance in the three-dimensional pictorial realm as symbolic, free-moving accents—altering the look of the work in real time.

To illuminate a concept in a provocative way, artists are employing custom and repurposed add-ons as titillating visual clues to the overall message of a work. Antique door knockers and handles, ornate dresser knobs, decorative fixtures and vintage techno-parts and trinkets bring a time-tempered, historical feeling to a piece of art, while natural accents such as dried flowers, leaves, twigs, bark, driftwood and shells provide an organic element. Artists almost never use their assemblage accents in the state in which they were found. Many like to craft the surfaces of found and repurposed objects, redefining them to fit their own visual vernacular. Acrylics, ink, oil sticks, water-soluble crayons, colored shellac, crackle varnish and wood stains are being applied with a rag or brush and then wiped, sponged, scratched or sanded to create interesting patinas and

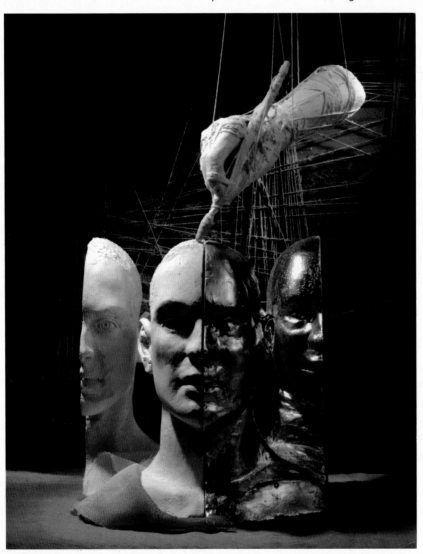

Stanford MBAs · Barron Storey
SIZE: 30" × 24" × 14" (76cm × 61cm × 36cm) / **MEDIUMS:** plaster, urethane foam, acrylic and spray paint / **MATERIALS:** cloth, wood and string / **TECHNIQUES:** casting, sculpting, wrapping and assemblage / **CLIENT:** *Stanford Business* magazine

Cages #6 Strata Part 2 · Dave McKean
SIZE: 16" × 24" × 1" (41cm × 61cm × 3cm) / **MEDIUM:** acrylic / **MATERIALS:** fly collection, pins and thread, shell, photography, color photocopy and tracing paper /
TECHNIQUES: xerography, collage and assemblage / **SURFACE:** wooden box / **CLIENTS:** Tundra, Kitchen Sink Press, NBM Publishing and Dark Horse Publishing

faux finishes. To further distress a surface, artists will even torch objects or allow them to rust. They are also sculpting their own dimensional accents by using urethane foam, self-drying clay or Super Sculpey, a sculpting medium that can be easily hardened in a conventional oven. In addition, plaster castings of the human form, decorative objects or low-relief surfaces can provide an intriguing sculptural element to any work.

For the dimensional artist, the creative process needs to move beyond aesthetic concerns to encompass both form and function. Carpentry skills and a strong sense of craft are a must. To keep each element in its proper position, artists are nailing, screwing, gluing, pegging, welding, hooking and wiring. Some elements of the construction may remain hidden while others become part of the overall visual landscape.

When searching for vintage and aged materials, yard sales, flea markets, junkyards, construction sites and even dumps are ideal places in which to uncover decayed, broken and disassembled remains of bygone eras. Whereas, frame shops, craft retailers, bakeries, hardware stores and fabric outlets provide common objects and materials that can be cleverly repurposed. Artists are becoming ever so sensually curious to their surroundings. Inspired and excited by the possibilities in the most inconsequential things, they are beginning to discover unexpected gems in the rough.

The methodology of picture-making is in transition. The application of dimensional substrates, constructs and assemblage accents onto the painting surface has opened up a plethora of visual possibilities. By breaking out of traditional classification, artists are beginning to realize that there are no longer boundaries or limitations to what can be done. The emerging pictorial idiom has created a new language, an even broader, more expressive visual vernacular for artists to embrace and explore.

Lisa L. Cyr:

visual poetry

Observe, contemplate, understand, then see anew; to interpret is to transform. The work of artist Lisa L. Cyr is a synthesis of multiple impressions that collectively create a new reality with a more expressive, symbolic arrangement, transforming the ordinary to the extraordinary.

A multidisciplinary artist with a content-driven approach, Cyr is always looking toward the abstract rather than the literal. Her highly poetic, imaginative compositions employ typographic elements, ideograms and ephemera that are taken out of their ordinary context and reorganized, overlapped and juxtaposed to illuminate a central subject, creating relationships that challenge the viewer to find alternative connections. "I like the way the abstract realm can alter the reading of a piece," says the artist. "Disparate and fragmented elements come together to create visual metaphors that impose the power of suggestion, extending the image beyond the sum of its parts." Cyr's lyrical, multilayered works detach conventional meanings to establish new associations, stimulating curiosity, provoking thought and encouraging the viewer to spend time with the work—always looking deeper to discover anew.

Cyr, also an accomplished writer, approaches her mixed-media aesthetic much like she does her journalistic endeavors. "I begin each piece with an idea, a concept that I want to articulate, and then I start to do my research," explains Cyr. "When brainstorming, I find that the library and a really great bookstore are some of my favorite venues. They are a vast resource of information, assisting me in establishing a fuller understanding of any subject." By immersing herself in a topic, the artist has something to work with and to draw from. "I see my initial ideation process as a search, much like walking through a maze where you ponder many possibilities until you finally discover the path you must travel." With her research in hand, Cyr synthesizes what she has unearthed, making connections and establishing relationships. Like a poet, the artist begins to pare down.

Intrigued by the road less traveled, Cyr takes a nonlinear approach to picture-making, which is complemented by her fascination with alternative materials and techniques. The artist's experimental spirit and innovative exploitation of mixed-media art pushes well beyond the pursuit of mere technique. The masterful amalgamation of content and process creates a dynamic spatial continuum that is not only multidimensional but also multi-sensual. "Art can be much more than just eye candy," says Cyr. "By appealing to the senses, one can evoke a deeper response—one that is memorable and lasting." The artist's expansive visual vernacular rhythmically combines drawing, painting, collage, assemblage and sculpture within the same pictorial idiom. "I gravitate towards materials and processes that speak to me and love to play around to see what I can discover."

The artist works with a push-pull process, where she adds things to the working surface only to later scrape, scratch and peel back into it, arriving at an environment

> "I like the way the abstract realm can alter the reading of a piece. Disparate and fragmented elements come together to create visual metaphors that impose the power of suggestion, extending the image beyond the sum of its parts."

The Courageous · Lisa L. Cyr

SIZE: 30¼" × 19" × 2½" (77cm × 48cm × 6cm) / **MEDIUMS:** acrylic, oil, acrylic gel medium and modeling paste / **MATERIALS:** ripped, cut, riveted and punched textured paper, tissue, ephemera, sticks, gold thread and decorative metal accents / **TECHNIQUES:** collage, assemblage, embossing, debossing, monoprinting, sponging and palette knife / **SURFACES:** linen canvas over Masonite and board with wooden framework / **COLLECTION:** the artist

Meditative Pathways · Lisa L. Cyr

SIZE: 20" × 17" × 2" (51cm × 43cm × 5cm) / **MEDIUMS:** acrylic, oil, ink, graphite, modeling paste and acrylic gel medium / **MATERIALS:** wire, beads, tissue, ephemera, decorative metal accents, clay and wood / **TECHNIQUES:** collage, assemblage, sculpture, dripping, sanding, scraping, spattering, sponging, peeling back, palette knife and type transfer / **SURFACES:** linen canvas over Masonite panel with wooden framework and inlaid boxes / **COLLECTION:** the artist

"Art can be much more than just eye candy. By appealing to the senses, one can evoke a deeper response—one that is memorable and lasting."

that ignites her imagination. To alter the surface geometry and further push the picture plane into the third dimension, Cyr will often insert boxes, apply imaginary windows and add assemblage accents. "By structurally building up the surface or making slight alterations to the painting ground, you can dramatically change the look and feel of the work," explains the artist. To add further visual interest, Cyr will mix sand, sawdust or wood fibers into gesso or modeling paste, and generously apply the plasterlike substance to the surface. While wet, she debosses patterns and textures into the surface to create a sculptural relief. When working dimensionally, Cyr always employs a rigid substrate, usually canvas over Masonite or hardwood that has been attached to a wooden framework, to ensure that the work is supported structurally.

This innovative exploration of unconventional materials and approaches has provided Cyr with a dynamic pictorial syntax, opening up endless visual possibilities for her work to move and grow. "When I first started working, I always approached picture-making with complete clarity, working under a process that would lock in a direction right at the sketch phase. Over time, I got bored and no longer felt challenged by the

process. I had to make some major changes to re-engage myself," recalls Cyr. "Now, I don't commit to any preset methodology. Instead, I respond to the surface as it develops, inventing my own outcome each time."

Treading new ground has given the artist the confidence to explore without the fear of making mistakes. By allowing the picture to dictate the journey, the artist has opened the door for the unexpected to enter. "The more I relinquish control and let the process guide me, the better my work has become, encouraging me to further straddle the edge," concludes Cyr.

"The more I relinquish control and let the process guide me, the better my work has become, encouraging me to further straddle the edge."

Self Awareness · Lisa L. Cyr
SIZE: 30¼" × 21¼" × 2⅜" (77cm × 54cm × 6cm) / **MEDIUMS:** acrylic, oil, ink and graphite / **MATERIALS:** textured paper, tissue, ephemera, dried flower, gold painted leaf, decorative metal accents and metal button / **TECHNIQUES:** collage, assemblage, dripping, sanding, scraping, peeling back, palette knife, tape resist and type transfer / **SURFACES:** linen canvas over Masonite and board with wooden framework / **COLLECTION:** the artist

dimensional substrates and treated surfaces

A multilayered working ground pushes the picture plane into the third dimension in a visually dynamic way. With the addition of textured and treated surfaces, the visual landscape becomes illustratively tactile. In this demonstration, artist Lisa L. Cyr uses multiple substrates, collage, assemblage, embossing and debossing relief treatments and lushly painted patinas to draw the viewer into the work.

1 Preparing the Panels

A Masonite panel is attached to a poplar framework using wood glue and screws that are recessed on top. Wood filler that is sanded down helps to smooth out the surface. The panel is covered with Bookbinder's PVA glue using a flat bristle brush. Starting from the middle, linen canvas is rolled over the glued surface in sections. A brayer is used on top to eliminate any air bubbles. When the canvas is fully attached, it is covered with wax paper and heavy books are placed on top to assist in the adhesion process. In addition, a rigid hardwood panel is also covered with canvas using the same process.

"By altering the pictorial topography, you create visual intrigue, alluring the onlooker in a multitude of ways."

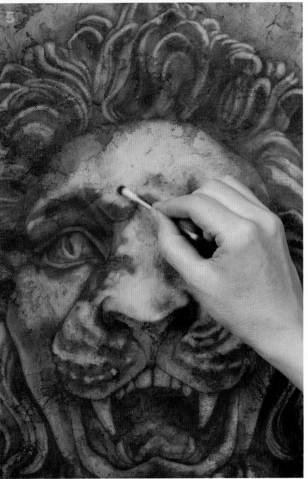

2 Securing the Canvas

To complete both dimensional panels, the sides are glued, wrapped using canvas pliers and adhered to the back temporarily with heavy-duty staples. Once the glue is dry, the staples are pulled out and replaced with small steel tacks.

3 Establishing the Values

A fully rendered value drawing of the lion is executed on the canvas-covered hardwood panel using a technical pencil and powdered graphite. Various round and flat bristle brushes are used to apply the powdered graphite to the canvas surface. A kneaded eraser and an adjustable eraser are used for lifting. When completed, the entire piece is sprayed several times with a photo lacquer using protective gear outside.

4 Creating an Aged Look

To create a weathered look, acrylic matte gel medium is applied to the canvas using a palette knife. It seals the surface, adds texture and dries clear.

5 Applying the Color

Sap Green oil paint is applied onto the textured surface with a cotton cloth in a circular fashion. Areas of light are removed with cotton swabs. When dry, the entire piece is sealed with a photo lacquer, using proper protective gear outside.

6 Applying Washes and Lifting Color

Pencil is used to mark the area where the smaller hardwood panel will be positioned on the larger substrate. Acrylic paint is thinned with water, applied to the canvas and immediately lifted out with a heavy-duty paper towel that has been randomly creased and folded. A piece of handmade paper that has been imbedded with leaves is also used for lifting color. The process is repeated several times to build up the color. Transparent acrylic washes from the same color palette are added to the lion painting to unify the two pieces.

7 Treating and Adhering Collage Elements

Colored papers, in an array of finishes and textures, typographic elements and ephemera are ripped, cut, riveted and punched to create visual interest. The elements are applied to the canvas surface using PVA glue and a flat bristle brush. Painter's tape is used to temporarily hold the pieces in place. Once they are glued into position, wax paper is placed on top and a brayer is used to remove excess glue and air bubbles. When the glue is dry, acrylic matte medium is brushed on top to seal the surface.

8 Debossing the Surface

Modeling paste mixed with gesso is applied throughout the composition using a palette knife. While still wet, the surface is debossed in an irregular fashion using heavy-duty lace with a stiff backing. The collage and modeling paste surfaces are painted with acrylic thinned with water and lifted out in areas using paper towels, handmade paper and sponges, leaving interesting patterns onto the layered surfaces.

9 Printing With Natural Objects

Several freshly-cut sprigs from various bushes are painted with a deep burgundy acrylic and laid down onto the surface of both panels. Gold acrylic paint is dripped on top and spread with a roller. The sprigs are removed before the paint dries, leaving an interesting organic impression.

10 Incorporating Typography

A typographic design is created on the computer and printed out on paper. Chalk is applied to the back for transferring purposes. By tracing over the outlines with a ballpoint pen, the lettering is transferred to the surface and painted in with gold acrylic using a paint roller.

11 Adding Paint Details

To both substrates, acrylic paint is opaquely applied using a brush and a palette knife for more dramatic mark-making. The sides are also painted to continue the image. Oil paint thinned with Liquin is used for rendering areas of detail.

12 Attaching Add-Ons

An antique metal door knocker and drawer handle are lightly sponged with copper acrylic paint and added to the panel as accents. The add-ons are secured from the back with flat screws that have been recessed into the panel. The two panels are put together using screws in the back. Sticks, wrapped with gold thread, are also added to the composition using a hot glue gun. The finished painting entitled *The Courageous* is shown on page 83.

beneath the surface

The facade of an individual reveals an incomplete picture, as we see only what we are allowed to. Many aspects are hidden. It is the mystery behind the physical persona and the contradictions it creates with the external self that fascinates artist Cynthia von Buhler, inspiring her to paint highly symbolic, tactile and often kinetic portraits of the mind. "I like to dig beneath the surface to try and find what it is hidden and why," says the artist. "By opening the canvas up, I can bring another dimension to a portrait. You not only see what a person is showing you on the outside, but you see what is on the inside as well." Von Buhler's sociopsychological visual commentaries diverge into issues such as morality, vanity, aging, sexuality and celebrity worship. She revels in making a direct connection with onlookers, urging them to think and question their own views.

Von Buhler's emotionally-driven, powerfully provocative work illuminates the interpersonal struggles that her characters endure, tantalizing the viewer to look ever deeper to discover the work's intended message. By symbolically displaying still-life objects or live animals in a box, a cage, or dangling from an eye bolt wrapped with wire, the artist is able to show us what is hidden and why. "I try to approach things from a different angle and explore what is inside a person, not only in their mind but in their heart and soul," adds the artist. Von Buhler's dimensional works penetrate the viewer's space in an emotional as well as a physical way. "I'm exploring new ways of looking at space beyond just an image on a flat canvas," says von Buhler. "Using moving objects or living creatures intensifies my work and the viewer's response to it."

Von Buhler's art is layered not only with meaning but also with different mediums. She uses an interesting mix of painting, distressing and assemblage to create her multi-dimensional works of art. Von Buhler's palette, mostly rich

> "By opening the canvas up, I can bring another dimension to a portrait. You not only see what a person is showing you on the outside, but you see what is on the inside as well."

Adam and Eve · Cynthia von Buhler

SIZE: 36" × 28" × 5" (91cm × 71cm × 13cm) / **MEDIUMS:** acrylic and gouache / **MATERIALS:** twigs, apple, wire, ceramic snake and wax seal / **TECHNIQUES:** sponging, dripping, sanding and assemblage / **SURFACE:** linen canvas / **CLIENT:** *Civilization* magazine

Joan of Arc · Cynthia von Buhler
SIZE: 44" × 38" × 10" (112cm × 97cm × 25cm) / **MEDIUMS:** acrylic, gouache and gold leaf paint / **MATERIALS:** chain mail, rod, live dove and wax seal /
TECHNIQUES: sponging, dripping, sanding and assemblage / **SURFACE:** linen canvas / **CLIENT:** Houghton Mifflin

jewel tones, radiates over a distressed outer surface. To age her work, the artist uses a combination of spraying water, dripping paint with a brush and sanding, repeating the process until the image has a time-worn quality. Using rubber stamps and stencils, von Buhler often incorporates typography into her work as a graphic—yet conceptually meaningful—accent. Assemblage objects and living creatures are added to provide character and interest. Frog skeletons, black widow spiders, snakes, rats, butterflies and doves as well as moving electronic parts, burning candles, spinning optical wheels and ticking clocks have each made an appearance in this visual storyteller's highly symbolic work. A wooden frame—boldly treated with plaster, distressed to simulate decay, then painted with gold leaf—often completes the picture. As a finishing touch, von Buhler uniquely signs each of her works with a custom designed wax seal that is adhered onto the painted surface with glue.

Von Buhler's studio is as compelling as her work. Its ruby walls, red velvet curtains and antique theater seats establish an intimate setting. Lit by a black wrought-iron chandelier, the room is filled with a mulitude of eclectic works. "The walls are lined with my paintings and unique objects such as a taxidermy peacock, a large gold cross sign from a missionary and a gold-painted deer head wearing a pearl," says the artist. "Other objects in the room include an enormous hourglass, a gothic dollhouse and a globe of the world which lights from within." While working, the artist listens to music and books on tape, mainly classic and historic novels. She finds the stimulation influences her work in an intriguing way.

An artist who loves to push boundaries, von Buhler recognizes that her work is in a constant state of flux. "My work is always changing," she says. "I started making static two-dimensional portraits, which later became three-dimensional. Then, living creatures and movement were added, interaction was later encouraged and now performance is being explored. I just love trying new things. It keeps me growing as an artist." As von Buhler's vision evolves, she sees herself pushing the envelope even further, adding elements of robotics and sound into her work. "I want to keep challenging myself," she says. "I feel as though I'm just bursting with ideas and new stories to tell."

"My work is always changing. I started making static two-dimensional portraits, which later became three-dimensional. Then, living creatures and movement were added, interaction was later encouraged and now performance is being explored. I just love trying new things. It keeps me growing as an artist."

Maestro Sartori Wants a Bit of Glory · Cynthia von Buhler

SIZE: 40" × 22" × 5" (102cm × 56cm × 13cm) / **MEDIUMS:** acrylic, gouache, gold leaf paint and plaster / **MATERIALS:** bull frog skeleton, wire and wax seal /
TECHNIQUES: sponging, dripping, sanding and assemblage / **SURFACES:** canvas with plaster-treated frame / **CLIENT:** Clive Barker and Zehrapushu

kinetic accents

One way to encourage viewer interaction with one's work is by adding kinetic accents. Unlike static pieces of assemblage, live and electronically-powered add-ons create a dynamic sensory experience. Real and moving objects captivate, engage and pique interest. The spontaneity of time, energy, light, motion and sound make for powerfully provocative storytelling. In this demonstration, multifaceted artist Cynthia von Buhler uses aging, distressing, rubber-stamping, custom constructs and a caged, live dove to illuminate the soul of her highly symbolic portrait of peace, love and tolerance.

MATERIALS

Pre-primed cotton duck canvas
Heavy-duty stretcher strips with a center support brace
Aspen wood
Pine wood: 2" × 4" (5cm × 10cm)
White sketch bond paper
Cardboard

Acrylic paint: Lamp Black
Gouache
Graphite pencil
Plaster of Paris
Oil and latex-based gold leaf paint
Wax

Natural and household sponges
Fan brush
Soft synthetic brushes: flat and round
Roman numeral rubber stamps
Custom seal
Spray bottle
Cotton rag
Putty knife
Painter's tape
Bird cage, wire and latch
Wire cutters and pliers
Metal straightedge
Craft knife
Pencil
Scissors
Wood glue
Screws and nails
Wire
Sandpaper
Candle and matches
Live dove

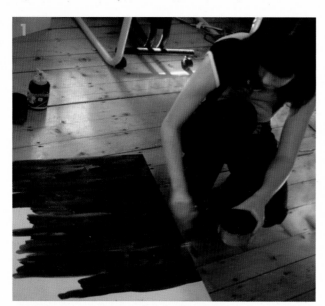

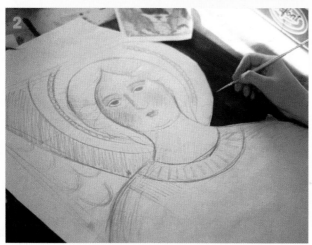

1 Preparing the Surface

To establish the working ground, primed cotton canvas is stretched over heavy-duty stretcher strips with a brace in the middle for additional support. The overall size of the piece is determined by the size of the live dove to be used later as an accent. The canvas is toned with a transparent mixture of Lamp Black acrylic paint and water, applied with a large brush.

2 Transferring the Composition

A sketch is made on white bond paper. The graphite drawing is cut into pieces and used as a stencil to transfer the composition in black gouache onto the toned canvas.

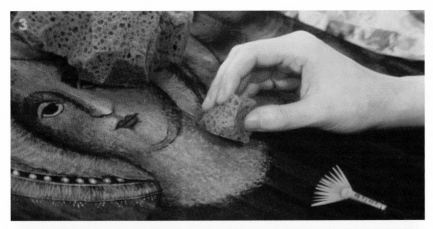

3 Laying In Color
With sponges, a fan brush, various soft synthetic brushes and a rich jewel-toned gouache palette, the painting is built in thin layers.

4 Aging and Distressing
To age and distress the surface, the painting is sprayed with water, dribbled with paint from a brush and lightly sanded. The process is repeated until the desired results are achieved.

5 Incorporating Typography
The working surface is broken up into sections and masked off using painter's tape. Latex-based gold leaf paint is loosely applied to rubber stamps and printed directly onto the canvas surface.

6 Penetrating the Surface
Using a metal straightedge and a craft knife, a hole is cut into the back of the stretched canvas. A box made of aspen is assembled, placed into the hole and adhered to the painting's stretcher strip framework in the back. Lamp Black acrylic is opaquely painted onto the interior of the box. To create a perch, a pencil, with both ends cut off, is painted gold and inserted into holes that have been drilled into both sides of the wooden box.

7 Constructing the Cage Door

A cage door is created using wire cutters, pliers and wire from bird cage parts. Once assembled, it is painted gold and attached to the wooden box using nails and wire. The door should swing open and closed without catching. A latch is added to fasten the door shut.

8 Creating the Frame

Using pine, an outer frame is created and plaster is boldly applied to it using a putty knife. Before it dries, a small piece of cardboard is dragged along the surface, removing some patches of plaster, giving the frame a worn, aged look. Once it is thoroughly dry, the plaster frame is painted with gold leaf latex paint and left to dry. Type is added using rubber stamps and an oil-based gold paint. Since one of the gold paints is matte and the other is glossy, they complement each other well. When complete, the frame is screwed into the stretcher strips of the base art.

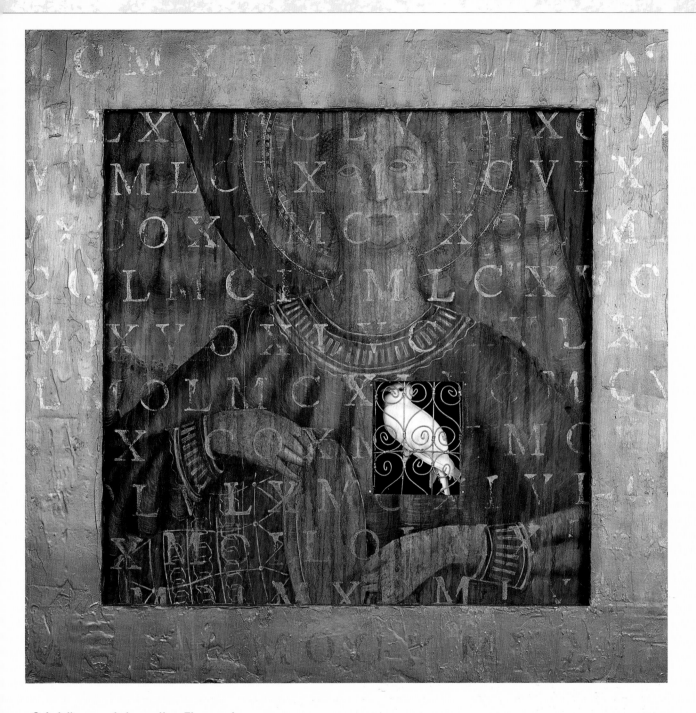

9 Adding an Interactive Element

To bring a kinetic flair to the work, a live dove is placed in the cage. The finished painting is uniquely signed using wax that has been heated with a candle, embossed with a custom seal and glued onto the painting surface with wood glue. For reproduction purposes, a 4" × 5" (10cm × 13cm) transparency is shot of the piece in the artist's studio. Entitled *Angel With Dove*, the piece was created for Sony Records as a cover for a classical CD called *A Christmas Legend: Resonet in Laudibus*.

"I'm exploring movement, interaction and performance to intensify my work, making it more visceral and emotionally-charged."

Robert Maloney:

deconstruction AND reconstruction

As a city's urban landscape becomes revitalized, the old fades and the new surfaces. With reconstruction comes deconstruction. If you look deep into the redevelopment process, you will see hints of what once was. A decayed framework, worn and tattered materials and scattered fragments remain as remnants. It is within the dust and debris that artist Robert Maloney finds inspiration. "I am very attracted to architecture and construction sites and like the idea of capturing the feeling of transition. Many of my pieces straddle the line between a structure being torn down and one being erected," says the artist. "I like to think of my work as a twenty-first-century archaeological dig, where decades of accumulated imagery and information are piled, layer upon layer."

Maloney's dimensional constructs bring together urban detritus and fragmented imagery to create an alternative arrangement, one that often projects out from the picture plane. To create depth and interest, the artist often alters the topography by separating his working surface into sections, positioning each part at varying heights. Perspective gives away to the ambiguous shifting of geometric planes, drawing the viewer into the work. "I really like the way a three-dimensional piece breaks up the light on the surface plane and the way it changes as you walk past it," says Maloney.

"Many of my pieces straddle the line between a structure being torn down and one being erected. I like to think of my work as a twenty-first-century archaeological dig, where decades of accumulated imagery and information are piled, layer upon layer."

Z · Robert Maloney
SIZE: 24" × 24" × 3½" (61cm × 61cm × 9cm) / **MEDIUMS:** ink and acrylic / **TECHNIQUES:** digital manipulation, digital image transfer, collage and assemblage / **SURFACES:** wood and Masonite / **COLLECTION:** private collection

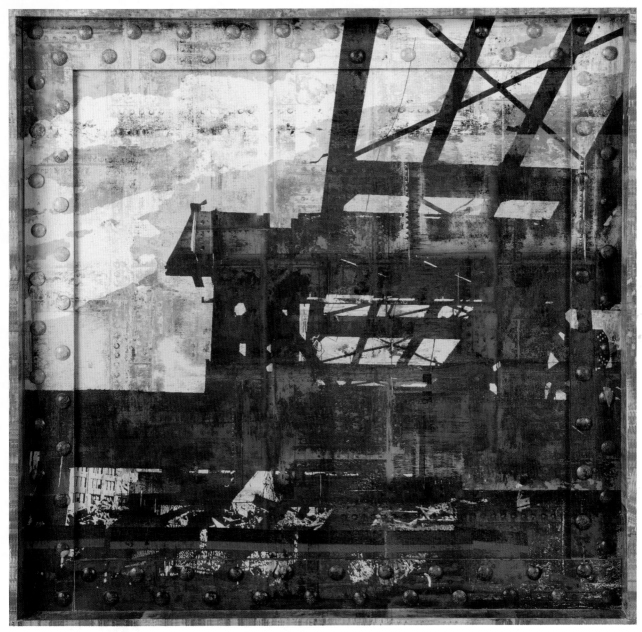

Coming Down · Robert Maloney
SIZE: 24" × 24" × 3½" (61cm × 61cm × 9cm) / **MEDIUMS:** ink and acrylic / **MATERIALS:** upholstery tacks / **TECHNIQUES:** digital manipulation, digital image transfer, collage and assemblage / **SURFACES:** wood and Masonite / **COLLECTION:** Karl and Teryn Wentz

"Some of my dimensional trademarks are faux support beams, slotted windows and bolted structures." For Maloney, every surface presents a new opportunity to express his vision. "I like to treat the segments that are viewed from the sides, top and bottom by coating them with layers of complementary colors, later sanding or scraping into them to reveal the layers below," explains the artist. "I also like to treat areas with old sewing pattern tissue, giving the surfaces a warm, aged look." To further add color, texture and visual interest, Maloney uses collage, digital image transfer and silkscreen printing in a layered fashion. "I like the effect that layering has," he says. "Some imagery bleeds through while others do not. It is similar to the way memories

and thoughts penetrate subconsciously in our minds." Because of the labor and drying times involved, the artist often works on several pieces at once.

For Maloney, coming up with the idea that will launch a single work or inspire a series is often trial and error. Digital sketching usually ignites the process. "On the computer, I can see what something might look like. I can add a simulated cast shadow from a surface plane, faux support beam or bolt," he explains. Using digital means,

Maloney feels free to experiment with an unlimited number of possible solutions before he commits to any direction. The artist will also glance through the vast array of pilfered debris, signage, textures and objects that fill his studio to see what may stimulate his creative juices. "I'm sort of a visual pack rat," admits Maloney. "I have drawers full of found and created scraps of textures. I also have clippings from magazines, photos of construction sites and machinery, old billboards and interesting aerial photos hanging on the walls."

Experimentation and the willingness to take risks is something Maloney embraces wholeheartedly. "If something isn't working, I'll just take a file or piece of sandpaper and grind away at it just to see how I can alter what I am doing," he says. "Sometimes the result ends up in the trash, but on the other hand, some of my most successful works have been things that were almost discarded experiments had I not taken them to the next level." It is the artist's willingness to take chances at any turn that has allowed him to continually push his work forward, straddling the edge between deconstruction and reconstruction.

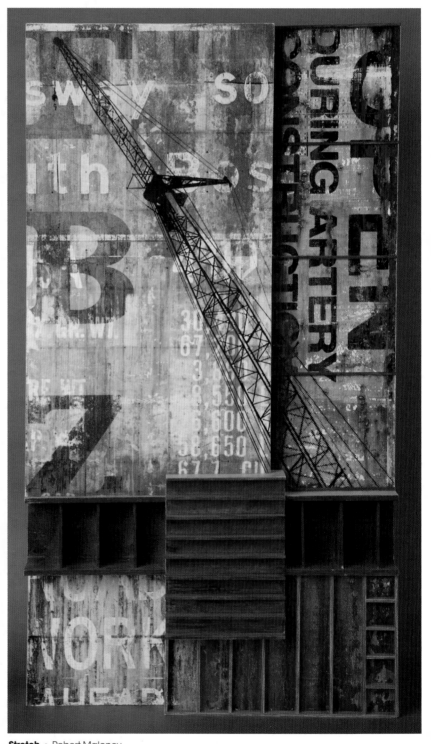

Stretch · Robert Maloney
SIZE: 30" × 16" × 6" (76cm × 41cm × 15cm) / **MEDIUMS:** ink and acrylic / **MATERIALS:** wood and Masonite / **TECHNIQUES:** digital image transfer, collage and assemblage / **SURFACES:** wood and Masonite / **COLLECTION:** the artist

signature constructs and add-ons

Unique constructs create a provocative, dynamic environment, as shifting light or different vantage points reveal a new image each time a work is viewed. Unconventional materials, surfaces and techniques can help an artist achieve distinctive effects. In this demonstration, artist Robert Maloney uses digital image transfer techniques, carving, silkscreen printing, scratching, scraping, collage and resists on a variety of surfaces to construct a multilevel, signature work.

MATERIALS

Océ FCPLS4 transfer film or DASS transfer film
Lauan plywood : 48" × 96" × ¼" (122cm × 244cm × 6mm)
Aspen wood: ½" (13mm) and ¼"(6mm)
Masonite: ⅛" (3mm)
Hardwood: ¾" (19mm)
Ink-jet transparency film
Plexiglas
Vintage sewing pattern tissue
Old maps, charts and magazine clippings

Acrylic gloss medium
White gesso
Acrylic paints: Yellow Ochre, Cadmium Red, Phthalo Blue, Titanium White and Ivory Black
Graphite pencil
Speedball permanent acrylic screenprinting ink: white
Diazo Emulsion Kit and silkscreen printing screen
Clear acrylic spray coating
Petroleum jelly
1½-inch (38mm) bristle brush
Palette knife

Wood glue
Wood filler
Craft knife
Masking tape: ¾" (19mm)
Blue plastic fine line tape
Straightedge
Razor blade
Nails and round upholstery tacks: ¼" (6mm)
Sanding block and sandpaper: 120-grit
Squeegee
Cotton cloth
Adobe® Photoshop®
Ink-jet printer and scanner
Drilled block of wood
Saw
Spray bottle
UV light source

1 Creating Digital Image Transfers

Using Photoshop, a compositional layout is created, layering texture, image and text. The design for the upper-right quadrant is printed out in reverse onto sheets of Océ transfer film in small manageable sections using an ink-jet printer. A piece of Masonite is cut, sanded and painted with several layers of gesso. Once it is dry, it is sanded smooth and sealed with a layer of acrylic gloss medium. Water-thinned acrylic gloss medium is then applied to the primed Masonite, and the sheets of transfer film are rolled onto the wet surface using consistent pressure.

2 Completing the Transfers

After the transfer film has set for a few minutes, one corner is lifted and peeled back. If the backing material comes off clear, the image has been successfully transferred and is left to dry. This process is repeated until the upper-right quadrant is completely transferred. To seal the surface, a clear acrylic coating is sprayed on top. Proper ventilation and protection is necessary when spraying.

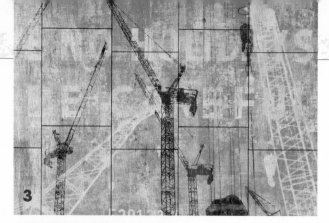

3 Scoring the Surface

To mimic the look of an old warehouse door, a vertical and horizontal pattern is scored into the surface using a craft knife and a straightedge. The narrow channels are carved out with a knife, masked off with blue fine-line tape and painted in with Ivory Black acrylic paint.

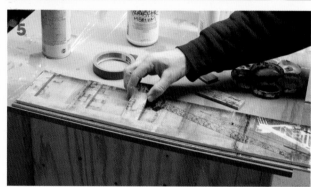

4 Building the Sides

A hardwood framework with a center support is made for the back of the upper-right quadrant. It is placed behind the base art and attached using wood glue. Once this is dry, an additional bead of glue is applied to the inside of the framework to reinforce it.

5 Adding Girders

For the upper-left quadrant, a ¼" (6mm) sheet of aspen is cut into various pieces. They are sanded, primed with several layers of gesso and sealed with acrylic gloss medium. The same digital transfer process that was used in the upper-right quadrant (steps 1 and 2) is repeated. Once dry, the girder sections are attached to the base art using wood glue.

6 Preparing Accents

Upholstery tacks are trimmed on the bottom, temporarily placed into a drilled block of wood, sanded on the top and primed with gesso. When this is dry, an underpainting is established using several layers of transparent acrylic washes: Yellow Ochre, Cadmium Red and Phthalo Blue. Next, several coats of a mixed light green are applied on top of the tack heads, allowing some of the underpainting to come through. Holes are drilled into the base art and the faux bolts are inserted and attached using wood glue.

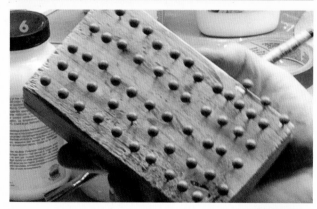

7 Creating a Faux Finish

To create the rustic faux finish in the lower-left corner, a piece of lauan is sanded but not primed. A digitally manipulated image made from several details of rusty surfaces is printed in reverse onto transfer film and directly imprinted onto the raw wood surface. Once this is dry, several coats of clear acrylic spray are added to give the surface an almost glasslike finish. A solid hardwood framework backs the base art. Always use proper protection and ventilation when spraying.

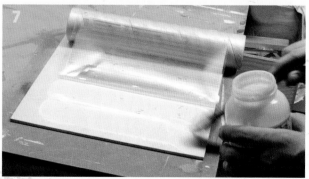

8 Raising the Surface

For the lower-right section, a ½" (13mm) thick piece of aspen is cut into seven strips at a 45-degree angle on two sides, making the pieces wider at the base. The right and left outer pieces are cut flush on the outside edges. The strips are then glued onto a base using wood glue. As a primer, several coats of gesso are applied to all the surfaces.

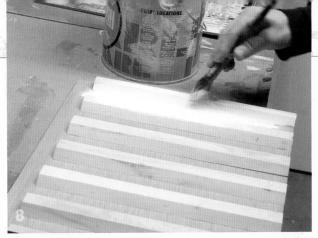

9 Using Collage

Vintage magazine clippings are adhered to the surface with acrylic gloss medium. Washes of Yellow Ochre, Cadmium Red and Phthalo Blue acrylic are applied as an underpainting. Opaque layers of a mixed neutral blue acrylic are then added on top. Before the paint thoroughly dries, it is scraped back using a piece of cardboard to reveal the warmer layers underneath. A razor blade and sandpaper are employed to scratch back into the surface once it dries.

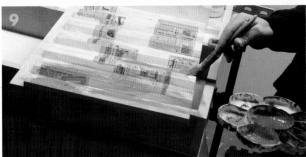

10 Silkscreen Printing

Text from an old mechanics ad is scanned into the computer and printed out onto transparency film. A silkscreen is coated with a photo emulsion using a squeegee and left to dry. The screen is exposed to a UV light source and washed out, leaving a text-based image available for printing. A silkscreen print is run on top of the corrugated raised surfaces of the lower-right quadrant, using white ink to add contrast. Paper is used to blot any excess ink. Once this is dry, sandpaper is used to further distress the surface.

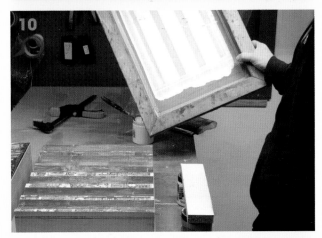

11 Building the Foundation

A 30" × 40" (76cm × 102cm) piece of lauan is sectioned off using a graphite pencil, marking the various quadrants of the piece.

12 Treating the Edges

The side of the upper-right quadrant that will face the girder section is primed and treated with several collage layers of vintage sewing pattern tissue adhered with acrylic gloss medium. Light sanding cleans up any raw edges. Masking tape helps to protect the top surface.

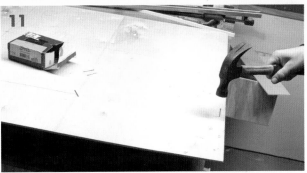

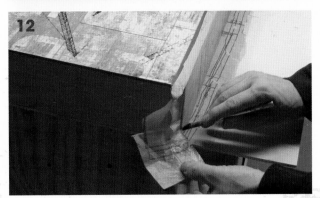

13 Adding Connectors

Connector slats are primed and treated using a digital image transfer process (steps 1 and 2). After being sealed with clear acrylic spray, the pieces are added to the girder section using wood glue.

14 Assembling the Piece

Both the upper and lower quadrants are glued to the base using wood glue. Weight is put on top for better adhesion. Once this is dry, the constructs are permanently nailed to the base art in the back. To fill in any gaps, wood filler is applied with a palette knife. When dry, the surface is sanded smooth and touch-ups are made using acrylic paint.

15 Creating Faux Windows

Sheets of aspen wood ¼" (6mm) thick are cut into pieces to make the faux window panes. Vintage sewing pattern tissue is collaged onto the various surfaces using acrylic gloss medium. Each piece is glued into place with wood glue.

16 Adding More Transfers and a Resist

For the back panel of the slotted windows section, Masonite is cut to fit, primed with gesso and sanded smooth. Acrylic gloss medium is applied on top as a transfer medium. Various fragments from old maps and charts are placed image-side down onto the wet surface. Once it completely dries, the transfer surface is sprayed with water and the paper is rubbed away until the image appears. This process is repeated several times, using acrylic gloss medium to seal the surface after each transfer. When this is dry, masking tape is used to divide the vertical piece into sections. Using a palette knife, petroleum jelly is applied as a resist. Red acrylic paint is applied on top and left to dry. A cotton cloth is used to remove the petroleum resist. The masking tape is removed and the finished art is glued into place using wood glue.

17 Adding Transparent Layers of Text

Three pieces of Plexiglas are cut to size and silkscreen printed with text patterns. Horizontal tabs are treated with vintage sewing pattern tissue and glued in place, separating and securing each piece of Plexiglas in place to form a transparent layering of text.

18 Treating the Sides

With a brush, several layers of gesso are applied to all four sides. For the final coat, a palette knife is used to provide texture. Vintage sewing pattern tissue is added on top using acrylic gloss medium and a brush. With the front area protected from dust, the sides are sanded to allow some of the gesso texture to come through.

19 The Finished Work

A final coat of acrylic gloss medium helps to seal the surface of the finished piece, which is entitled *Never Over*.

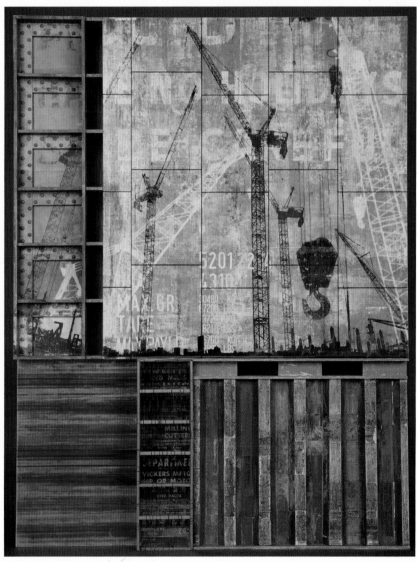

Susan Leopold:
artistic dialogue

For creativity to take flight, one has to free one's mind of preconceived notions, completely immersing oneself—mind, body and soul—into the process. When one is in harmony with the creative spirit within, clarity, insight and understanding are robustly acute and work flows in a free and almost effortless way. For three-dimensional artist Susan Leopold, pure psychic automatism guides her hand to reveal a symbolic, highly tactile pictorial idiom. "The process of touching, playing and manipulating opens some gateway for me, spurring on my creativity," says the artist. "I get into what is called *flow*, which for me is like a dialogue or dance. I put something down and then

Valentine · Susan Leopold
SIZE: 4½" × 5" × ¾" (11cm × 13cm × 2cm) / **MEDIUM:** acrylics and water-soluble crayon / **MATERIALS:** photography, postcard, post-consumer goods, found paper ephemera, fabric, thread and handmade paper / **TECHNIQUES:** painting, stitching, collage and assemblage / **SURFACE:** handmade paper / **CLIENT:** *Traditional Home* magazine

the piece tells me what to do next. When I'm really tuned in, something fresh and unexpected occurs."

Leopold's visceral approach relies heavily upon trust and having faith in the process. "Working with materials like handmade paper is like riding a wave. You think you can control it but it will outdo you each time," she says. "So, by understanding the natural properties of the material, I've found ways to somewhat harness it, but it still always surprises me and I love that." For Leopold, the natural life force inherent in every material creates a unique tension that she finds fascinating. "You see the work form in real time and watch it shape into something that was not there before, especially when it was wet. It transforms right before your eyes and I think that people relate to that on some level."

In Leopold's distinctly handmade work, processes such as carving, molding, etching, scratching, wrapping, sculpted embossing, encaustic, image transfer and stitching work in tandem with a diverse range of materials from handmade paper and woven fabric to distressed wood, found metal and glass. "Texture is a primary factor in what I do and the sense of touch has always been implicit in my work," notes Leopold. "I love things that are imperfect, raw-edged and torn. When I am adding surface detail, I am right up close to every inch of the piece, getting physically connected to the materials." Through a process of arranging, rearranging, destroying and blending, Leopold's work reveals itself. To keep her approach fresh, the artist constantly challenges herself. "Sometimes, I will put something down just to throw off the composition," she says. "Ultimately, I know that whatever problem or tension I create on canvas, wood or fabric, I can eventually resolve."

The manipulation of materials and techniques employed in Leopold's artistic oeuvre convey much more than just a provocative tactile sensation. Beyond their explicit texture and three-dimensional form, Leopold's sculptural works tease the boundaries of space to create multiple layers of meaning. They transcend their physical presence to establish a direct connection with the viewer—one that often is universal in nature. "We all have sense-based reactions to things, like body memories that go back to childhood," explains Leopold. "When it comes to materials, fabric and paper, for instance, can look like skin—evoking the human body in the mind of the viewer. In addition, certain processes can also communicate. Tearing can feel quick and violent while laborious techniques, such as intense stitching, obsessive mark-making or wrapping, can convey something much more refined, such as the passing of time." Over the years, Leopold has become acutely sensitive, consciously recognizing her own innate responses to the materials, objects and processes she uses in her work. When she needs to, she draws from her vast memory bank.

Leopold's vast collection of vintage objects and nostalgic mementos are a tribute to their heritage. "I am drawn to materials that reflect their history and I have a

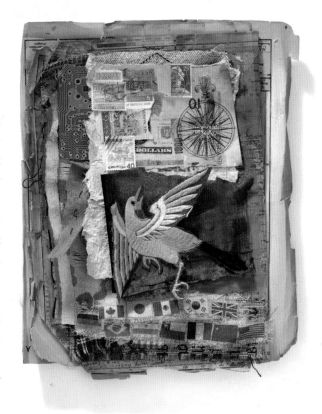

Bird · Susan Leopold
SIZE: 11" × 8½" × 1" (28cm × 22cm × 3cm) / **MEDIUM:** water-soluble crayon / **MATERIALS:** metal, circuit board, various fabric, handmade and commercial papers, old maps, embroidered bird, currency, stamps and wire / **TECHNIQUES:** digital composite, stitching, collage, photo transfers and assemblage / **SURFACES:** fabric and paper / **CLIENT:** Deloitte & Touche

"I get into what is called *flow*, which for me is like a dialogue or dance. I put something down and then the piece tells me what to do next. When I'm really tuned in, something fresh and unexpected occurs."

tendency to hoard the special things I find," she says. "Most of what I use in my work has been picked up before I had any real idea how I would use it. It's like finding little parts to a puzzle that I can't really see but know will ultimately come together. I love this mystery and I trust my eye as well as my instincts." Much of Leopold's work is cross-cultural in nature. "I've done a lot of traveling to different countries and enjoy all of their various rituals and art forms," says Leopold. "I am very fascinated by the symbolism that exists and use it in my work."

For Leopold, the ambiguity that is always present in her art provides a sense of mystery and intrigue. "My approach mimics the way the mind works, exploring the dynamics between the past and present," she explains. "My images are disjointed and I am drawn to outrageous juxtapositions where elements come together out of context, much like the mind's replay of the past." By leaving the door open for personal interpretation, Leopold's incomplete narratives entice viewer participation, continuing the dialogue that began during the work's conception.

"My images are disjointed and I am drawn to outrageous juxtapositions where elements come together out of context, much like the mind's replay of the past."

Unity · Susan Leopold
SIZE: 8" × 8" × 2¼" (20cm × 20cm × 6cm) / **MEDIUMS:** acrylic, watercolor and ink / **MATERIALS:** wood, beads, cord, wire, fabric, raffia, waxed linen thread and glass / **TECHNIQUES:** wrapping, carving, scratching, ink rub-off, etching with Dremel tool and assemblage / **SURFACES:** wood, mirror back, brass frame and fabric / **CLIENT:** *Discipleship Journal* magazine

sculptural and tactile surfaces

Every material has natural properties and inherent characteristics that make it unique. The way something dries, bends and moves through space makes working with it a true process of discovery. Throughout this demonstration, artist Susan Leopold explores her affinity for organic materials and textures. Using papermaking techniques, dyeing, molding, wrapping, rubbing, encaustic and stitching, the artist builds a one-of-a-kind sculptural creation.

MATERIALS

White cotton linters
Reusable, absorbent kitchen wipes
Woven fabric
Cardboard
Old letters of correspondence
Waxed linen thread and dental floss

Acrylic paints
Acrylic matte medium
Wax blocks and encaustic medium and paint
Fabric stiffener
Prismacolor NuPastel Color Stick: blue
Water soluble crayons
Carriage House Paper Aardvark Colors (dyes)

Plastic Fluorescent lighting grid
Old woodblock with Buddhist text
Blender (dedicated for papermaking)
Vintage glove hand-mold and rubber glove
Soft flat brush, hake brushes and metal spatula
Spray bottle
Craft knife
Scissors
Hot plate with temperature gauge
Stainless steel pans
Cloth
Sealable plastic bags
Tape

1 Preparing Paper Pulp

To give the piece a signature look, custom paper is created. Sheets of white cotton linters are soaked in water until they are soft and can easily be pulled apart. The linters are then placed in a blender with just enough water to make it spin smoothly, creating a malleable pulp. For color, dye is added. To produce a custom two-toned sheet (*duplex*), two colors are created: yellow for the inside and a muted green for the outside. Proper protective gear and adequate ventilation is used.

2 Making the Paper

The yellow pulp is poured onto a dampened household cloth laid on top of a plastic grid. A wool blanket is placed underneath to absorb excess water. A sponge is used to help shape the pulp into paper. Green pulp is added on top of the yellow to create the custom duplex. Depending upon humidity, it may take a full day before the paper can be molded without falling apart.

3 Sculpting and Shaping

Before it permanently dries, the paper is shaped into a cradle-like form. Folded cardboard serves as a support. The surface is sprayed lightly with water to keep it malleable. When the working day is done, the sculpted paper is kept moist in a sealed plastic bag to allow further manipulation later on.

4 Preparing the Mold

To create the hand, a vintage glove-making form is used. A rubber glove is placed over the form so that it can be easily released once the piece is complete.

5 Wrapping the Hand

Old letters are cut into strips with a craft knife and wrapped around the rubber-covered glove-making form. Since nothing will permanently adhere to the rubber, the first few strips are temporarily taped on, forming a base. The rest are applied using acrylic matte medium. Each finished layer is coated with fabric stiffener to create a firm support. Only three-quarters of the hand is wrapped, leaving parts open for establishing a connection with the outer cradle form later on. The fingers are left irregular to give the work an organic, chrysalislike feel.

6 Creating the Butterfly

Butterfly wings are cut out of paper and wrapped using the same process as the hand in step 5. For the body, an armature is created using waxed linen thread, where multiple layers of the same red thread are wrapped around to form the head, thorax and abdomen. The wax covering on the thread aids in establishing smooth transitions. Color is added to the butterfly using acrylic paint and water-soluble crayons.

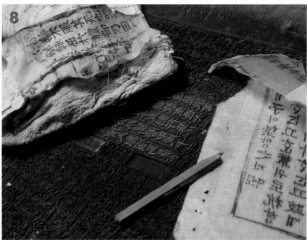

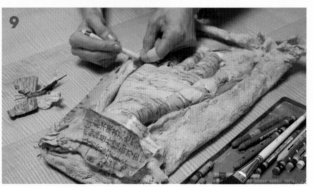

7 Adding Encaustic

Blocks of wax, encaustic medium and encaustic paint are melted in stainless steel pans on a hot plate set on medium heat, not exceeding 250°F (121°C). Paper is covered in encaustic wax using hake brushes and a metal spatula to produce smooth transitions. While still wet, the paper is manipulated into the desired shape. Proper ventilation and protection is used.

8 Rubbing the Woodblock

The encaustic-covered paper is placed over an ancient Buddhist text woodblock and rubbed with a blue Nupastel stick until the type is revealed. The wax encapsulates the dry pigment, darkening it in an almost antique fashion. The rubbing is then further sealed in encaustic.

9 Assembling and Embellishing

The cradlelike form is lined with a piece of stained and torn woven fabric. Using water-soluble crayons, the entire piece is embellished with color. The glove-making form and rubber glove are removed and all of the elements are secured together with waxed linen thread and dental floss.

10 The Finished Work

The finished piece, entitled *The Artist's Hand*, suggests a new creation rising from its formative chrysalis.

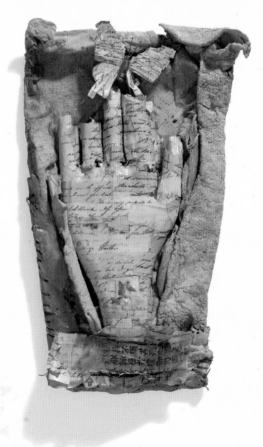

recasting
the everyday

Every object has a history, a cycle of life and death. It's created, serves a purpose and then spends eternity in a vast sea of unwanted debris. This wasteland of expired treasures—decayed, broken and disassembled remains of bygone eras—fuels the art of painter and sculptor A.E. Ryan. She rescues the unwanted trinkets of time, repurposing them into her esoteric assemblages of the trivial and the wondrous.

From her collection of reclaimed materials and objects, a gestalt idea ignites within. Certain elements take on a leading role, while others act as supporting characters in Ryan's fragmented narratives. "There is always one thing that starts me off and then I work to create a balance between texture and form," she explains. "The piece just evolves from there." Intrigued by the challenge to resolve, Ryan intuitively layers her highly textural materials and found objects, allowing the relationships that occur to guide her throughout the process. The subconscious works in tandem with the conscious to unfold the dimensional image. For inspiration, the artist draws from medieval, gothic and early Renaissance art and architecture. The works of the Lorenzetti brothers, Duccio di Buoninsegna and the Sienese painters are a big influence. "Their art, to me, seems very sculptural even though it is really quite flat," says Ryan. She also sees an affinity with the artists of the Surrealist movement. "I like how they felt free to alter scale and plane as a provocative way to get the viewer in." To energize her creative muse, the artist travels twice a year. She loves to go to Italy and revels in the area's architectural details, sculpture and religious art.

For Ryan, the search for obscure objects and materials is an ongoing process. The artist will often go to yard sales, junk stores, frame shops, cake decorating establishments and woodworking outlets in her quest for new textural surfaces to play with. "My work is a celebration of found objects, and I'm a junkie for materials. I'll even walk around the street looking for stuff," she admits. "People also give me some pretty interesting pieces." Ryan finds that she is most often drawn to objects of antiquity. "There is something about an aged surface that seems so delicious and seductive," she says. "My eye is always on the lookout for decorative woods, like the back of a broken chair that has some really nice carving on it. I also love old and rusty metal parts, ceramic tile, plastic objects, rubber and shattered glass."

Ryan's work, a synthesis of both painting and sculpture, is very labor intensive. Her studio is much like that of a highly skilled carpenter, as the structural engineering that combines the pieces into a whole is crucial. To keep each element in its proper position in the three-dimensional composition, the artist will nail, screw, glue, peg, hook and wire the pieces in place. "Over the years, I've learned a lot about construction and have gotten wiser about how to proceed from A to B," says the artist. "Much of my work is problem-solving. It's part of the joy and the frustration." Ryan almost never

"My work is the antithesis of slick, and I like it that way."

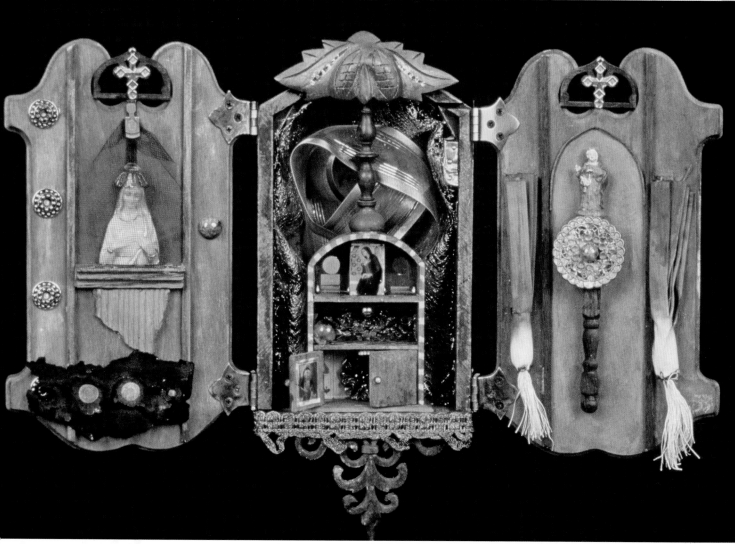

And The Ladies Lunched on Leeks · A.E. Ryan

SIZE: 13" × 17" × 8" (33cm × 43cm × 20cm) / **MEDIUMS:** acrylic, ink, oil stick and wood stain / **MATERIALS:** rubber, silk and paper leeks, dollhouse furniture, ribbon, decorative trim, wood, brass, ceramic, buttons, fabric mesh and a plastic statue / **TECHNIQUES:** assemblage of sanded, painted and stained found objects that are glued, screwed or wired in place / **SURFACES:** wood and hinges / **COLLECTION:** Franklin Blanchard and Judith Coughlin

uses any of the assemblage elements she finds in their purely natural state. Instead, she likes to alter, age and distress the surfaces, bringing them in line with her own vision. The artist often applies acrylic gel medium to decorative trims, ribbons and fabric to make them rigid, simulating the feel of decorative molding. Acrylics, inks, oil sticks and wood stains may be applied to found objects with a rag or brush and then wiped off to create interesting patinalike effects. The artist will also sand, scrape or apply crackle varnish to a surface, aging and distressing it. "To alter a surface, I'll even spray saltwater on it and let it sit outside for a while to rust," she says. "My work is the antithesis of slick, and I like it that way."

Ryan's elaborate, arch-framed reliquaries position the ordinary next to the praised, revealing the artist's wry sense of humor. Commonplace objects of everyday life such as electronic parts, dollhouse furniture and kitchen utensils are unexpectedly juxta-

"Over the years, I've learned a lot about construction and have gotten wiser about how to proceed from A to B. Much of my work is problem-solving. It's part of the joy and the frustration."

posed next to religious statuary, prayer beads and church relics to create imaginative, ambiguous spaces with unexpected visual content. "There is a kind of game that goes on in my work, and I love it when people get it and perhaps see even more," says the artist. A clash of the magical and the mundane, Ryan's work fuses to become a window through which the viewer can look into a world filled with irony.

"There is a kind of game that goes on in my work, and I love it when people get it and perhaps see even more."

St. Anthony of the Dry Kits and Bottles · A.E. Ryan
SIZE: 25½" × 10" × 3½" (65cm × 25cm × 9cm) / **MEDIUMS:** acrylic, ink, oil stick and wood stain /
MATERIALS: photo reproduction of dry kits, frame, ginseng bottles with ginseng inside, old map, decorative and fabric trim, metal, wood, glass, mirror, clock parts, electronic supplies, bicycle reflector and old stove parts /
TECHNIQUES: altered xerography and assemblage of sanded, painted and stained found objects that are glued, screwed or wired in place / **SURFACE:** old wood serving tray / **COLLECTION:** the artist

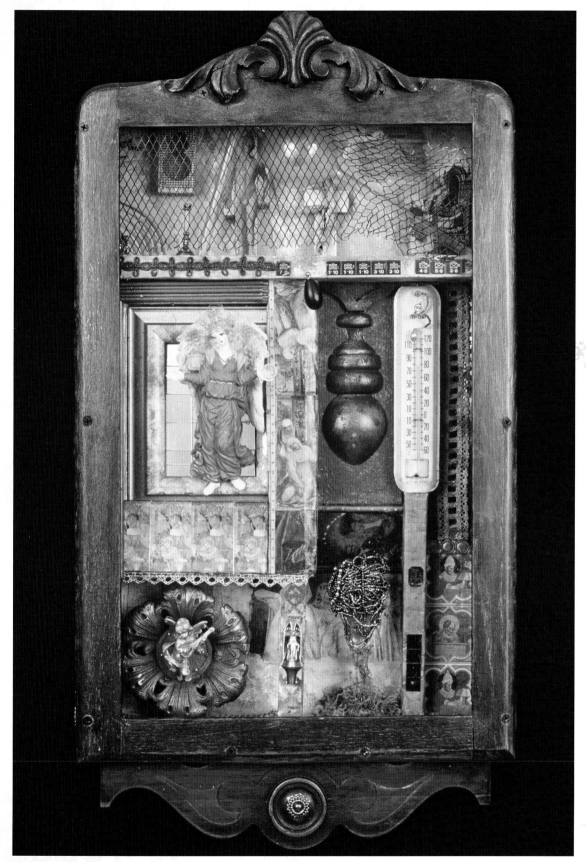

Forsooth. What's a Girl to Do? · A.E. Ryan

SIZE: 27" × 14½" × 4" (69cm × 37cm × 10cm) / **MEDIUMS:** acrylic, ink, oil stick and wood stain / **MATERIALS:** box, glass, thermometer, metallic photograph, puppet hair, decorative trim, eyelashes, metal, fabric, plastic angel, cocktail glass with tiny sparkle beads, wire mesh and glass tube / **TECHNIQUES:** collage and assemblage of sanded, painted, and stained found objects that are glued, screwed or wired in place / **SURFACES:** wood frame screwed into a fabricated wood box / **COLLECTION:** the artist

the digital
realm

Creatives are exploiting the digital environment to broaden their artistic vision. With each technological advancement, new possibilities in art-making are being brought into the ever expanding visual vernacular. The sophistication of computer graphics software and hardware has allowed artists to experiment as never before. A multimedia mindset is at the forefront.

For most artists, integrating both traditional and electronic processes is the predominant direction. Through experimentation, many have found that solely relying on the computer leads to a homogenized aesthetic. However, when combined with traditional approaches that employ the unique signature of the human hand, computer-generated art can break away from its anonymous roots to become more personal and distinctive. Many see the creative mining of both traditional and digital approaches as a way to honor the past while staying in the vanguard of modern pop culture.

Digital artists who embrace both classic and electronic media enter into the creative process in different ways. Some begin in a more traditional manner, producing hand-drawn and painted elements that are then scanned into the computer and further manipulated. Others start digitally, altering photographs and combining them with scanned elements to create a base image that is later printed out onto a custom substrate and reworked using a variety of drawing and painting materials and processes. From classical to high-tech, an image can go through several transformations before the desired look is eventually achieved. One of the advantages of working digitally is that elements may be reused once they have been stored electronically. Like a collage artist, the digital creator will collect a vast array of texture samples, objects and images. Instead of warehousing the items, the artist of the digital domain brings everything into the computer, storing the collection for future use as files on a hard drive or on a series of portable storage devices. This practice allows elements to be recycled in numerous ways, changing the color, size or shape each time.

Artists are using digital cameras and scanners to import images in inventive ways. Imaginative still-life subjects may be imported into the virtual environment, so that natural and man-made elements are combined in surrealistic settings, then digitally photographed against lushly painted backdrops. To create unexpected abstract effects, creatives are bending and manipulating images and objects over a scanner. To achieve backlighting, digital-savvy artists can move a light source at the same rate of speed as the scanner's light above an object, removing unwanted shadows. Textures painted on glass can be scanned into the computer and easily wiped off, creating a new surface to work on without wasting paper, canvas or board in the process. Advances in desktop technology have also allowed artists to create custom lenticular add-ons, virtually animating the printed surface. Holographic images create depth, move, change color and morph into other things, enhancing the spatial acrobatics within the two-dimensional realm. To create intriguing effects, artists are grabbing from video and importing the sequential imagery into their work.

Gods and Monsters · Matt Manley
SIZE: 11" × 8" (28cm × 20cm) / **MEDIUMS:** oil and alkyd / **MATERIALS:** Crescent illustration board, broken tiles, old window frame, torn screen, wood, type, anatomical snake diagrams, alchemical engravings and passages from the Bible / **TECHNIQUES:** digital manipulation, digital collage and digital assemblage / **SURFACE:** archival ink-jet print on canvas / **CLIENT:** *Connecticut* magazine

Burunyika · Stephanie Dalton Cowan
SIZE: 10" × 20" (25cm × 51cm) / **MEDIUMS:** acrylic, ink, acrylic gel medium, charcoal, oil stick and oil pastel / **MATERIALS:** photogravure, astronomy book pages and postal ephemera / **TECHNIQUES:** digital manipulation, rubber stamping, tape resist, peeling back, sanding, and image and line art transfers / **SURFACE:** Arches 300-lb. (640gsm) cold-pressed watercolor paper / **CLIENT:** Murphy Design

The digital realm offers creatives great flexibility, allowing for seamless alterations, additions and edits throughout the creative process. The power of "undo," available in software programs, encourages experimentation free of risk—something that traditional practices could never offer. But with such freedom, a certain level of control is necessary. Artists can get so caught up trying every avenue that they can easily overwork a piece. The variety of options available on the computer can become a distraction, causing artists to lose sight of their original intent. The best digital creators have learned to use the computer as a tool to enhance their vision, not overpower it.

With the advancements in ink-jet printing technology, the digital image can move beyond cyberspace onto a plethora of porous and nonporous surfaces. Using an ink-jet printer with high head clearance and a straight paper path, almost any material can be printed on if it is sealed with an ink-jet-receptive coating. Commercial sealants such as inkAID or Golden's Digital Ground are available in clear gloss and matte white. Unconventional surfaces such as metal, tile, film, cork and plastic are being experimented on. By utilizing pigment-based inks onto archival surfaces, digital works can offer a high rate of longevity. With the addition of UV protective gels and sprays, the life of a work can be further extended.

Digital technology has certainly come a long way, working at higher speeds and yielding enhanced overall quality. The demand for more sophisticated processes has required software and hardware developers to continually revise, fine-tune and update their products at an unprecedented rate. Technology has not only become faster and more powerful but also more affordable, making it easier for artists to make the initial investment into the digital domain. Cross-pollination between the disciplines has expanded the possibilities for artistic expression, virtually revolutionizing the visual arts. Opportunities to be truly creative are seemingly limitless.

Matt Manley:

paradoxical rhythms

Throughout life, we are presented with great contrasts—such as good and evil, love and hate or war and peace—to which we carve out our existence. Such opposites and the symbolic, almost ambiguous relationships that exist between them excite artist Matt Manley and inspire him to create his metaphorical, mixed-media works. "I tend to be drawn to opposing themes but am not interested in showing the stark contrasts," says the artist. "Rather, I like to illuminate the more intangible, even paradoxical rhythms of life that exist between the poles. To me, the ambiguity is a much more accurate expression of life than any simplistic black-and-white point of view."

An avid scholar of psychology, mythology and alchemy, Manley gravitates toward concepts that challenge his mind as well as his brush and mouse. "There are recurring themes in my work, certain concepts that I find fascinating. Unwieldy, complex and even esoteric topics are more interesting to me than those that are relatively straight-forward, simple and easy to read," he says. "Making the intangible tangible can be both frustrating and rewarding at the same time. The challenge helps me grow and expand my visual and conceptual vocabulary." When establishing a direction in his work, Manley prefers to imply or hint at rather than be literal or overtly symbolic. "I find that mystery is much more interesting than explanation," he says. "The essence of an idea or concept is rarely concrete, leaving the door open for personal reinterpretation." His abstract, nonlinear approach to visual storytelling is almost lyrical in fashion. "Like a story, many of my concepts have a beginning, middle and end, but they're not neces-sarily shown in that order," he explains. "Sometimes they exist simultaneously."

Manley's subjective exploration of life's ambiguous contradictions begins outside the visual realm. Rather than sketch, the artist likes to enter into the process recording his thoughts in a journal. "Writing has always been my starting point," says Manley. "I write out my ideas, exploring concepts and describing potential compositions to myself." Authors Thomas Mann and James Joyce, poets T.S. Eliot and W.B. Yeats and composers Bach, Beethoven and Tchaikovsky are just some of the sources he seeks to stimulate his creative muse. "Exposure to different viewpoints opens my eyes to other possibilities," Manley adds. "I find it an enlightening exercise in imaginative expan-sion." While working, Manley often relies on his intuition. "I don't always feel that I'm entirely in control of my art. I'm the servant, not the master," he explains. "Quite often images and ideas come to me unbidden."

Although considered digital, Manley's art really exists between the realms of classi-cal and high-tech. A seamless synthesis of traditional drawing and painting on textured canvas and board combined with digital photography, collage and assemblage, the artist's work embraces the speed and exploratory power of digital innovation while maintaining the traditional philosophies that give the work a signature look. "By incor-porating elements of both new and old media, I can experience the past and the future

> "I tend to be drawn to opposing themes but am not interested in showing the stark contrasts. Rather, I like to illuminate the more intangible, even paradoxical rhythms of life that exist between the poles."

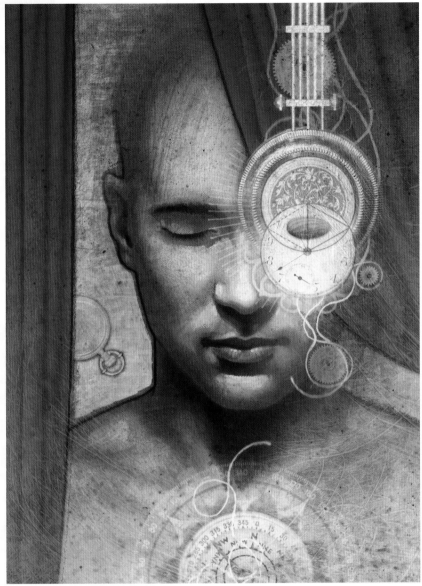

Time Within Time · Matt Manley
SIZE: 15" × 10¾" (38cm × 27cm) / **MEDIUMS:** oil, alkyd, graphite and digital photography / **MATERIALS:** canvas, paint on glass, pocket watch, gears, coarse twine, compass, dahlia flower, ornate brass medallion, almond, compass face, pendulum (photo) and curtains (photo) / **TECHNIQUES:** digital manipulation, digital collage and digital assemblage / **SURFACE:** archival ink-jet print on canvas / **CLIENT:** Brush Dance

all at once without giving up either one," says Manley. Using the computer, Manley is able to experiment and explore options that are just not possible using purely traditional means. "I paint with oils on glass, creating textures that can be easily scanned into the computer, wiped off and repeated several times quickly," he says. "For certain effects, I'll scratch into the painted glass with wire or a palette knife. I may also dribble thinner into the paint, spatter it or use acrylics, later scraping parts off the surface when it is mostly dry. It all depends on the feel I'm going for." To alter his mark-making, the artist avoids any off-the-shelf approach to painting and employs a number of old brushes that have been frayed, worn, altered and reshaped. The time-tempered tools provide irregular and unpredictable textures that Manley finds fascinating.

Incarnation 1 · Matt Manley

SIZE: 11" × 8½" (28cm × 22cm) / **MEDIUMS:** oil, alkyd and digital photography / **MATERIALS:** unprimed canvas, curtain (photo), key, watch, frames, rope, flower, keyhole and line art map of New York City / **TECHNIQUES:** digital manipulation, digital collage and digital assemblage / **SURFACE:** archival ink-jet print on canvas / **CLIENT:** *St. Anthony Messenger* magazine

To further break away from the rigidity that is often found in computer-generated art, the artist looks toward nature. Shells, leaves, tree bark, flowers and feathers are just some of the elements Manley has incorporated into his rhythmic compositions. Aged surfaces that have been distressed, sanded, dented, rusted, weathered, bent, peeled or stained have also found their way into the artist's subtly layered, highly symbolic works. To connect the various parts in an intriguing way, Manley utilizes curves, grids, typography and other line art and decorative accents, layering and blending in Photoshop to create one cohesive image. Every object, texture or graphic element in Manley's work is carefully chosen for its ability to illuminate the concept. Not until all of the various parts have been placed into their proper spatial relationships does the work's true meaning become apparent.

As an artist, Manley feels that experimentation is a necessary component of growth. He enjoys keeping his process fluid, adding an element of surprise each time. "I like changing gears as much as I can," says Manley. "It's all about learning, and to me the creative process is much more important than the image that results from it. Even a difficult struggle— or, in some cases, an outright failure— can be worthwhile if it reveals something about me or my work." By continuing to embrace his traditional roots, the artist is able to distinguish himself in the digital domain. "Most collage-oriented, digital work is heavily photographic and tends to be rather cold, and that's something I've tried to overcome through my slightly complicated combination of techniques," says Manley. "The warmth that I add to the digital process through my paintings and textures makes it distinctive." Working between the poles, Manley is able to draw from an array of perspectives, developing a vision uniquely his own.

"The essence of an idea or concept is rarely concrete, leaving the door open for personal reinterpretation."

Sad Time Stretching Before and After · Matt Manley
SIZE: 13" × 8½" (33cm × 22cm) / **MEDIUMS:** oil, alkyd and digital photography / **MATERIALS:** unprimed canvas, egg (photo), flower (photo), key, scissors, twine, frames, watches, compass, rusty paint can lid, text, maps, stars, Fibonacci spiral and sheet music / **TECHNIQUES:** digital manipulation, digital collage and digital assemblage / **SURFACE:** archival ink-jet print on canvas / **COLLECTION:** the artist

digital collage: from classical to experimental

Digital media offers a wide array of possibilities for the visual artist. When combined with traditional mediums, the digital image transforms, breaking free from its software-driven roots to become distinctive and signature in style. In this demonstration, artist Matt Manley combines the classical feel of traditional drawing and painting processes with the high-end capabilities of the digital environment to create a unique work of art.

MATERIALS

Cotton duck canvas (unprimed)
Printer paper
Acetate
Picture glass
Broken tile
Stained board
Butterfly
Various objects: key, flower and petals, peacock feathers, gears, rope, two compasses, wire bracelets, silver ring, tablecloth
Photos: teacup, black and white spheres, a keyhole and cube

Alkyd paint
Oil paint
Winsor & Newton Artists' Oil Painting Medium
Odorless mineral spirits
Acrylic gloss medium
Graphite pencils: 3B–5B

Sandpaper: 150-grit
Brushes: round and flat
Masking tape: 1-inch (25mm)
Flatbed scanner
Digital camera: 10.3 megapixels
Ink-jet printer
Adobe® Photoshop®

1 Drawing With Graphite

A line drawing is created in graphite on unprimed cotton duck canvas. When this is complete, the surface is sealed with two coats of acrylic gloss medium applied with a brush. Light sanding is done between each coat.

2 Establishing the Values

The values of the portrait are lightly blocked in using alkyd paint thinned with odorless mineral spirits in a well-ventilated area.

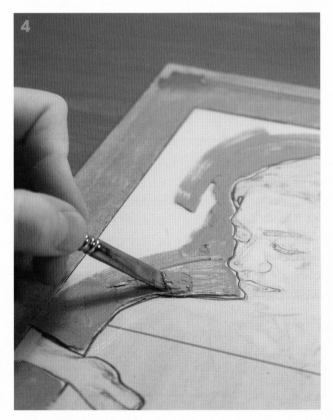

3 Drybrushing

Alkyd paint is applied in opaque layers, further rendering the areas of color and detail using a dry-brush technique. Under the same process, additional figurative elements are introduced.

4 Adding Painted Textures

The figurative paintings are scanned into the computer. In Photoshop, the portrait is changed to grayscale and the Find Edges filter is applied, simplifying the image and accentuating the outer edges. It is printed out onto paper and taped to the underside of a piece of glass that is large enough to rest on the outer edges of a scanner without touching the surface. On top of the glass substrate, several backgrounds are created. As each background is painted, it is scanned with the lid of the scanner up, then wiped clean so a new texture may be created. The painting instruments and approach are altered each time so a variety of backgrounds are produced.

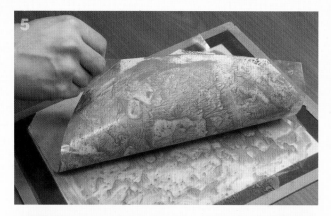

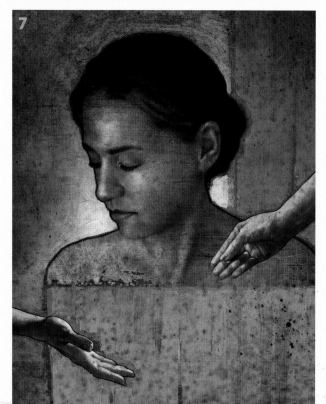

5 Painted Textures With a Subtractive Approach

Acetate, textured with acrylic medium that has been built up on the surface, is placed face down onto oil paint that has been brushed on glass. The acetate is moved around in a swirling motion, agitating the wet paint in a dynamic way. When done, the acetate is lifted off and the glass is scanned into Photoshop and saved as various painted texture files.

6 Adding a Textured Patina

Raw canvas, stained board, paint drips and broken tile are added to the working Photoshop file from the artist's vast digital texture collection. The unprimed canvas texture layer is placed at the bottom of the file to blend with the overlying layers, and the dirty tile texture is placed on the top, using the Multiply Blending mode to create a subtle but continuous patina over the entire image.

7 Working in Layers in Photoshop

Using Photoshop, the painted textures from steps 4 and 5 and figurative elements from step 3 are cleaned up, the backgrounds are removed and each element is put into a separate layer. Most of the textural backgrounds are placed underneath the figure. Textures that run over the figure have portions masked out so that the figure painting shows through in places. The Liquify filter is used extensively to reshape the edges of the painted textures around the figurative elements. Various blending modes (Multiply, Soft Light, Hard Light, Lighten and Overlay) help to unite all of the layers. The Blur filter is also used to soften edges and knock back some of the detail in certain areas of the piece.

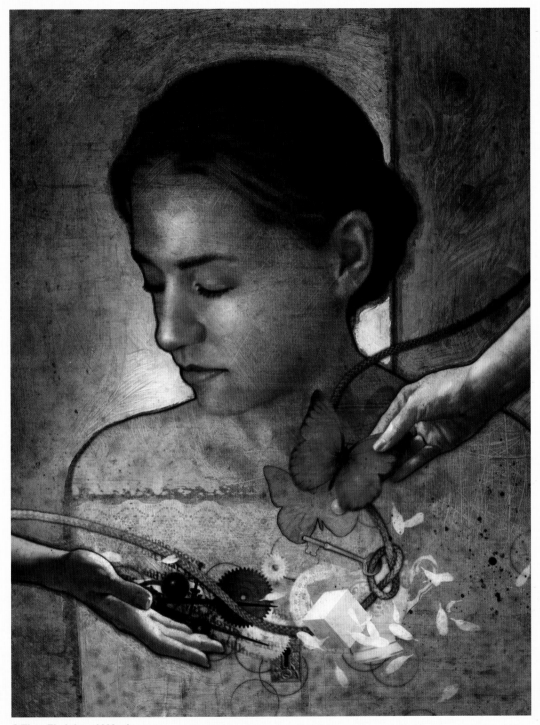

8 The Finished Work

Using a scanner with the lid open, various objects are scanned and brought into the composition. In addition, digital photographs of a teacup, black and white spheres, a keyhole and a cube are also introduced. In Photoshop, each element is sized and color adjusted. The edges are blurred, the backgrounds are removed and each piece is placed on a separate layer. The Liquify, Gaussian Blur, Shear and Twirl filters are employed along with various blending modes (Screen, Soft Light, Hard Light and Multiply) to create a cohesive image. The Photoshop file is flattened and saved as a TIFF file under a new name, retaining the original working file. The finished piece, entitled *Reciprocity*, is digitally printed out onto canvas.

Stephanie Dalton Cowan:

narrative
juxtapositions

Pieces of vintage ephemera, tattered and torn cloth, a handwritten letter and a hint of typographic dialogue are cleverly overlapped and juxtaposed with imagery of a bygone era. Without notice, we are drawn in; something catches our eye and our minds start to wander. Our curiosity is piqued and suddenly a vision begins to unfold. We are encouraged to rely on our own imaginative faculties to complete the narrative. This sense of mystery and fascination is at the heart of artist Stephanie Dalton Cowan's metaphorical, mixed-media works. "When a word, symbol or image is barely exposed, we become naturally curious. There is something alluring and inviting about the unseen," says the artist. "Much of my work is like a whisper to a story, and I like it when people are pulled in and begin to connect the dots."

In her highly symbolic, montage-style work, Dalton Cowan presents a fragmented world where each element has a significant role to play. Archetypal patterns, iconography, typographic elements, broken and distressed imagery and abstract shapes are taken out of their familiar contexts to represent more than what they appear to be. With further inspection, relationships begin to form and hidden messages are discovered. "By using analogies and visual metaphors, I explore transformative ideas that lean towards a visionary or spiritually imaginative perspective," explains Dalton Cowan. "Through my work, I aspire to project a higher level of consciousness and am diligent at unearthing the subtle nuances of my subject matter." Investigative research is a catalyst for the artist's process. "As I begin to generate a concept and direction for my work, I go through an exploratory stage," she says. "Often when the subject matter is complex, it requires additional knowledge and understanding before embarking on creating the visual." After the point of ideation and insight, Dalton Cowan works intuitively, examining various directions throughout the process. "Oftentimes, I will start with a single found object or piece of textured fabric, laying down a surface pattern or background," she says. "Collectibles, isolated words, recycled book pages, antique letters and photographic fragments find their way into the work when I am examining possible compositions." As the layers build, the artist begins to excavate into the surface, sanding back to reveal the hidden gems that lie beneath. "Visual cues and metaphors present themselves, guiding me to the final composition," she says. "I intuitively follow the internal dialogue and throughout the process, a visual story slowly unfolds. The trick is recognizing when to keep moving forward and when to stay put."

> "Visual cues and metaphors present themselves, guiding me to the final composition. I intuitively follow the internal dialogue and throughout the process, a visual story slowly unfolds. The trick is recognizing when to keep moving forward and when to stay put."

Myopic Vision · Stephanie Dalton Cowan
SIZE: 26" × 22" (66cm × 56cm) / **MEDIUMS:** acrylic, oil stick, oil pastel, beeswax, molding paste and acrylic gel medium / **MATERIALS:** antique book pages, 1903 French encyclopedia text and image, sculpture plate and antique marbleized papers / **TECHNIQUES:** digital manipulation, collage, encaustic, debossing and image, type and line art transfers / **SURFACE:** Arches 300-lb. (640gsm) watercolor paper / **COLLECTION:** the artist

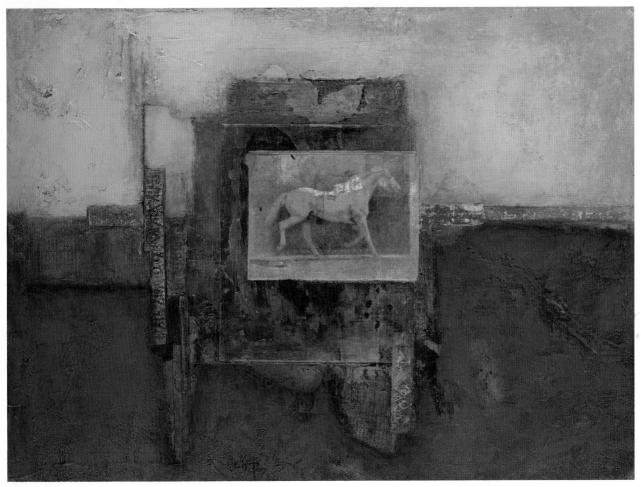

Free From Past · Stephanie Dalton Cowan
SIZE: 30" × 40" × 3" (76cm × 102cm × 8cm) / **MEDIUMS:** acrylic, oil stick, oil pastel, ink, pumice gel and molding paste / **MATERIALS:** linen cloth, photo, raw canvas, African bark paper, vintage book spines, antique botanical book pages from an Asian almanac, distressed leather book cover with tape and Eadweard Muybridge image (public domain image courtesy of the Photographic History Collection of the National Museum of American History at the Smithsonian Institution) / **TECHNIQUES:** digital manipulation, digital printing, collage, debossing and sanding / **SURFACE:** canvas / **COLLECTION:** the artist

Dalton Cowan's mixed-media work fuses photographic techniques, digital manipulation and collage with low-relief texturing, impasto painting and distressing techniques to create an image that seamlessly blends the past with the present. Photographic imagery is layered with aged textures in the digital environment, giving the work a timeless quality. Using ink-jet printing and archival inks, the digitally-enhanced work is printed out and either directly adhered or image-transferred to a textured substrate. With the addition of gel medium boldly applied to the surface in layers, the image begins to take on an organic, frescolike appearance. The artist has also experimented with digital printing on vintage book covers and other unconventional surfaces, attaching the dimensional print to the working ground for a tactile, textured effect. "The application of gel medium allows me to create a deep textural foundation," says Dalton Cowan. "I can build up the layers, later debossing, scratching or distressing to add a rich sensual quality to the surface and an element of mystery to the fragments below." To further embellish and enliven the textural landscape, acrylic paint, oil sticks and beeswax are often applied on top. The layered application conveys an element of decay, adding character and a sense of history to the art.

Dalton Cowan employs a variety of tools, including trowels, palette knives, brayers, brushes, scrapers and cotton rags, as well as various unconventional instruments collected during her travels. "In my painting studio, I house a wide range of wooden stamps from India and Africa, as well as other architectural wood fragments. I also own a circa-1903 edition of French encyclopedias, an antique Asian almanac and a Chinese apothecary jar filled with letters, foreign stamps, old ticket stubs and photos that I use in my collages," says Dalton Cowan. The artist also collects a variety of handmade papers, fabrics and parts of worn and tattered vintage books from various cultures, all of which contributes to the global influence in her work.

The best visual narratives create an element of intrigue, leaving the audience wondering what is yet to come. In Dalton Cowan's artistic oeuvre, familiar iconography is unhinged from its source and assigned a new identity. Throughout the narration, vital links are left to the imagination, keeping the door open for personal interpretation. Aesthetics work in tandem with messaging to further spark curiosity and dialogue. By appealing to the senses and engaging the audience on a cerebral level, the artist invites onlookers into the creative process where further conversation and exchange create a memorable impact.

"By using analogies and visual metaphors, I explore transformative ideas that lean towards a visionary or spiritually imaginative perspective. Through my work, I aspire to project a higher level of consciousness and am diligent at unearthing the subtle nuances of my subject matter."

Singular Points · Stephanie Dalton Cowan
SIZE: 18" × 18" × 3" (46cm × 46cm × 8cm) / **MEDIUMS:** acrylic, oil stick, oil pastel and acrylic gel medium / **MATERIALS:** African bark paper and antique book page / **TECHNIQUES:** emulsion lift and transfer, collage, debossing and scratching-in / **SURFACE:** canvas / **COLLECTION:** the artist

embellishing the digital surface

Through digital means, a series of visual elements can be easily taken out of their ordinary context and altered, resized, colorized, textured and recomposed to create a new, more metaphorical arrangement. When the digital image is output, adhered to a textured substrate and layered with heavy gel medium, the work begins to transform. In this demonstration, artist Stephanie Dalton Cowan uses vintage photographs, aged textures, digital manipulation, ink-jet printing, distressing, relief texturing, collage, impasto painting and oil stick rubbing to create a densely layered, fresco-like painting.

MATERIALS

Deep stretched canvas: 8" × 8" × 3" (20cm × 20cm × 8cm)
Double-sided matte ink-jet paper
Plexiglas
Millinery buckram: heavy-duty
Vintage photograph
Antique book page
Vintage typography book

Acrylic paints: heavy body
Acrylic gel medium
UV-resistant clear acrylic coating
R&F pigment sticks
Graphite pencil: 4B

Antique fabric printmaking blocks
Sandpaper: 220-grit
Palette knife
Bean bags
Cotton rag
Craft knife
Metal ruler
Flatbed scanner
Ink-jet printer
Adobe® Photoshop®

1 Preparing the Digital Image

A vintage black-and-white photograph is scanned into the computer, re-sized and layered on top of an antique book page texture in Photoshop. To give the piece a tintype look and feel, the color is altered. The digitally-enhanced image is printed out onto matte ink-jet paper and trimmed on all sides.

2 Aging the Surface

The ink-jet print is sprayed twice with a UV-resistant clear acrylic and lightly sanded to scratch up the surface. Proper ventilation and protective gear is a must.

3 Adhering the Digital Print to the Working Surface

The digitally-enhanced print is adhered to stretched canvas using acrylic gel medium and a palette knife. To ensure the print sticks firmly to the canvas, a piece of Plexiglas is placed on top; and bean bags help to weigh it down while it dries overnight.

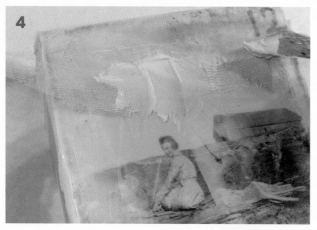

4 Adding Texture

To give the piece the appearance of a vintage fresco, the entire surface and sides are irregularly coated with acrylic gel medium using a palette knife. While this is still wet, heavy-duty millinery buckram, with some of its threads pulled out for random irregularity, is applied to the working surface. Gel medium is added on top to seal the surface.

5 Debossing

To further texture the working ground, another layer of gel medium is applied and various abstract patterns are debossed into the wet surface using antique fabric printmaking blocks from India and Africa. The patterns are overlapped for visual interest.

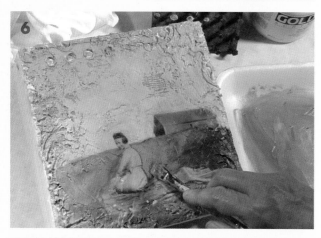

6 Applying Color

Working dark to light, acrylic paint is applied opaquely using a dry-brush technique.

7 Adding Collage

A thin strip of type from an antique typography book is added to the foreground of the painting as a collage accent. It is adhered to the surface using acrylic gel medium. Once it is dry, it is sanded and then coated with acrylic paint.

8 Accentuating the Texture

To bring out the heavy impasto surface, pigment sticks are rubbed into the crevices and grooves with a cotton cloth, blending the darker tones toward the lighter areas. The piece is lightly sanded when dry and bone-colored pigment stick is rubbed over the peak areas, with increasing pressure toward the center of the piece. Graphite pencil is added to delineate key elements.

9 The Finished Work

The self-standing impasto painting is entitled *Just a Moment Ago*.

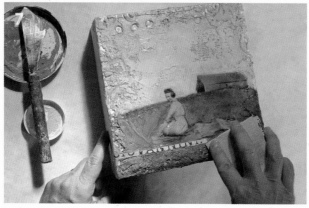

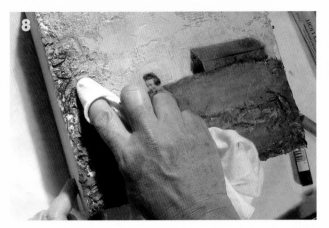

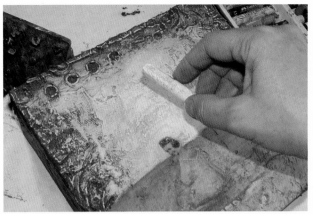

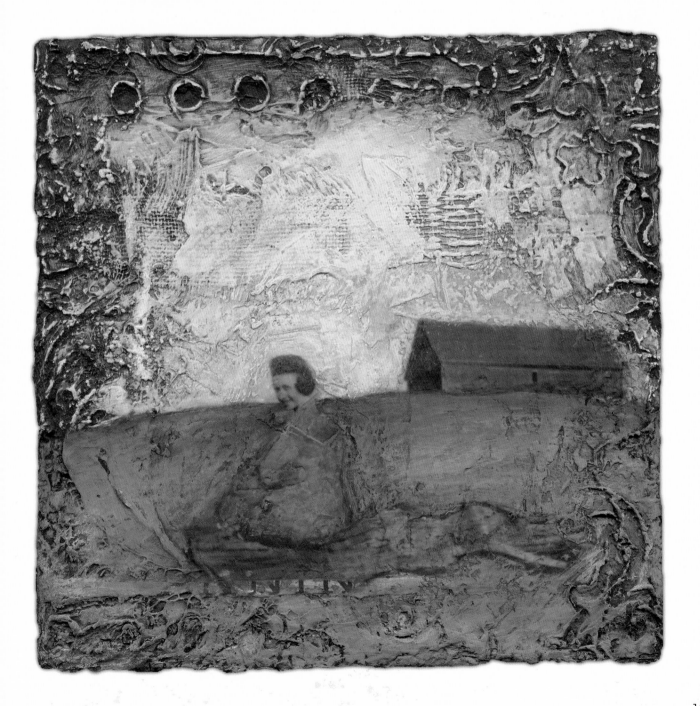

passages of time

One's existence is made up of many interwoven layers, a synthesis of personal triumphs, tragedies and transitional states. As each minute passes, the challenges of life propel one's evolution, yielding insight and understanding. For artist Richard Tuschman, art, like life, is about the accumulation of experiences and the relationships that result. "When working, I see each new layer as analogous to an event in the life of the piece, one leading to the next," says the artist. "Just as in a person's life, even those layers that seem to be forgotten or invisible in the finished piece have somehow contributed to the whole."

Tuschman's artistic oeuvre explores opposing themes such as beauty and decay, memory and dreams or wounding and healing. The artist revels in time's ability to turn the tide from one state of being to the next. "It is my hope that my work mirrors reality, which I see as a network of tensions or unity of opposites that ideally creates an integrated whole," says Tuschman. "As an artist, I am always trying to reconcile the tensions that exist to create a sense of harmony." Throughout Tuschman's work, elements of youth and beauty intermingle with the aged and weathered. "I think a lot of my work is about the beauty of imperfection," he says. "I like to juxtapose beautiful faces, plants or objects against distressed or corroded surfaces." With their juxtapositions and subtle layering, Tuschman's evocative assemblages engage us on an emotional level. Their warm-toned, subdued color palette, organic elements, painterly textures and small scale each contribute to the experience. "As an artist, I create to give tangible, meaningful form to otherwise invisible but deeply felt impulses, thoughts and feelings, imbuing a certain intimacy, soulfulness and depth in the work," explains Tuschman. "In life, there is a cosmic flow and we are constantly taking things in. Making art is a way to expend and release what we experience, making a personal record of it."

A seamless amalgamation of digital and traditional processes, Tuschman's mixed-media work combines abstract painting, sculptural constructs, digital photography, collage and assemblage. The artist's expressively painted backgrounds and textures imbue his primarily digital art with an organic, physical quality that cannot be produced using digital means alone. "The painted textures featured in my montages are built, layer upon layer, of brushed, scraped, rubbed and glazed oil or acrylic paint, using all sorts of tools from putty knives, sandpaper and razor blades to conventional brushes and an etching tarlatan," says Tuschman "I really love the surface subtleties and the richness of paint, the serendipity of collage and assemblage, the frozen moments of photography and the power and flexibility of the computer. My work is an attempt to capitalize on the descriptive strengths of photography while respecting the modernist notion of the integrity of the picture plane." Working within a pluralistic aesthetic, Tuschman has become acutely aware of the inherent characteristics and limitations of each particular medium he employs. "Making art is a dialogue,

"As an artist, I create to give tangible, meaningful form to otherwise invisible but deeply felt impulses, thoughts and feelings, imbuing a certain intimacy, soulfulness and depth in the work."

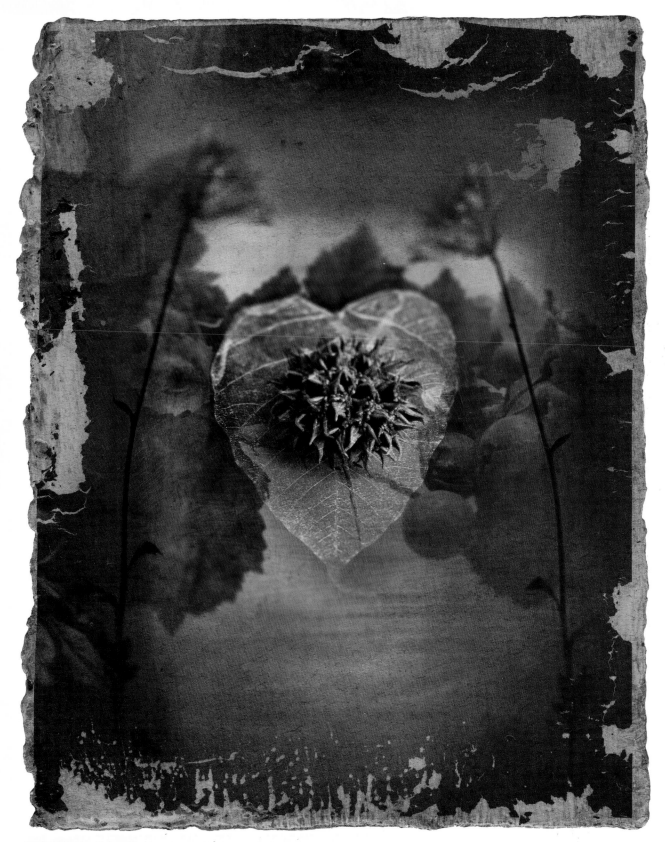

Prickly Heart · Richard Tuschman
SIZE: 15" × 11¼" (38cm × 29cm) / **MEDIUM:** oil / **MATERIALS:** plywood, thistle, Asian leaf, chrysanthemums and plastic grapevine / **TECHNIQUES:** ink-jet transfer, digital photography, digital manipulation, digital collage and digital assemblage / **SURFACE:** archival ink-jet print on rag paper / **COLLECTION:** the artist

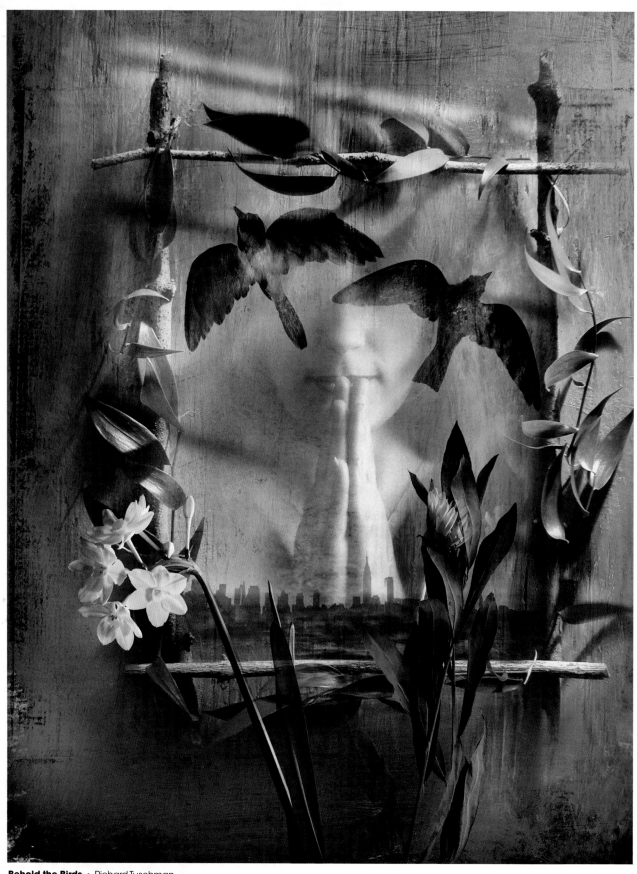

Behold the Birds · Richard Tuschman
SIZE: 15" × 11¼" (38cm × 29cm) / **MEDIUM:** acrylic / **MATERIALS:** plywood, twigs and leaves, and photos of flowers, birds, female face and New York City skyline /
TECHNIQUES: digital photography, digital manipulation, digital collage and digital assemblage / **SURFACE:** archival ink-jet print on rag paper / **CLIENT:** *Guideposts* magazine

the collaboration between my own sensibilities and whatever medium I am working in at the moment," he says. "When I'm painting, I am sensitive to the way the medium behaves on the surface of the picture. When I'm taking a photograph, I am sensitive to the way the light is illuminating a scene. I am always listening with my eyes, letting them dictate my choices. The priority is on the process and responding to the visual consequences thereof."

To ignite his process, Tuschman likes to engage in creative ideation and play. "I often start by randomly arranging objects and textures just to see what happens. These improvisational pieces are made without a preliminary sketch or preconceived end in mind," says Tuschman. "My creative process tends to be very intuitive and I find that when I attempt a more conscious method, I tend to get blocked." To keep his mind active, Tuschman fills his studio with tokens of inspiration. Anything from an Old Master reproduction to a rusty piece of metal can trigger the artist's imagination. "I think inspiration comes from the inherent beauty in the elements and materials and a desire to make use of them. The most important thing is to be aware and in tune with what speaks to you," he adds. "I am not a big believer in waiting for inspiration. I think half of an artist's job is to pay attention. The other half is to show up in the studio and get to work."

For Tuschman, creating balance between opposing elements is an ongoing challenge that continues to intrigue him. Whether it is in the transient themes he chooses to convey or the diametrically opposing media he employs, the artist is always blurring the boundaries to what is possible, opening our minds to the subtle passages that lie between.

"I am always listening with my eyes, letting them dictate my choices. The priority is on the process and responding to the visual consequences thereof."

Possible House · Richard Tuschman
SIZE: 15" × 11" (38cm × 28cm) / **MEDIUMS:** acrylic and oil / **MATERIALS:** balsa wood, acetate and paper construction (window), birch plywood and found plywood, dried plants and photograph of rose / **TECHNIQUES:** digital photography, digital manipulation, digital collage and digital assemblage / **SURFACE:** archival ink-jet print on rag paper / **COLLECTION:** the artist

virtual assemblage

Digital photography can be quite inventive when it employs imaginative, surrealistic environments and out-of-scale props. Painted backdrops, custom textures and unique finishes further add distinction. In this demonstration, artist Richard Tuschman combines digital photographs of natural and man-made objects with a variety of scanned, painted and distressed textures to create a multi-layered virtual assemblage.

MATERIALS

Saunders Waterford series hot- and cold-pressed watercolor paper
Etching tarlatan cloth
Unprimed decorative dollhouse molding
Balsa wood
Cardboard

Acrylics and oil paints: Alizarin Crimson, Phthalo Blue, Cadmium Orange and Titanium White
Acrylic matte medium
Golden Crackle Paste
Japan drier
Stand oil
Alkyd resin painting medium
Cold wax medium
Odorless mineral spirits

Modelmaker's miter box and saw
2-inch (51mm) ox-hair mottler brush
Large synthetic flat brush
Palette knife
Custom lighting box
Wood glue
Paper towels
Digital camera: 10.1 megapixel and 50mm macro lens
Flatbed scanner
Ink-jet printer
Adobe® Photoshop®

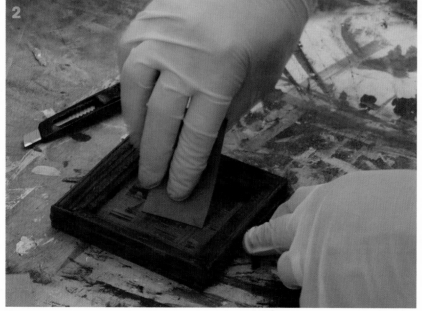

1 Building the Frames

To build the central frame, unprimed decorative molding is cut at angles using a modelmaker's miter box and saw. Balsa wood is employed for the backing material. The pieces are assembled and adhered into place with wood glue. Using the same process, two other frames are also created.

2 Painting the Frames

The central frame is painted dark using acrylics. When this is dry, a warm-toned mixture is opaquely painted on top and areas are wiped out with a paper towel to give the surface a patinalike finish. The interior portion of the frame is painted and distressed by lifting the paint with a piece of cardboard before it sets. Three frames are painted for use in the final piece.

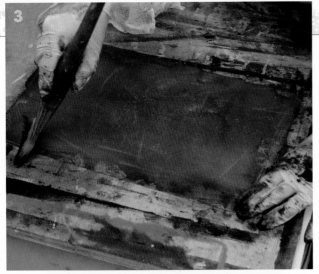

3 Painting and Distressing the Surface

A mixture of Alizarin Crimson, Phthalo Blue and Cadmium Orange oil paint thinned with odorless mineral spirits is applied on a sheet of hot-pressed watercolor paper using a brush. After the surface is dry, Titanium White oil paint is mixed with stand oil and Japan drier and applied to the surface. As a finishing coat, a glaze of Alizarin Crimson, Cadmium Red and Phthalo Blue oils thinned with alkyd resin painting medium, cold wax medium and odorless mineral spirits is applied. A brush and etching tarlatan are used to rub the paint into the surface. Proper ventilation and protection is a must.

4 Applying Textured Fabric

Using matte medium, a piece of etching tarlatan is adhered to a sheet of hot-pressed watercolor paper, with the fabric wrapping around the outside edges to the back. To add color, a mixture of Phthalo Blue and Cadmium Orange acrylic thinned with water is brushed on top. While this is still damp, Titanium White acrylic is brushed over the top, blending with the layer below.

5 Creating a Crackled Surface

A thick coat of crackle medium is spread on top of a sheet of heavy cold-pressed watercolor paper. Phthalo Blue and Cadmium Orange acrylic are thinned with water and brushed over the surface to build a color foundation. A dark oil glaze thinned with odorless mineral spirits is applied on top. Before it dries, a thick layer of Titanium White oil paint mixed with stand oil and Japan drier is randomly applied on top using a palette knife and a brush. Proper ventilation and protection is required.

"Working on the computer is empowering. I'm free to experiment all the way through the process up until the piece is finished. The computer is simply unprecedented in its role as an image processor, enhancer and manipulator, and it find it irresistible."

6 Photographing With a Custom Lighting Box

Still-life elements are photographed using a custom lighting box made from black foamcore panels attached to a wooden framework. Removable foamcore windows attach to the frame with Velcro strips. These allow for great flexibility when it comes to lighting. A seamless wall made of paper is set in the back. Some objects are shot against the seamless wall using a limited depth-of-field while others are shot flat on a textured surface.

7 Digitizing and Assembling the Layers

The digital photos are loaded onto the computer and brought into Photoshop. Each painted texture is scanned and saved as a separate layer. Other textures from the artist's extensive digitized collection are also pulled into the layered composition. Using Photoshop, the painted textures and photographic elements are scaled, colorized and assembled into a cohesive composition.

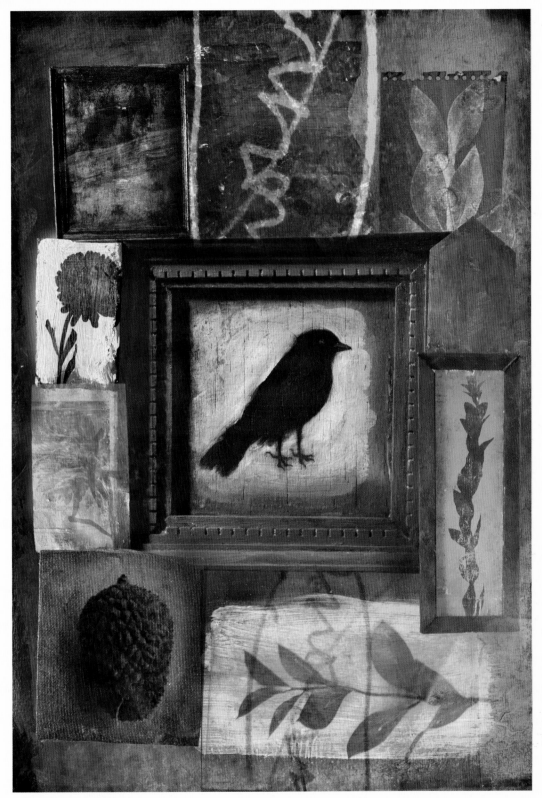

8 The Finished Work

With all of the elements on separate layers, various Blending modes (Multiply, Hard Light, Soft Light and Overlay), filters (Gaussian Blur and Lens Blur) and masking strategies are employed to create the virtual assemblage, entitled *Nature Study*.

Dorothy Simpson Krause:

visualjournalist

Firsthand knowledge and engagement with the world is vital in establishing a direct sensory connection with a subject, event or place. When interwoven into the culture, the artist becomes an active observer and can draw from personal experience, offering a fresh and unique perspective. Picture-making then becomes about capturing the spirit of what has transpired, not just the mere replication of slice-of-life scenes. This is the practice of visual journalism, the art of observation and perception creatively documented on paper, canvas, wood and other materials for all the world to see. For digital and mixed-media collage artist Dorothy Simpson Krause, the world is her muse and she is eager to explore its depths, sharing her insight and revealing certain truths.

Traveling the globe, Krause sees herself as a witness to the truth. Veering from the typical tourist sites, she is most drawn to locales of historical interest. She especially loves native costumes and indigenous rituals. Her inquisitive, almost childlike curiosity

"My work embeds archetypal symbols and fragments of image and text in multiple layers of texture and meaning. The components are added, subtracted, repositioned, altered and recombined with other elements until each part is in perfect relation to the whole. By overlaying images whose relationship may not be obvious, the viewer is challenged to focus, interpret and consider what they have seen."

Lady of the Flowers · Dorothy Simpson Krause
SIZE: 24" × 22" (61cm × 56cm) / MEDIUMS: pigment ink, gold leaf and colored pencil / MATERIALS: Romanian woman (photo by Jan Doucette) and celestial map / TECHNIQUES: digital manipulation, digital collage, digital printing and digital image transfer / SURFACE: handmade Indian bagasse paper / COLLECTION: American Art Museum of the Smithsonian Institution, variant edition of 20

opens the artist to whatever her travels may bring, allowing the randomness of life to enter into process.

With investigative research as her point of departure, Krause's artistic journey continues her search for answers to profound questions. "By focusing on timeless personal and universal issues like hope, fear, lies, dreams, immortality and transience, I challenge myself and the viewer to look beyond the surface to see what depths are hidden," says Krause. "I imbue my work with the quality of allegory, not to be factual but to be truthful in character. There are no prescriptive messages, but an invitation to subversive readings." Krause uses her travels as a way to feed her artistic process as well as her mind.

Over her career, she has visited Cuba, Vietnam, India, Peru, Italy and various locations throughout the United States. Krause finds that there is always something that captures her interest, and she diligently follows its lead. In February 2001, the artist spent three weeks in Cuba, taking hundreds of photographs and keeping a visual journal. "Shortly after I arrived, I found a history book on Cuba published in Havana in 1925," recalls Krause. "It sparked me to begin focusing on the differing perspectives authors bring to their accounts and how time and political persuasion affect, counteract and obliterate viewpoints." By collecting images, literature, fabric and other ephemera, the artist can record and document her experience. Often prevalent in her work are words and phrases read as thoughts, dialogue or chatterlike babble. Krause synthesizes what she has unearthed and recomposes the elements into new graphic arrangements. "My work embeds archetypal symbols and fragments of image and text in multiple layers of texture and meaning. The components are added, subtracted, repositioned, altered and recombined with other elements until each part is in perfect relation to the whole," she says. "By overlaying images whose relationship may not be obvious, the viewer is challenged to focus, interpret and consider what he or she has seen. Dissecting disparate views of reality and interlacing them into a cohesive representation, a new vision, is empowering."

While working in journals, Krause is always aware of sequencing and the relationship of the spreads and pages to the whole. "In a bound book, you move through it in a time-oriented fashion from one page to the next," says Krause. "To create interest in the pacing, you need to have variation and repetition in such a way that everything relates." In recent years, Krause's visual journals have become increasingly significant to the artist. "Although I have worked with book and book-like forms for several years, I have always thought of them primarily as repositories for ideas in process," she notes. "Gradually, I have begun to treat them as works of art in their own right, and give them the attention they deserve. They continue to grow in importance in my work."

Although the artist spends a great deal of time gathering and recording, the studio is where the magic really happens. Krause digitally scans the pages of her journals and incorporates other images and elements from her vast collection, translating them into larger thematic works in series. "My creative process is almost entirely intuitive. I gather the elements I've collected and start to play, pushing things around until something speaks to me," says Krause. "I combine word and image where the layers add depth, complexity and richness to both the content and the formal image qualities, allowing for the addition of other voices or perspectives."

Krause, a trained painter and a collage-maker by nature, has always been willing to experiment. "In the mid 1970s, I began working with a Xerox color copier, shifting colors and enlarging images to incorporate them into my collages," she recalls. "The availability of affordable computers in the early 1980s took collage to a new level, allowing images to be scanned, combined with transparency and printed as a seamless whole." Utilizing technology alongside traditional processes, the artist's mixed-media work embraces the best of both worlds. "I can combine the humblest of materials like plaster, tar, wax and pigment with the latest in technology to evoke the past and herald the future," she says. "My surfaces replicate fresco walls, worn and tattered leather, faded and torn paper, and distressed metal." Advancements in printing have enabled Krause to imprint onto a wide range of dimensional surfaces, including Plexiglas, copper, birch bark, corrugated cardboard, wood, aluminum, cork, plaster, leather, fabric, lenticulars and custom substrates. With the clever underprinting and overprinting of digital images onto handmade supports, the layers begin to build, giving a more physical presence to a virtual medium. For the artist, the innumerable variables provide an element of surprise each time. "I'm easily bored," admits Krause. "If I have done something once, I need to explore new territory, both in content and in form, expanding my artistic expression."

Today, an entire generation is growing up with unprecedented technological innovations, allowing achievements that were unimaginable a few decades ago. Yet, with all the advancements, our culture is becoming ever more dissociative and immune from daily experience, especially with the proliferation of e-mail, video conferencing, text messaging and the Internet. Krause's work shows the value of getting out of the studio, traveling and becoming more actively involved with a subject. For it is only then that art will truly reflect our time—a mirror to life with all its eccentricities.

"I can combine the humblest of materials like plaster, tar, wax and pigment with the latest in technology to evoke the past and herald the future."

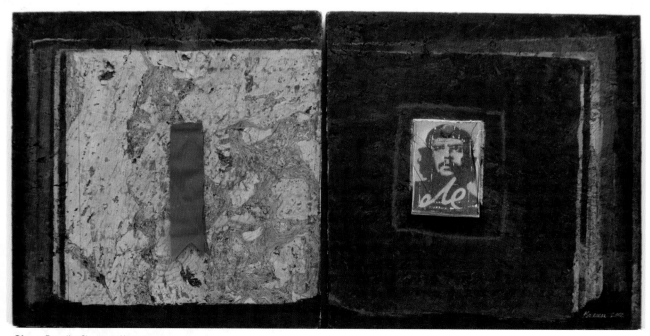

Che · Dorothy Simpson Krause
SIZE: 12" × 24" (30cm × 61cm) diptych / **MEDIUMS:** pigment ink, oil stick, molding paste, ink and acrylic / **MATERIALS:** grosgram fabric ribbon and pushpin / **TECHNIQUES:** digital manipulation, collage, digital printing, ink-jet emulsion transfer and rubber stamping / **SURFACES:** wood, cork tiles and aluminum / **COLLECTION:** the artist

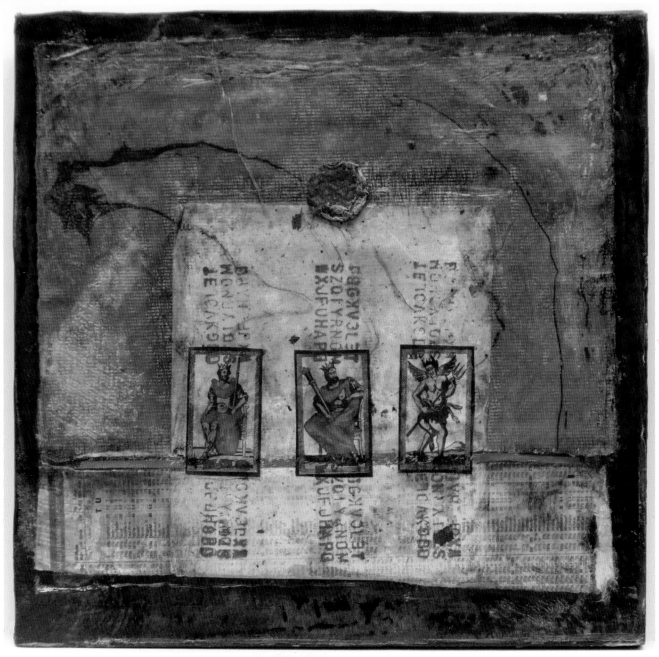

Three Kings · Dorothy Simpson Krause

SIZE: 12" × 12" (30cm × 30cm) / **MEDIUMS:** acrylic, ink, metallic powdered pigment, acrylic molding paste and wax / **MATERIALS:** brown paper, newspaper, metal, gauze, wood, rusted bottle cap and handmade paper / **TECHNIQUES:** suminagashi marbling, collage, rubber stamping and encaustic / **SURFACE:** (original art was digitally deconstructed and printed as a lenticular image) / **COLLECTION:** artist

ink-jet printing: alternative surfaces and approaches

With advancements in printing technology, artists can now employ cutting-edge techniques using ink-jet printers with custom substrates, with both porous and nonporous materials. In this demonstration, artist Dorothy Simpson Krause produces a multi-surfaced, multi-media cover illustration for a handmade book that seamlessly combines both traditional and digital processes.

MATERIALS

Arches hot-pressed paper and black cover stock
Aluminum: mill finish
Mylar polyester film: 5mil
Gold moiré optical plastic film
Mat board: 2-ply
Clear transparency film (for ink-jet printer)

Imitation silver leaf
2-inch (51mm) 3M silver tape
Pigment inks
Acrylic paint
Black gesso
Black India ink
Old World Art adhesive size: water-based
Isopropyl alcohol: 91%
inkAID Clear Gloss Precoat Type II

Slot ruler: 1-inch (25mm) aluminum tubes, packaging tape and coins
Paper towels: heavy-duty
Foam and bristle brushes
Black marker
Scissors
Flat burnishing tool
MACtac double-sided adhesive: clear
Steel wool
Awl
Utility knife
Citra Solv cleaner and degreaser
Heavy black linen thread
Flatbed scanner
Photo printer
Adobe® Photoshop®

1 Creating the Base Art

Symbolic elements of the solar cross are painted on hot-presssed and black cover stock, using acrylics, black gesso and India ink. Once dry, the work is torn and arranged into double-page spreads. To provide continuity and interest, bright abstract paintings are printed onto translucent Mylar and inserted at intervals throughout the handmade book.

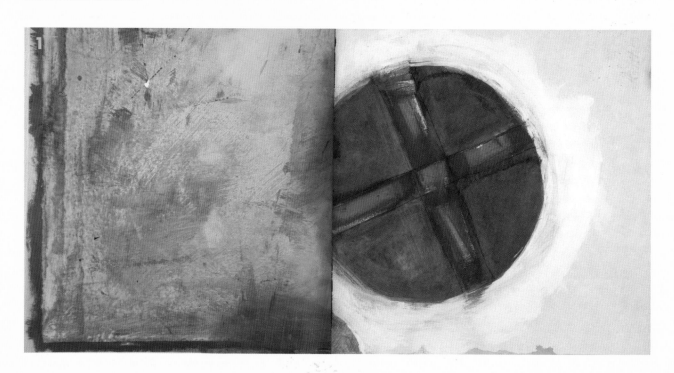

2 Creating a Template

Elements from the interior spreads are scanned into the computer and a cover composition is created in Photoshop. A title is added to the design and the digital file is printed onto clear transparency film, serving as a template for building the multi-layered print surface. The main circular design is then cut out of the film using scissors. The points of the cross are marked off using an awl.

3 Preparing the Aluminum

A sheet of mill-finish aluminum is cut with a utility knife and then lightly rubbed with steel wool to remove the oily finish. The surface is cleaned with Citra Solv and a paper towel. When this is dry, isopropyl alcohol is used for a final cleaning.

4 Applying Silver Tape

Using the template as a guide, silver tape is marked off with a black marker and the four arms of a cross are cut out using scissors. The tape is then placed in position on the aluminum surface and flattened with a burnishing tool.

5 Applying Silver Leaf

A sheet of imitation silver leaf is applied to the center of the cross using adhesive sizing. Excess particles are carefully brushed away.

"The rapid pace of technological advances makes creative exploration particularly stimulating. Integrating this technology with tradition art materials and techniques provides me with continual challenges, enabling me to create unique imagery that defies categorization."

6 Applying Gold Moiré Film

The protective coating of double-sided sheet adhesive is removed and placed onto the back of the gold moiré film. The working template is placed over the film, a circular shape is traced using a marker and then the area is cut out using scissors. The film is then placed at the top of the aluminum surface in its proper position. The backing of the adhesive sheet is peeled away as the film is being securely adhered to the metal surface.

7 Print Preparation

To prepare the non-porous surfaces of the custom substrate for ink-jet printing, the entire multilayered collage is coated with inkAID using a foam brush. Two coats are applied in opposing directions to ensure even coverage.

8 Checking the Head Clearance

To make sure that the printer heads do not strike the substrate when printing, the head clearance is checked ahead of time. A slot ruler is made by taping the ends of square aluminum tubes around coins set to the thickness of the printer's clearance. The multilayered substrate is passed through the slot ruler to ensure that it will go through the printer smoothly; in this case, the printer has a head clearance of 1.5mm.

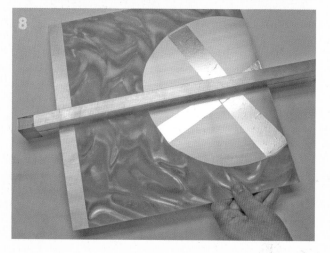

9 Making a Jig

In order to print a full bleed, a jig is needed. A hole is cut in the center of a sheet of mat board while the collaged substrate is put into the surround and taped into place in the back using packaging tape. Because the jig adds a two-inch (51mm) extension to the substrate, the image is set to print two inches (51mm) down from the top and two inches (51mm) in from the side at 101 percent for a slight overprint.

10 Printing Full Bleed on a Rigid Substrate

The substrate is sent through the straight paper path of the ink-jet printer, which accommodates the rigid material. Vivid pigment inks are used in the print process.

Please note that the use of ink-jet printers or other such equipment in alternative ways may void the manufacturer's warranties. Evaluate any process for suitability before proceeding.

11 The Finished Word

The finished piece becomes the cover of a handmade book entitled *Solar Cross*. The twenty-eight-page interior is adhered to the front and back covers using double-sided adhesive. It is stitch-bound by hand with heavy black linen thread.

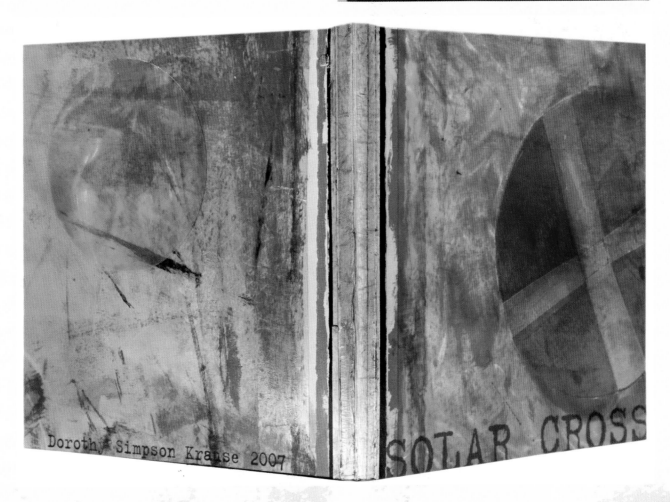

new media for
a new world

New media is an exciting area of contemporary art that is expanding the definition of art and the role of the artist. With advances in technology and the advent of the Internet, we are seeing a plethora of computer-based works being introduced into the culture. The opportunities in this cutting-edge aesthetic seem endless. For artists, the new media movement creates a vast playground for experimentation and exploration.

With emerging technologies, interactive, nonstatic compositions possible. Viewers coalesce with the art form, creating an experience that can be uniquely personal. Visuals, sound, motion and storytelling—both narrative and abstract—are utilized. The experience may be a solo act or shared by a community. It may encompass multiple spectators or players within one space or, through the Internet, it may involve several locales

MirrorMask UK Film Poster · Dave McKean
SIZE: 30" × 40" (76cm × 102cm) / **MEDIUMS:** acrylic and digital / **MATERIAL:** photograph / **CLIENT:** Tartan Film Distribution

MirrorMask: Giants · Dave McKean
SIZE: 1080 x 1920 pixels / **MEDIUM:** digital / **TECHNIQUES:** live action 35mm film plate and computer 3-D graphics / **CLIENT:** The Jim Henson Company and Sony Pictures

and time zones to reach a broad audience simultaneously. This really changes the way we conceptualize the pictorial landscape. There are also reactive new media art forms—such as digital animation for film, video and the Internet—that do not involve the onlooker in the creation process but still utilize many of the same sound, motion and visual qualities as their interactive counterparts. Artists that embrace this computer-based aesthetic are quite tech savvy. Although many work with commercial software packages, there is a growing number of artists that do their own coding, creating custom software to produce limited-edition and one-of-a-kind works of art. Programming and computer algorithms are used to respond to such things as motion, heat or light input from video, sensors, actuators and other such devices to create virtual art. The variety of work being introduced is quite vast, so much so that any attempt to

The variety of new media artwork being introduced is quite vast, so much so that any attempt to divide the genre into categories is almost impossible.

Abundance · Camille Utterback

SIZE: 80' × 60' (24m × 18m) projection with a 100' × 100' (30m × 30m) interaction area / **MEDIUMS:** interactive video installation (custom software, video camera, computer, projector and lighting) / **TECHNIQUES:** algorithmic drawing software, video tracking and interactive installation / **SURFACE:** San Jose City Hall, San Jose, CA / **CLIENT:** ZER01 / **PHOTO CREDIT:** Eric Austin

divide the genre into categories is almost impossible. With every advance in technology, new aspects of the art form are being introduced. We are just seeing the tip of the iceberg.

The new media genre, although still in its infancy, is flourishing. Works are being presented worldwide via the Internet. Gallery affiliation or publication no longer restricts public exhibition. The mass populace of Internet users and the volume of their interactions with the medium have caught the eyes of major players in the art world. Today, new media works are being acquired and commissioned by museums and collected in both the public and private sectors. The biggest challenge that artists of this technology-based genre face is in the archiving of their work. Because the art form relies on hardware and software that will, in time, become outdated, the work has a limited lifespan. To address this dilemma, the industry is constantly trying to come up with new ways to maintain the original integrity of works, whether it is through documentation or re-creation with more current forms of technology.

New media art will continue to be a force in the art world as long as it is in sync with our fast-paced, information-infused, multitasking lives. No longer monolithic in concept, medium and approach, artistic expression is evolving and a new generation of artists is redefining what it means to communicate through pictures.

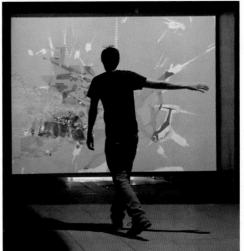

External Measures: Untitled 5 and 6 · Camille Utterback
SIZE: 7½' × 10' (2m × 3m) projection with a 7½' × 10' (2m × 3m) interaction area / **MEDIUMS:** interactive video installation (custom software, video camera, computer, projector and lighting) / **TECHNIQUES:** algorithmic drawing software, video tracking and interactive installation / **SURFACE:** screen / **COLLECTION:** Henderson Development Corporation, Hong Kong (*Untitled 5*, edition 1/3) / **PHOTO CREDIT:** Peter Harris

Although many work with commercial software packages, there is a growing number of artists that do their own coding, creating custom software to produce limited-edition and one-of-a-kind works of art.

contributors

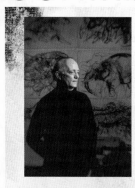

Marshall Arisman
314 West 100th Street
New York, NY 10025 [USA]
Tel 212.967.4983
Fax 212.366.1675
marisman@sva.edu
www.marshallarisman.com

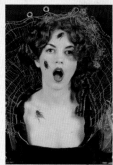

Cynthia von Buhler
CVB Enterprises Inc.
22 Fort Hill Circle
Staten Island, NY 10301 [USA]
Tel 646.221.5239
cvb@cynthiavonbuhler.com
www.cynthiavonbuhler.com

Kathleen Conover
The Studio Gallery
2905 Lakeshore Boulevard
Marquette, MI 49855 [USA]
Tel 906.228.2466
Fax 906.228.2466
michstudio@aol.com
www.kathleenconover.com

Stephanie Dalton Cowan
Cell 678.910.2757 [USA]
stephanie@daltoncowan.com
www.daltoncowan.com
www.daltoncowangallerie.com
www.altpick.com/sdcowan
Gerald & Cullen Rapp, Illustration Agent
(www.rappart.com)
Film Art LA/Jennifer Long, Film Agent
(www.filmartla.com)
Lyon & Lyon Fine Art, New Orleans, LA
(www.lyonandlyonfineart.com)

Lisa L. Cyr
Cyr Studio LLC
PO Box 795
Stroudsburg, PA 18360 [USA]
Tel 570.420.9673
Fax 570.420.9673
lisa@cyrstudio.com
www.cyrstudio.com
www.altpick.com/lisacyr
http://lisalcyr.profilestock.com

Lynne Foster
260 Convent Avenue, Suite 82
New York, NY 10031 [USA]
Tel 212.996.2136
Cell 917.301.4952
lynnefoster@mac.com
www.lynnefoster.com
www.altpick.com/lynnefoster

Rudy Gutierrez
Illumination Studio
45 East Main Street
Bogota, NJ 07603 [USA]
Tel 201.646.1362
rudygut@optonline.net
www.rudygutierrez.net
www.altpick.com/rudygutierrez

Brad Holland
96 Greene Street
New York, NY 10012 [USA]
Tel 212.226.3675
Fax 212.941.5520
brad-holland@rcn.com
www.bradholland.net

Dorothy Simpson Krause
Viewpoint Studio
PO Box 421
Marshfield Hills, MA 02051 [USA]
Tel 781.837.1682
Fax 781.834.1782
dotkrause@dotkrause.com
www.dotkrause.com
Judi Rotenberg Gallery, Boston, MA
(www.judirotenberg.com)

Susan Leopold
90 Beech Avenue
Toronto, Ontario
Canada M4E3H6
Tel 416.690.6654
susan@susanleopold.com
www.susanleopold.com
Lindgren & Smith, agent
(www.lindgrensmith.com)

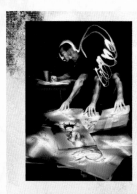

David Mack
c/o Allen Spiegel Fine Arts, agent
221 Lobos Avenue
Pacific Grove, CA 93950 [USA]
Tel 831.372.4672
asfa@redshift.com
nohgirl@yahoo.com
www.allenspiegelfinearts.com
www.davidmack.com
www.davidmackguide.com
www.myspace.com/davidmackkabuki

Dave McKean
c/o Allen Spiegel Fine Arts, agent
221 Lobos Avenue
Pacific Grove, CA 93950 [USA]
Tel 831.372.4672
asfa@redshift.com
www.allenspiegelfinearts.com
www.asfa.biz
www.davemckean.com

Robert Maloney
57 Brookside Avenue #6
Jamaica Plain, MA 02130 [USA]
Tel 617.721.9608
bawb.m69@gmail.com
www.robert-maloney.com

Matt Manley
213 Antisdel PL NE
Grand Rapids, MI 49503 [USA]
Tel 616.459.7595
art@mattmanley.com
www.mattmanley.com
Kolea Baker, agent (www.kolea.com)
Tel 206.784.1136

Michael Mew
2974 Burdeck Drive
Oakland, CA 94602 [USA]
Tel 510.530.6267
Fax 510.530.6267
mewseum@sbcglobal.net
www.michaelmewstudio.com
Kidder Smith Gallery, Boston, MA (www.kiddersmithgallery.com)
Deborah Page Gallery, Santa Monica, CA (www.deborahpagegallery.com)
Erickson Fine Art Gallery, Healdsburg, CA (www.ericksonfineartgallery.com)
Mauger Modern Art, Bath, England (www.maugermodern.com)

Fred Otnes
fredotnes@optonline.net
www.fredotnes.com
The Reece Galleries [USA]
www.reecegalleries.com

A.E. Ryan
12 Williams Street
Brookline, MA 02446 [USA]
Tel 617.731.0014
aeryan@rcn.com
www.aeryan.com

Kazuhiko Sano
105 Stadium Avenue
Mill Valley, CA 94941 [USA]
Tel 415.381.6377 or 415.259.7886
kazu@kazusano.com
www.kazusano.com

Barron Storey
852 Union Street
San Francisco, CA 94133 [USA]
Tel 415.673.0580
rossbarronstorey@aol.com
www.barronstorey.com

Richard Tuschman
Richard Tuschman Images [USA]
Tel 216.702.3088
rt@richardtuschman.com
www.richardtuschman.com
www.richardtuschman.blogspot.com

Camille Utterback
1777 Yosemite Avenue #325
San Francisco, CA 94124 [USA]
Tel 415.822.2255
Fax 415.822.2255
info@camilleutterback.com
www.camilleutterback.com

manufacturers, suppliers & artist resources

Below are the manufacturers and suppliers used by the artists in the demonstrations throughout the book. Many of the materials used in this book are easy to find from your favorite art supplier. Before embarking on any new procedure or technique it is important to be knowledgeable about the products you will be using. For health and safety information go to the manufacturer's website or contact them directly. See the disclaimer on page 2 for more information.

Adobe
www.adobe.com
(Photoshop)

Albums Inc.
www.albumsinc.com
(Sureguard Retouch photo lacquer)

Arches
www.arches-papers.com
(140-lb. (300gsm) hot-pressed watercolor paper and cover stock)

Art Alternatives
www.art-alternatives.com
(Deep stretched canvas)

Benjamin Moore Paints
www.benjaminmoore.com
(Latex paints)

Bienfang
www.forframersonly.com
(Sealector tacking iron and no. 360 graphic layout paper)

Bob Ross Painting Supplies
www.bobross.com
(Black gesso)

Canon
www.usa.canon.com
(copy machine, 10.1 megapixel camera and scanner)

Caran d'Ache
www.carandache.ch
(Supracolor Soft Aquarelle pencils and Neocolor II Aquarelle crayons)

Carriage House Paper
www.carriagehousepaper.com
(Handmade paper, cotton linter and Aardvark Colors/dyes, linters)

Citra Solv
www.citra-solv.com
(Cleaner and degreaser)

Crescent Cardboard
www.crescent-cardboard.com
(140-lb. (300gsm) watercolor board)

Daler Rowney
www.daler-rowney.com
(Stay-Wet Palette)

Daniel Smith Finest Quality Artist's Materials
www.danielsmith.com
(Quinacridone Gold acrylic paint)

Digital Art Studio Seminars
www.digitalartstudioseminars.com
(DASS transfer film)

Dupont
www2.dupont.com
(Mylar polyester film: 5mil)

Epson
www.epson.com
(Ink-jet printers, photo scanners, flatbed scanners, ink-jet clear transparency film, double-sided matte ink-jet paper and UltraChrome Inks)

Escoda
www.escoda.com
(Ox-hair mottler brush)

Fredrix Artist Canvas
www.fredrixartistcanvas.com
(Cotton duck and raw canvas)

Gamblin Artists Colors
www.gamblincolors.com
(Gamsol, Galkyd Medium and Cold Wax Medium)

Gane Brothers & Lane
www.ganebrothers.com
(Yes! Paste)

General Pencil Company
www.generalpencil.com
(Charcoal pencils, compressed charcoal sticks, graphite pencils and powdered graphite)

Golden Artist Colors
www.goldenpaints.com
(Heavy body acrylic paints, acrylic matte medium, GAC 400 fabric stiffener, digital grounds, heavy gel matte medium, crackle paste, molding paste and black gesso)

Grumbacher
www.grumbacherart.com
(Stand oil)

Home Depot
www.homedepot.com
(Masonite, wood, metal and building materials)

inkAID
www.inkaid1.com
(Clear Gloss Precoat Type II)

Krylon
www.krylon.com
(Clear spray, workable clear matte fixative and UV-resistant clear acrylic coating)

L.A. Gold Leaf
www.lagoldleaf.com
(Imitation silver leaf)

Liquitex Artist Acrylic
www.liquitex.com
(Modeling paste, acrylic matte medium, acrylic gloss medium and varnish, gel medium, modeling paste, white gesso, and soft body, medium viscosity and heavy body acrylic paints)

Luco
www.uhlfeldergoldleaf.com/products.htm
(Artist and decorative painting brushes)

MACtac
www.mactac.com
(MACtac double-sided sheet adhesive)

Martin/F. Weber Co.
www.weberart.com
(Odorless Turpenoid and Japan drier)

Microtek
www.microtekusa.com
(Scanner)

Nielsen Bainbridge
www.nielsen-bainbridge.com
(80-lb. (170gsm) cold-pressed illustration board)

Nova Color
www.novacolorpaint.com
(Acrylic polymer gel medium, gloss and matte gel medium)

Paper Mate
www.papermate.com
(Pink Pearl adjustable eraser)

Papersafe
www.papersafe.demon.co.uk
(Bookbinder's PVA glue pH neutral)

Prismacolor
www.prismacolor.com
(Nupastel color sticks and colored pencils)

Rex Art
www.rexart.com/owa_gold_leafing.html
(Old World Art adhesive size)

R&F Handmade Paints
www.rfpaints.com
(Pigment sticks, encaustic wax bars, medium and paint)

Ridout Plastics
www.ridoutplastics.com
(Gold moiré optical plastic film)

Sony
www.sony.com
(10.3 megapixel digital camera)

Speedball Art Products
www.speedballart.com
(Permanent acrylic white ink, Diazo Emulsion Kit and silkscreen printing screen)

Staedtler
www.staedtler-usa.com
(Graphite pencils)

Strathmore Artist Papers
www.strathmoreartist.com
(500 Series illustration board, vellum heavyweight, 400 Series Bristol 2-ply vellum and tracing paper)

Saunders Waterford Series
www.inveresk.co.uk
(Waterford Series hot- and cold-pressed watercolor paper)

The Compleat Sculptor, Inc.
www.sculpt.com
(Plaster, clay and sculpting tools)

3M Worldwide
www.3m.com
(Scotch 471 Series Blue Plastic Fine Line tape, Scotch double-sided mounting tape and 3M silver tape)

Winsor & Newton
www.winsornewton.com

index

Look for these titles from
North Light Books

Get ready for the creative ride of your life! Tradition is out, experimentation is in with this cutting-edge how-to sampler of techniques to use with acrylic, the world's most versatile medium. *Rethinking Acrylic*'s workshop-style instruction covers a wide range of acrylic approaches demonstrating inventive, non-traditional, downright inspirational ways to paint with acrylics. What will *you* think of next?

ISBN 13: 978-1-60061-013-4
ISBN 10: 1-60061-013-7
Z1060

**Hardcover with concealed spiral
160 pages**

Watercolor moves like no other medium. Just add water, and the pigment takes on a life of its own. *Watercolor Essentials* contains everything you need to expand your skills and paint with confidence. Includes page after page of beginning and advanced instruction—over twenty-eight technique exercises and twelve full step-by-step demonstrations—plus more than forty lessons on the companion DVD.

ISBN 13: 978-1-60061-094-3
ISBN 10: 1-60061-094-3
Z2003

**Hardcover with concealed spiral
128 pages**

The Creative Edge takes you on an amazing exploration of your own artistic potential. Heighten your awareness of color, texture and design as you infuse your work with symbols and metaphors of special significance to you. Artist Mary Todd Beam invites you to build on basic creative processes to help you go deeper into your observations and experiences following more than twenty-five techniques.

ISBN 13: 978-1-60061-111-7
ISBN 10: 1-60061-111-7
Z2118

**Hardcover with concealed spiral
144 pages**

These and other fine North Light books are available at your local art & craft retailer, bookstore or online supplier, or visit our website at **www.artistsnetwork.com**